Porcelain and Bone China

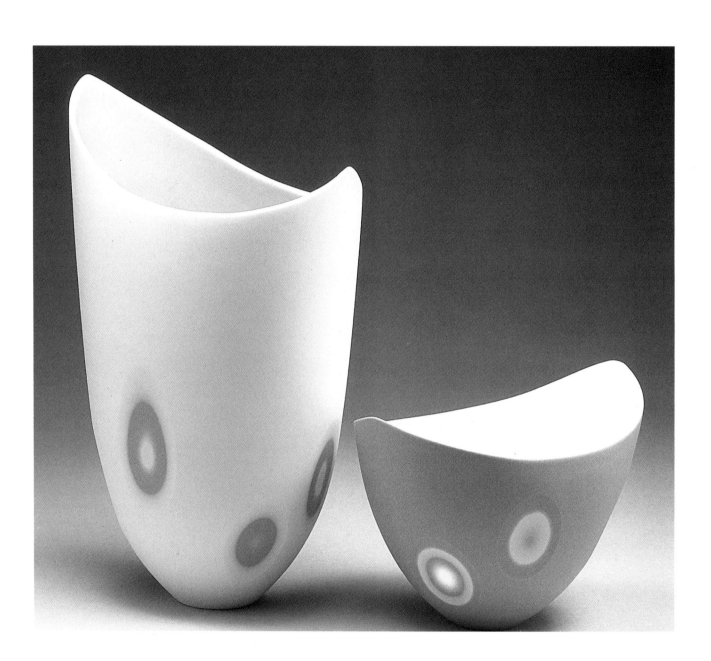

Porcelain and Bone China

Sasha Wardell

The Crowood Press

First published in 2004 by
The Crowood Press Ltd
Ramsbury, Marlborough
Wiltshire SN8 2HR

www.crowood.com

British Library Cataloguing-in-Publication Data
A catalogue record for this book is available from the British Library.

ISBN 1 86126 693 6

Acknowledgements
First of all, I would like to thank all the ceramicists who have so readily contributed and whose work features in this book. In particular, I would like to extend further thanks to the following people whose contribution has been invaluable in the sourcing and preparation of this book: Angela Mellor and Sandra Black in Australia; François Ruegg and Wolfgang Vegas in Switzerland; Pascale Nobécourt in France; Hubert Kittel and Karin Bablok in Germany; Adrienne Kriel in South Africa; and Sue Pryke, Kathryn Hearn and Tavs Jørgensen in the UK, as well as Keeley Traae at Wedgwood and Nadia Demetriou Ladas at Vessel in London.

I would also like to mention the assistance offered by the CPA Charitable Trust, the British Museum and the Museum of East Asian Art, Bath, for which I am most grateful. The technical advice given by Alan Ault of Valentine's Clay Products and John Liddle from Ceram Research was invaluable, and thanks must also go Mary Clark and Peter Scott for their painstaking proofreading and to Charlie for his computer advice.

Typeset and designed by D & N Publishing
Hungerford, Berkshire.

Printed and bound in Malaysia by Times Offset (M) Sdn. Bhd.

Contents

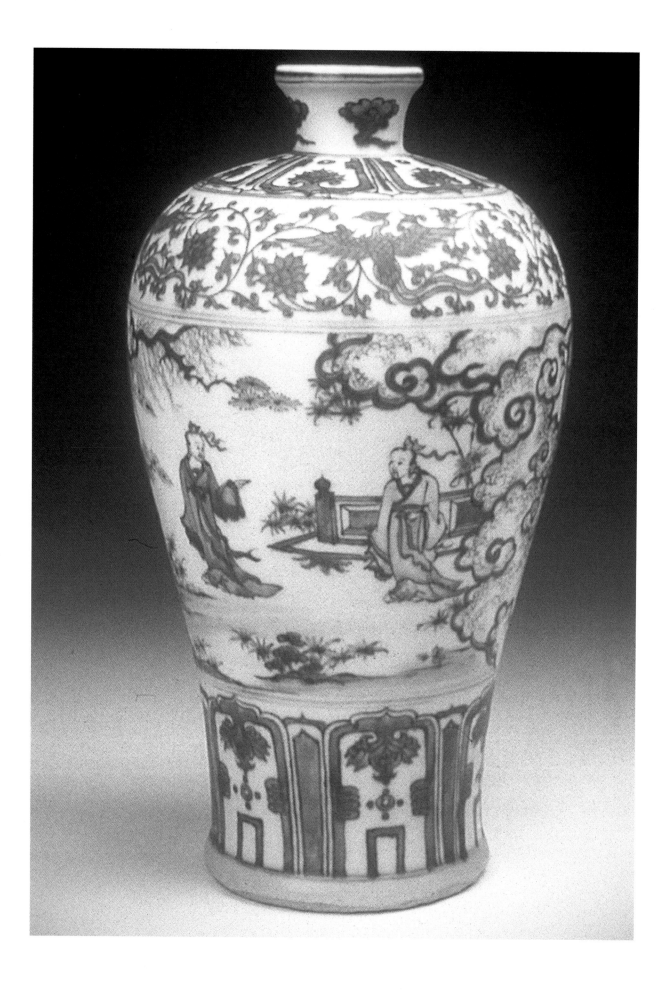

Introduction
~
'White Gold'

This introduction aims to give a brief overview of the history of the origins of porcelain and bone china, particularly with reference to the economic and social developments of the ceramic industry of the UK and continental Europe.

Porcelain

It is not possible to give an exact date for the discovery of porcelain, as its creation was a long, slow evolution that took place over several millennia. China, with its naturally occurring kaolin deposits and already skilled potters, presented the ideal combination for the beginnings of porcelain manufacture.

At that time, the Chinese empire stretched from Mongolia in the north to Vietnam in the south, and its population was subject over time to a wide variety of monarchs and regimes. It is believed that the first porcelain was made during either the Sui (AD 581–617) or early T'ang (AD 618–906) dynasties and was of an appearance which we today would liken to a high-fired white stoneware.

The Liao dynasty (AD 907–1125) produced what was termed a 'porcellanous' body, which was close-grained and white with a distinctive creamy glaze, whilst the Song dynasty (AD 1128–1279) produced some fine, varied and classically simple porcelain wares, which were predominantly flower-inspired. Taking the form of lotus bowls and vases, they were minimally decorated apart from subtle surface carving and pale green celadon glazes.

A melon-shaped ewer has been found in a tomb dated AD 1099. The long spout is typical of the period, while the blue tinge of the piece is indicative of early eleventh-century ware. In the first half of that century such blue was occasionally produced by accident; however, by the late eleventh century, this effect was actively sought.

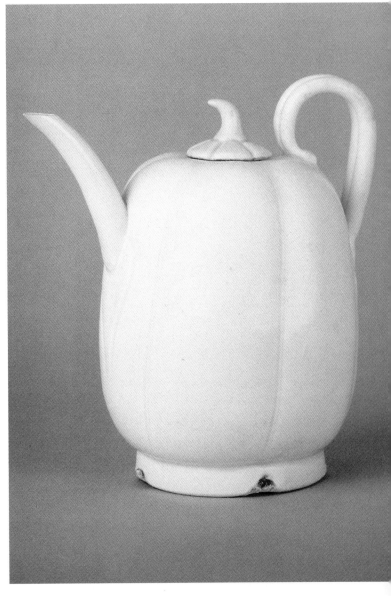

THIS PAGE:
Qingbai melon-shaped ewer.
Northern Song dynasty. (Permission of the Museum of East Asian Art, Bath)

OPPOSITE PAGE:
Blue and white meiping vase decorated in the 'windswept' style.
Ming dynasty, second half of the fifteenth century. (Permission of the Museum of East Asian Art, Bath)

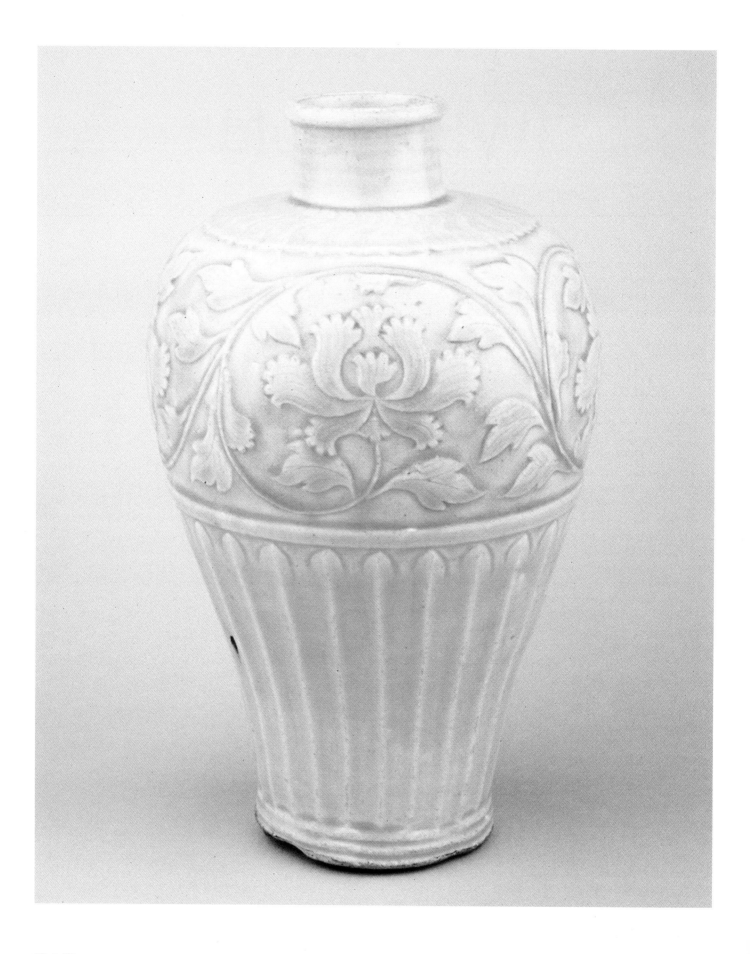

Following this period, the Mongols came to power and formed the Yuan dynasty (AD 1280–1368). Porcelain manufacture started to become grander and more complex, due to the improvements in technology and clay composition. However, weak monarchs, disorderly administration and general poverty coupled with natural disasters, such as droughts and floods, all contributed to the decline and collapse of this relatively short-lived dynasty.

The meiping vase shown here has a body decorated with a broad band of carved peony scrolls with incised details delineating the leaves, bordered by overlapping swirling petals on the upper part and tall lotus petals around the lower half. The vase is covered with a glossy bluish Qingbai glaze. The decoration is similar to that found on Longquan celadon wares of the Yuan dynasty. This type of decoration, whilst typical of celadon of the Yuan period, is rarely seen on Qingbai pieces. It has been suggested that it was probably produced at one of the celadon kilns of Zhejiang province rather than in Jingdezhen, a town that was significant in the production of porcelain.

Following the Yuan dynasty, the Ming dynasty (AD 1368–1644) spanned a period of some 300 years of peace and prosperity. Seventeen autocratic emperors ruled over China's transformation from an agriculturally based society to a more industrialized one. Profound social changes took place, which led to the development of a cash economy, technical advances, huge growth in cities, the spread of literacy and the industrialization of handicrafts.

It was during the Yuan and Ming dynasties that Jingdezhen became particularly significant in the production of porcelain. This town, in the southern province of Jiangxi, developed as the most important centre for porcelain manufacture due to its geographical position. Being well-situated on a system of inland waterways, and close to raw material deposits, it was an ideal choice for a manufacturing centre, especially as, with dwindling agricultural work, there was also a ready made workforce available for employment. Advances in technology went on to pave the way for more sophisticated and colourful porcelains, moving away from the previously popular celadons.

Porcelain was used throughout Chinese society, ranging from small-scale family use to the royal households, with decoration depicting five central themes: historical, technological, trade, religious and social. A variety of imagery and iconography was used on the ware, including cranes and peaches symbolizing long life, as well as hobby-horses, which were a metaphor for scholarly success.

The discovery of pottery and porcelain artefacts in burial graves has greatly assisted our understanding of these materials. Following the Buddhist belief of 'life after death', people were buried with bolts of cloth, gold ingots for currency, as well as entire miniature porcelain crockery sets, fully equipping them for the life hereafter.

Although Chinese celadon porcelains had been sent to the West centuries before, it was during the Ming era that the first large parcel shipments of 'blue and white' were exported to Europe (Portugal), America (New Mexico) and Africa (Malindi), fuelling interest and intrigue regarding this precious commodity. It was in fact the Europeans who coined the name 'porcelain' deriving it from the Portuguese word 'porcellaneous' meaning 'shell-like'. There was direct trade between Europe and China after the successful achievements of maritime exploration. In 1517 Vasco da Gama returned to Portugal from one voyage with porcelain and pepper for King Manuel I.

After dominating these trade routes in the early 1500s, the Portuguese were superseded by the Dutch. This followed the closure of the port of Lisbon by Philip II of Spain during the war between Spain and Portugal. However, by then Chinese porcelain had reached nobility in other parts of Europe, including Henry VIII in Britain and Francesco I de' Medici in Italy. The latter resulted in the earliest recorded attempts to recreate Chinese porcelain in his court laboratories in Florence in the 1570s.

Korea was the next country after China to produce porcelain, and a thriving industry developed. However, the Koreans suffered defeat at the hands of the Japanese in 1592 and the industry collapsed. A Korean potter was taken to Japan as a prisoner, in the hope that he would divulge his knowledge to the Japanese. He discovered a fine porcelain stone in the mountain of Izumiyama in the Arita region and production began. Being close to the port of Imari, from which it got its name, this famous Japanese porcelain was subsequently shipped all over the world. Although the Japanese gleaned their porcelain-making skills from the Chinese and Koreans, a typical Japanese style developed with the Arita potter, Sakaida Kakiemon, whose famous onglaze decoration was later imitated by the Worcester, Derby and Meissen factories in the eighteenth century.

The introduction of porcelain to Europe, by way of shipments via the English and Dutch East India Companies, provoked an enormous interest and quest to find the *arcanum* (recipe) for this precious material. During the 1600s, there had been several unsuccessful attempts to simulate porcelain which had, by then, become as important a commodity as gold, or 'white gold' as it came to be known. It was common practice for northern European monarchs to create a 'porcelain room' where huge collections were on show.

After the experiments in the Medici porcelain factory in Florence in the 1570s, there was quite a period of time before other countries such as Holland, Switzerland, Denmark, Sweden and Russia conducted experiments. However, Germany and France were to become the main players. In Germany,

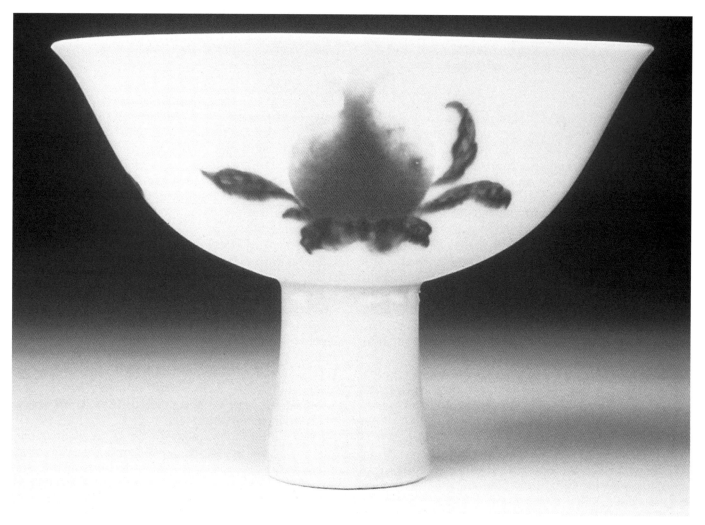

Stem bowl decorated in underglaze blue and Langyao red.
Qing dynasty, Yongzheng mark and period (1723–35). (Permission of the Museum of East Asian Art, Bath)

events were unfolding that would lead to the invention of 'true' or hard-paste porcelain. This colourful and compelling story is superbly described in Janet Gleeson's book *The Arcanum*. However, to put it into some form of historical context, the main events are chronicled as follows.

An alchemist named Johann Freidrich Böttger (1682–1719) was taken prisoner by Augustus of Saxony, King of Poland. Böttger proclaimed that he could make gold and, latterly, porcelain – a rash claim. However, in 1708, after five years' imprisonment, and with the assistance of scientist Pabst von Ohain and, subsequently, mineralogist Ehrenfried Walther von Tschirnhausen (1651–1708), Böttger was able to produce some early experimental pieces. The resultant ware using clay and alabaster (later substituted with feldspar) was the key to the breakthrough they had been working for – a white and translucent porcelain that held its shape. Coupled with the discovery of some kaolin deposits at Colditz, Böttger was well on the way to reproducing the

highly acclaimed hard-paste porcelain of the Orient. Unfortunately, von Tschirnhausen died the same year as the breakthrough, which meant he did not live to see the results of his combined efforts and Böttger had lost his main ally and confidant.

In 1710 the Meissen factory was established under the patronage of Augustus of Saxony, with Böttger being appointed the factory's administrator. However, following his death in 1719, at the age of 37, the factory was found to be in huge financial debt. Much of the subsequent developments have been credited to Johann Gregor Herold (1696–1775), an Austrian painter and colour chemist, who had joined the factory in 1720, and to Johann Joachim Kändler (1706–75) in 1730, a gifted modeller who set the precedent for the famous Meissen figures.

In France, the perfection of artificial porcelain, known as *pâte tendre* or soft-paste porcelain, was first credited to the Poterat family at Rouen *c*.1673. The characteristics of this

material were a lack of translucency and a 'softness' which meant that the glaze could easily scratch.

At that time, there were four significant producers located in and around Paris.

In 1678 at St Cloud a soft-paste porcelain was developed, although official production only started in 1702 when the patent was granted. Influenced by the Imari, *famille vert* and Kakiemon ware, this porcelain had the appearance of a creamy or ivory tone, with a soft and shiny surface indicating that a glassy frit was used as a flux, instead of feldspar.

Production then began at Chantilly in 1726, and the town became famous for its Kakiemon-inspired ware and distinctive opaque tin glaze. Later, production commenced at Villeroy, with an early ware that was similar to St Cloud and included rococo-style pot-pourris. Finally, a factory opened at Vincennes in 1740. This latter factory was an important landmark in the production of porcelain for, having been granted a royal warrant for the exclusive rights of manufacture of 'porcelain in the style of Saxony', it was able to produce richly decorated ware with flower and bird motifs using gold. However, Vincennes still had to be content with producing the soft-paste body, as kaolin was not discovered in France until 1768. In 1756, the Vincennes factory moved to Sèvres, becoming the most important manufacturer in France thanks to its technical expertise and variety of colour and decorating techniques.

During this period, the all-important discovery of kaolin in 1768 at St Yrieix in the Limousin occurred. This meant that hard-paste porcelain could, at last, be produced, leading to the development of new and extended colour ranges and techniques, in particular enamel on gold foil. The two pastes or clays were simultaneously produced up until 1804, when soft paste was abandoned in favour of hard paste.

In the midst of all this production around the capital, the town of Limoges became synonymous with porcelain, as it still is today, not only because of its proximity to the newly found kaolin deposits, but also thanks to a few entrepreneurial businessmen who capitalized on this discovery by mining and exporting kaolin all over Europe. They subsequently opened up porcelain factories where highly skilled craftsmen collaborated with well-known artists to produce some of the finest examples of European porcelain.

Bone China

During this time, England had been pursuing its own experiments. Triggered by the increasing popularity of tea drinking, porcelain was in great demand, so, by the 1740s, factories in Staffordshire, London and Bristol had embarked on the familiar quest. Prior to 1780, however, English porcelain was likened to the early soft-paste French bodies where a glassy frit was added and firings were carried out to 1100°C. This differed from the hard-paste porcelains found in Germany and later in France, where the firing temperatures reached 1400°C.

Although a relatively successful attempt to create 'true', or hard-paste, porcelain was made at Plymouth in 1768, these fritted wares were difficult to work with, particularly when used in conjunction with the unplastic nature of the English china clays. The successful manufacture of porcelain, therefore, was seriously inhibited until the introduction of bone ash, which lessened the risk of collapse during firing. By 1747 inclusions of this versatile material had been undertaken in factories at Bow in London and Lowestoft with some success. However, it was not until 1749, when Thomas Frye of the Bow works patented, for a second time, the use of bone ash, that any headway was made into the development of a relatively high-fired white clay or 'china'. Frits, however, were still included in the body at that time.

This remained the case until finally, in 1794, Josiah Spode of Stoke-on-Trent initiated the change to the present mixture of bone ash, Cornish stone and china clay. This English hybrid between soft- and hard-paste porcelain was originally termed 'Stoke China', later becoming known as bone china. Having dispensed with the use of frits entirely, this resulted in a body that eventually became the basis of today's bone china. Stoke-on-Trent became synonymous with bone china production, remaining so to this day.

Even in the present economic climate, factories such as Worcester, Derby and Wedgwood, which have their origins in the mid-eighteenth century, still exist and continue to produce both classical and innovative products, albeit for what appears to be a dwindling market. However, a new generation of small, independent factories has sprung up to cater for the ever-changing needs of today's consumer (*see* Chapter 7).

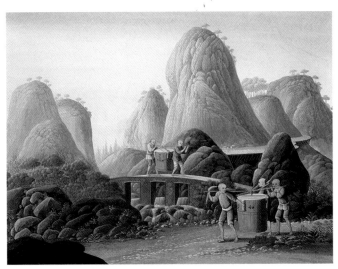

An illustration taken from a series of twenty-four nineteenth-century album illustrations showing the manufacturing process of porcelain. Ink and colours on paper. (British Museum – given by Miss W. M. Giles)

'Forest Floor' by Les Blakebrough. (22cm diam. × 18cm h.)
Thrown Southern Ice porcelain with water erosion technique.
Unglazed. Reduction-fired to 1300°C. 2001. (Photo: Uffa Schultz)

1

Composition of Porcelain and Bone China with Recipes

Although porcelain and bone china are sometimes erroneously classed as one and the same material, there are some fundamental differences that distinguish them from each other both historically (*see* Introduction) and technically. Whilst they share some raw materials and characteristics in common, their differing ingredients, recipes, shrinkage rates and firing treatments serve both to highlight and contribute to their individual qualities.

Both possess 'whiteness', translucency and strength, to a lesser or greater degree, as well as being high-fired and vitrified when mature. However, there are some subtle differences concerning their properties: porcelain tends to be 'warmer', with tones of white ranging from creamy off-white (in oxidizing firings) through to bluish-white (in reduction firings). Bone china, on the other hand, tends to be ice-white, or 'cold' in colour, unless it has been under-fired, whereupon it takes on a pinkish hue. Some say that the colour of the body determines how translucent the clay appears, even when both have been fired to their maturing temperatures.

Porcelain is generally stronger in its 'green', or raw, state, allowing for certain decorating techniques such as piercing at the leather-hard stage. Bone china, however, requires a soft firing to 1000°C before the ware can be safely handled (*see* Chapter 5). The fired strength of these materials is determined by their respective high-firing temperatures, with hard-paste porcelain being particularly strong.

The following recipes highlight the differences between the two materials. The recipes are supplied courtesy of Alan Ault of Valentine's Clay Products in Stoke-on-Trent (*see* Suppliers).

Basic Recipes for Porcelain and Bone China

A basic porcelain recipe is as follows:

- 50% china clay
- 25% feldspar
- 25% quartz
- 2–3% ball clay/bentonite.

Standard low biscuit firing: 1000°C.
Standard glaze firing: 1280–1450°C*
 *(hard-paste porcelain).
Shrinkage after firing: 12–15% (depending on the firing).

Bone China

A basic bone china recipe is as follows:

- 50% bone ash
- 25% china clay
- 25% Cornish stone*
- 1% ball clay.

* A type of feldspar now replaced by a more stable Italian feldspar.

Standard high biscuit firing: 1250°C + 1hr 30min soak.
Standard glaze firing: 1020–1080°C.
Shrinkage after firing: 10–12% (depending on the firing).
Average length of biscuit firing cycle: twenty-four hours, including cooling.

When looking at these basic recipes, the two main differences in the ingredients become clear: porcelain contains quartz and no bone ash, whilst the reverse is true for bone china. The fact that there is no quartz present in bone china means that it can be fired straight up to its top temperature in two hours, without any of the concerns normally associated with quartz inversion (*see* Glossary). Although the ceramic industry has kilns that are capable of fast-firing, it is not recommended for the individual ceramicist, as this will quickly damage the elements of a studio kiln.

The bone ash that makes up half of a bone china recipe is a by-product derived from cattle bones that were originally imported from Argentina, Holland and Sweden. As animal bones are used in the glue industry, once they have been boiled for manufacture, the residue is calcined and ground, then introduced into the china body. (Crown Derby Bone China manufacturers use ox bone ash from a Dutch glue factory.) By-products feature quite prominently in the china industry, as bone china biscuit seconds are used as 'landfill' underneath Tarmac roadways!

Raw Materials

The analysis of raw materials can be obtained from suppliers.

China Clay (Kaolin)

(AL_2O_3 $2SiO_2$ $2H_2O$)

The name kaolin is derived from the Chinese word *kao-ling*, which refers to the 'high mountains' in which the deposits of the original clay were found. China clay is a primary clay, meaning it is closely associated with the parent rock, and is obtained by washing the rock using high-pressure hoses with the slurry being collected in settling troughs. It is found in large quantities in Cornwall (UK), Florida and Carolina (USA), Tasmania, New Zealand and other areas of Western and Central Europe.

It is a very white clay with a large particle size. This results in poor plasticity, or workability, and generally means that other ingredients are required to make it a viable material. Chinese kaolin is the most plastic, with Cornish china clay being the least.

China clays have a high alumina content and can contain very small amounts of titanium and iron oxides, which will ultimately affect the colour of the body – the lower the quantities, the whiter the body. Grolleg and Standard Porcelain China Clay from Imerys in Cornwall (*see* Suppliers) are amongst the whitest firing, along with Edgar Plastic Kaolin (EPK) from the USA and Tonganah kaolin from Tasmania (*see* Southern Ice porcelain recipe p. 15).

Feldspar (Potash Feldspar)

(K_2O AL_2O_3 $6SiO_2$)

Feldspars come from a large group of minerals that have decomposed from granite and igneous rocks. They consist of the alumino-silicates of potassium, sodium and calcium. The most commonly used in high-firing clays is potash feldspar, which is pinkish in colour and acts as a primary flux (that is, has the effect of lowering the melting point of silica) in porcelain bodies. Large amounts will increase translucency, as well as the possibility of distortion, whereas smaller amounts will raise the maturing temperature but reduce translucency.

Quartz

(SiO_2)

This is almost pure silica occurring as rock crystals or as silica sand. Loch Aline on the west coast of Scotland is the main source for silica sand in the UK. Flint can also be used, but it is not as pure as quartz. Quartz is the glass-former in a porcelain body, rendering it hard and durable. It has a very high melting point of 1710°C, therefore must be used in conjunction with a flux. Quartz is finely ground and available in 'mesh' sizes, for example 300s mesh; the higher the mesh number, the smaller the particle size. If too much quartz is present, the porcelain may crack, whereas too little may lead to crazing problems in glazes.

The quartz is normally 'leached', a process whereby the iron is removed, resulting in as pure a material as possible.

Ball Clay

The name 'ball clay' derives from the 30lb balls in which this clay was originally formed for transportation by horse and cart. These are secondary, or transported, clay deposits, produced by the weathering and erosion of granite rocks, which are broken down and carried by streams.

Ball clay has a very fine particle size, therefore it is very plastic in nature, with a high shrinkage rate. It can cause

discolouration if used in large amounts; however, small quantities of 1–3% will improve plasticity and strength in both porcelain and bone china bodies.

Bentonite

Bentonite is also a secondary clay. It can be used as a substitute for ball clay as it also has an extremely fine particle size.

The differing properties of these raw materials, whilst nonviable when they stand alone, form the basis of arguably the most seductive of high-firing clays when they are combined.

It is now possible to buy a range of ready made porcelain and bone china bodies from reputable manufacturers worldwide (*see* Suppliers), including the French Limoges porcelain, which is designed to fire to 1400°C and is a favourite amongst many ceramicists.

Ready-Made Porcelain Clays for Individual Makers

An increasing number of ready made clays have been created to meet the needs of individual makers. Notable examples of these in the UK are **David Leach** porcelain (Potclays), which was developed by him in the 1970s, and **Audrey Blackman** porcelain (Valentine's Clay Products). Southern Ice porcelain (Walker Clay Co.) features strongly in Australia.

The basic recipe for the **David Leach** porcelain is as follows:

- 52% standard porcelain china clay
- 25% potash feldspar
- 20% quartz 200
- 3% Quest white bentonite.

Anne James (UK) (*see* Chapter 6) uses this as the basis for her raku body:

- 52% standard porcelain china clay (powder or Grolleg)
- 25% FFF feldspar
- 18% quartz 200
- 5% bentonite.

She makes a slurry and sieves this recipe twice (80s and 120s meshes) before adding 10% molochite (refractory grog) to it.

Audrey Blackman (UK) porcelain is another body which was specifically developed for a particular need – namely modelling and throwing. Due to the high plasticity of this body, it is not suitable for casting and is only available in pugged or plastic form. It has a firing range of 1220–1280°C. Both **Margaret O'Rorke** (UK) and **Gilda Westermann** (Germany/UK) use this porcelain body for certain aspects of their work.

Karen Downing (USA/UK) uses a 50/50 blend of Valentine's Audrey Blackman and Special porcelain for her thrown work. She says:

> After experimenting with a number of porcelain bodies, I settled on the Audrey Blackman because of its whiteness and responsiveness in throwing. However, problems with spiral cracking in drying make it untenable to continue using on its own. I now mix the two bodies in a de-airing pug mill and seem to have resolved the spiral cracking without compromising the qualities which initially drew me to the Audrey Blackman. The pots are then fired in an electric kiln to cone 8 (1260°C).

Les Blakebrough (Australia) has produced a porcelain clay with particularly white, translucent qualities (*see* the Chapter opening illustration). Southern Ice porcelain derives its name from the area where it was generated – Hobart, Tasmania, which is one of the southernmost parts of the Southern Hemisphere. It was developed over a period of six years by a small team of associates with support from the Australian Research Council and the University of Tasmania. Since its commercial release by Clayworks of Dandenong, Victoria, the clay is now being exported to several countries including the UK and USA.

One of the issues that drove this research was the fact that Blakebrough wanted a clay that would stand up to scrutiny even if it remained unglazed. Being dissatisfied with what was currently available, he embarked on the Southern Ice project, attempting to use the local raw materials. Kaolin deposits found at Tonganah, near Scottsdale, were already being used in a paper manufacturing plant and proved to be suitable. However, high-quality feldspar, silica and bentonite were not available locally, so it was necessary to turn to commercially produced materials for the rest of the recipe.

Therefore, after a series of tests involving slight alterations in the major body constituents of kaolin, feldspar and silica with the addition, or deletion, of auxiliary fluxes, the following recipe seemed the most favourable:

- 50% Tonganah kaolin
- 30% potash feldspar
- 20% silica 300
- 5% bentonite H.

(For further information on this research refer to *Ceramics Technical*, No.1, 1995, and *Ceramic Art and Perception*, Vol. 24, 1996.)

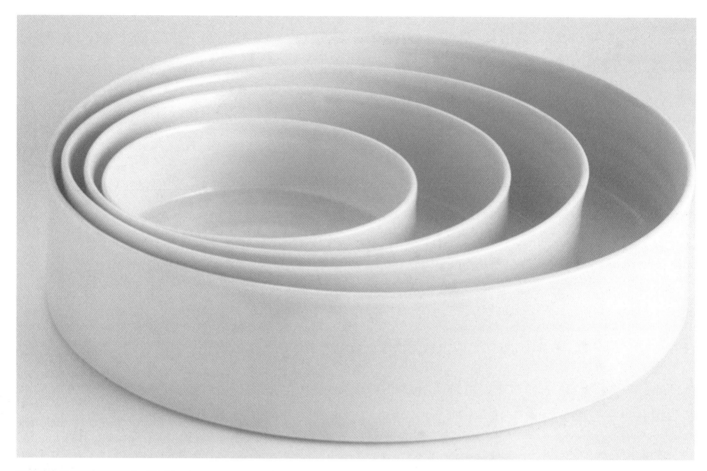

ABOVE: *Stack of straight-sided porcelain dishes by Karen Downing. 2002. (Photo: Mark Somerville)*

LEFT: *'Whites' by Juliet Armstrong. Slip cast, pierced and polished bone china.*

RIGHT: 'Waterfall' series by Angela Mellor. (18cm h.)
Slip cast bone china with paperclay inlay.
Fired to 1250°C. 2002. (Photo: Victor France)

A few UK makers have adopted this clay, reinforcing its popularity. Amongst them are **Joanna Howells** (*see* Chapter 2) and **Peter Lane** (*see* Chapter 5).

Bone china has the reputation of being notoriously difficult to make up in a studio situation, so makers generally rely on the commercial manufacturers to do the hard work (this is certainly true in my case!). However, being a particularly 'English' material, very few makers outside of the UK are willing to pay the high cost of importing what is already an expensive material. Nevertheless, this has not deterred South African ceramicists **Martha Zettler** (*see* Chapter 5) and **Juliet Armstrong**.

Armstrong has persevered in producing her own bone china body. However, she has experienced a high failure rate – with whiteness and translucency being her prime objectives, this has meant that the body has been pushed to the top of its vitrification range.

Her recipe is as follows:

- 50% bone ash (using a chemical substitute tricalcium phosphate)
- 25% SS porcelain (imported from UK)
- 25% Blesberg feldspar (from South Africa).

Firing temperature: 1260°C with a one-hour soak.

Ceramicists working in bone china on the other side of the world have experienced the same type of problems. Both **Sandra Black** (*see* Chapter 5) and **Angela Mellor** use a recipe which was developed by Dr Owen Rye in Australia:

- 30% Eckalite No.1 kaolin
- 45% bone ash – natural
- 22.8% potash feldspar
- 2.2% silica.

To make this plastic body into a casting slip add:

- 2g Dispex* per kg of dry weight
- 1g sodium silicate
- 600ml water per kg of dry weight.

* *See* Glossary

In the recent past, paperclay, used in combination with both porcelain and bone china, has resulted in some fine examples of heightened translucency. **Anne Lightwood** is a UK maker who has carried out extensive research into this area. Her book, *Working with Paperclay* (The Crowood Press), is an excellent source of reference on this subject. The porcelain recipe she uses, in conjunction with the paperclay, originated from Donald Logie (Duncan of Jordanstone College in Dundee):

- 45% Grolleg china clay
- 20% Hyplas 71 ball clay
- 20% feldspar
- 15% quartz
- 2% bentonite
- 2–5% molochite.

When in slip form, she adds one part soaked cellulose pulp to two parts slip.

Others who include paperclay are **Frances Priest** (UK) using it with bone china (*see* Chapter 3) and **Maggie Barnes** (UK) with porcelain. Barnes makes her porcelain paperclay

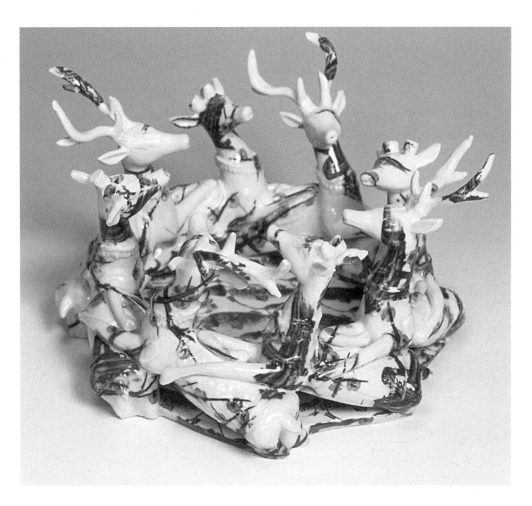

from equal parts of Southern Ice porcelain and 100% cotton-fibre pulp. The slip should be the consistency of thick cream and the prepared pulp should have as much surface water as is feasible. The mixture is well-beaten in a glaze-mixer, then poured onto plaster bats to remove surplus moisture. The resultant sheets are rolled thin for translucent work, or laminated together to create thicker slabs for tiles and panels.

The less formal, more abstract tiles and panels are decorated by first brushing a layer of pure porcelain slip, either white or coloured, over the surface. Subsequent layers of colour are built up by sponging, or brushing slip, onto selected areas. Resist techniques are used on some sections: wax, masking tape and a variety of mesh screens assist in adding pattern and texture to parts of the surface.

Work is dried slowly, over several days, between sheets of absorbent paper and weighted boards. They are once-fired to 1260°C in either an oxidized or a reduction atmosphere and finished by polishing with carborundum paper.

Whilst porcelain is generally used for its translucent, white characteristics, **Jenny Beavan** (UK) prefers to combine it with other clays and materials, resulting in richly textured pieces. Her work is reminiscent of the Cornish landscape and coastline where she lives. Describing her work, she says:

In all my making processes, I aim to achieve a balance between freedom of expression and consideration of order. For example, when building a random form, this form then presents suggestions about its chaotic structure. Transformation, by imposing action, necessitates spontaneous decision making, trust and willingness within a kind of relationship, in order to explore and create a new inner form whilst retaining elements of a former existence.

Jenny Beavan's piece 'Earth Vessel' was made as a result of a four-month study period in Japan. A cylinder of porcelain was wrapped around a sheet of local Shigaraki clay mix and rolled together. Using a cutting wire, a section was removed, leaving a 'U' shaped form. This was left to find its own form, determined by the water content of the clay. The piece was fired to 1270°C in an electric kiln.

Ceramicist **Carol McNicoll** (UK) has also used Shigaraki clay whilst working as Guest Artist for the Japanese Foundation Millennium project in Japan. Her 'Deer Pond' fruit bowl was constructed from slip cast elements using the local porcelain casting slip, to which she added a small proportion of paper pulp. It was reduction-fired to 1270°C with a clear glaze using locally bought underglaze transfers.

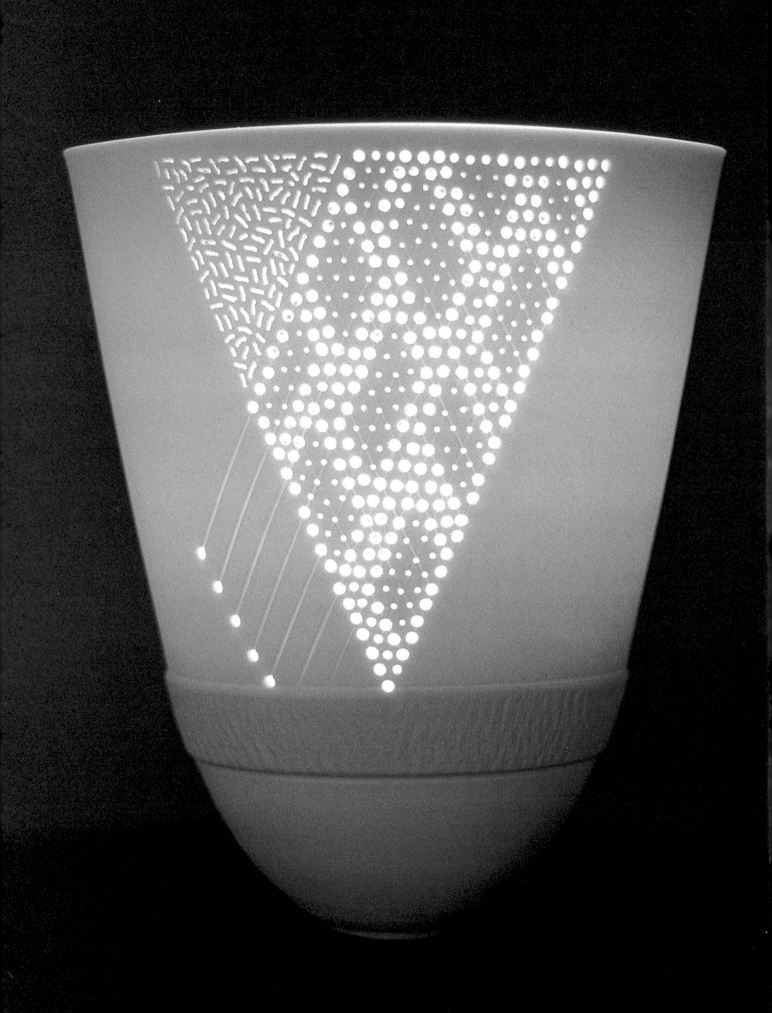

Making Methods
~
Throwing

Porcelain

Porcelain can be considered a difficult clay to throw with, especially for beginners. However, once mastered its possibilities are endless. The secret lies in deciding on the most appropriate clay for the desired form, as well as understanding the structure of the form. What appears possible in stoneware or earthenware will be entirely different when made in porcelain. Quite apart from the plastic nature of this fine clay, shrinkage and distortion are both factors that need to be recognized and understood for successful results.

It is advisable first to do some testing to establish the nature of the clay. The 'knot test' is a method whereby the plasticity of a porcelain can be determined. Roll out a thin coil of clay and tie it in a knot. Observe what happens – some porcelains will form smooth knots, whilst others will crack. Those that crack are too short to be easily used for handbuilding.

As far as shrinkage is concerned, commercially produced bodies will have a shrinkage guide that varies depending on the type, firing and so on, but a rough estimate from plastic to fired porcelain is between 12–15% at a temperature of 1250°C.

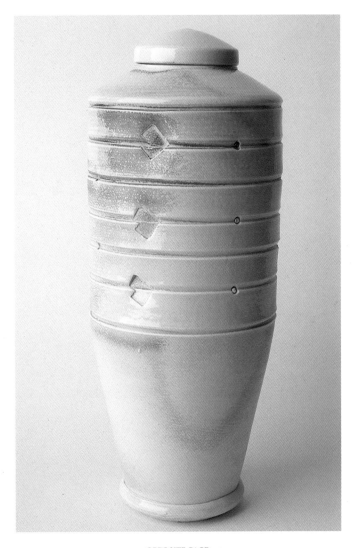

Preparation

Cleanliness in the studio is paramount. Particles of rust from equipment or tools, as well as contamination from other clays, will undoubtedly affect the porcelain. Good preparation of the clay is essential. If you are working in

OPPOSITE PAGE:
Oval thrown and pierced form by Horst Göbbels. (18cm h.)
TM 10 Limoges porcelain. Reduction-fired between 1280–1320°C.

THIS PAGE:
Tall ribbed jar by Jack Doherty. (50cm h.) Potclays Harry Fraser porcelain
(1149). Once-fired and soda glazed to 1300°C. (Photo: Sue Packer)

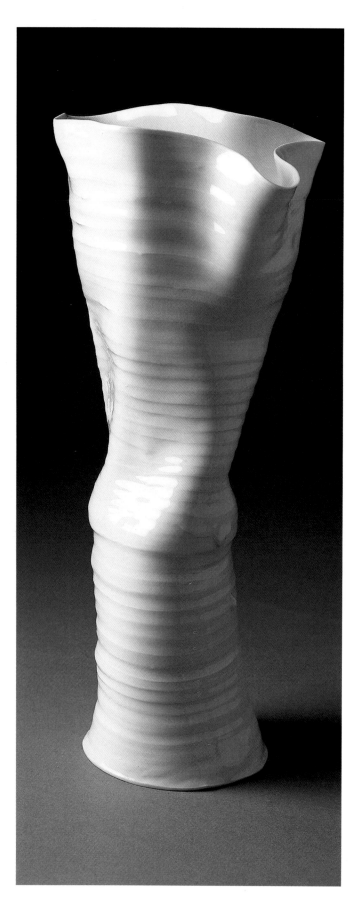

LEFT: 'Unfolding Vase' by Takeshi Yasuda. (45cm h.)
Limoges porcelain. Fired to 1300°C. 2002.

RIGHT: 'Green Pod Vase' by Sophie Cook. (30cm h.)
Valentine's Royale porcelain. Fired to 1245°C. (Photo: Ian Cook)

large quantities, a de-airing pug mill is a valuable piece of equipment and thorough kneading is necessary to achieve the right consistency. **Jack Doherty** (UK) (*see* Chapter 6) recommends spiral kneading on a wooden surface and suggests avoiding rapid-drying on plaster bats as this will alter the plasticity of the porcelain, making it short and crumbly.

Centring and Throwing

Although throwing with porcelain follows the same general principles as other clays, there are a few particular rules that can be applied to minimize warping and cracking. Most makers will use either plaster or marine plywood throwing bats because any direct cutting from the wheel head will certainly encourage distortion.

As porcelain has a tendency to absorb water rapidly, it is therefore more prone to collapse. To combat this, many makers throw with a firmer clay, using a thin porcelain slurry instead of water. This has the effect of clinging to the pot for longer and so allowing more throwing time.

Centring and opening up of the form is normally done at a slower speed than other clays; however, the rest of the process depends upon the individual approach.

For example, there are makers such as **Takeshi Yasuda** (Japan/UK) who throw spontaneously and freely with little, if any, turning, and those who prefer a more considered, almost mechanical approach. **Sophie Cook** (UK) is one who throws the piece fairly thickly then refines and thins the walls by turning. This has the added advantage of minimizing warping.

Tools

Various tools are used to remove the excess slurry and to stretch the clay. These include flexible scrapers, fine hardwood throwing ribs, sponges (both synthetic and natural) and sponges attached to a stick (dottle sponge). As sharpness and precision are required with this dense, fine-grained clay, it is important that the hardwood ribs possess sharper edges and steeper angles than is normally the case.

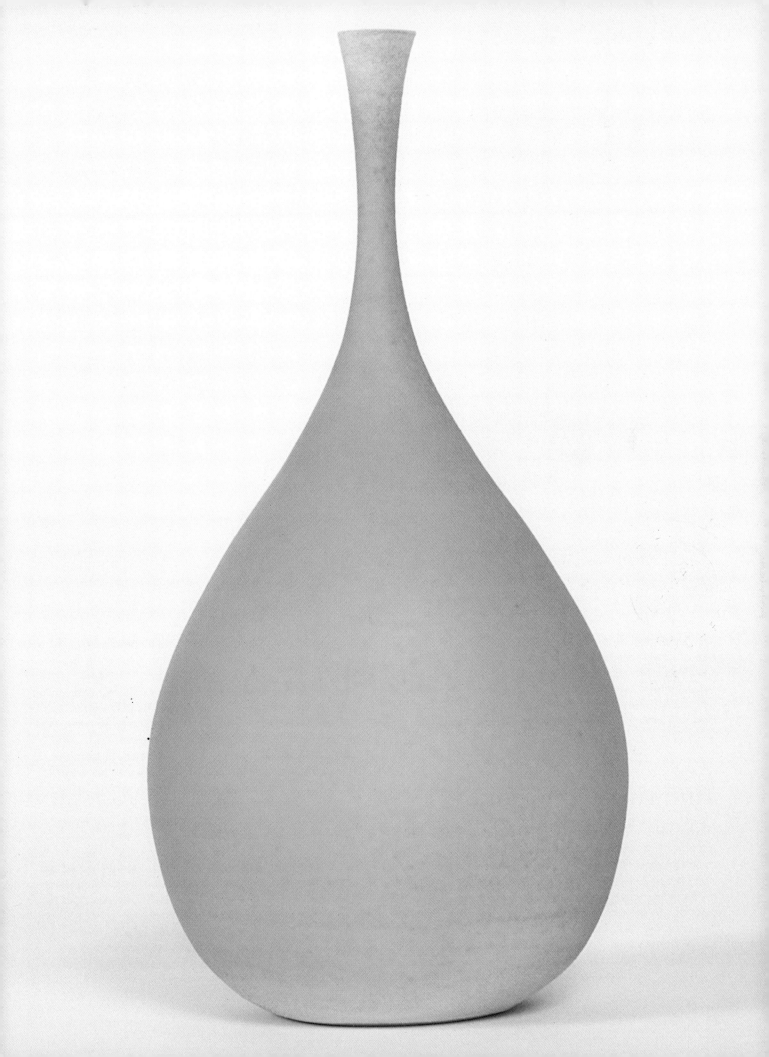

'Linea' by Niamh Hynes.
(Jug 20cm h.; bowl 18cm h.)
Valentine's porcelain, thrown and
glazed. Fired to 1305°C. 2002.
(Photo: Trevor Hart)

Once thrown, it is important to release the piece from its bat, otherwise base cracks can appear. This is due to uneven thicknesses between the wall and the base, therefore the work must not be allowed to dry on the bat. Cutting wires, in turn, need to be sharp. Some makers use single thread wire as opposed to those with several strands twisted together.

Throwing and Altering

Having mastered the idiosyncrasies of throwing porcelain, alterations can then be introduced either at the wet, damp or leather-hard stage. For example, **Joanna Howells** (UK) alters her pieces immediately after throwing. Depending on the form, she will sometimes leave the piece to stiffen for an hour or two to prevent collapse and is careful not to let the porcelain dry too much as cracks on the rims are irreparable. Turning is kept to a minimum and usually means just trimming the base.

Another maker who also throws and manipulates the form is **Bruce Cochrane** (Canada). Describing his work he says:

After twenty-five years of working in clay, utility continues to serve as the foundation for my ideas. The pots I make, no matter how simple or complex, are meant to be experienced on a physical and visual level. The way an object carries, lifts, cradles, pours and contains are properties which I strive to make engaging for the user, offering more than just convenience. I explore and develop ideas through working in multiples. Concentrating my efforts on a specific series of forms allows me to define and clarify my thoughts, as well as solve problems in a sequential order.

The work of **Mary Roehm** (USA) demonstrates the height that can be achieved when throwing and assembling porcelain. Working with porcelain since 1977, she describes her commitment to the material as follows:

With such a rich history and so full of social context, porcelain continues to engage me as a material and the vessel format

ABOVE: *Thrown teaset with forged iron handle by Joanna Howells. Southern Ice porcelain. Reduction-fired to 1280°C. 2002. (Photo: Sue Packer)*

RIGHT: *Ewer and stand by Bruce Cochrane. (12cm h.) Reduction-fired porcelain to cone 10. 1300°C. (Photo: Peter Hogan)*

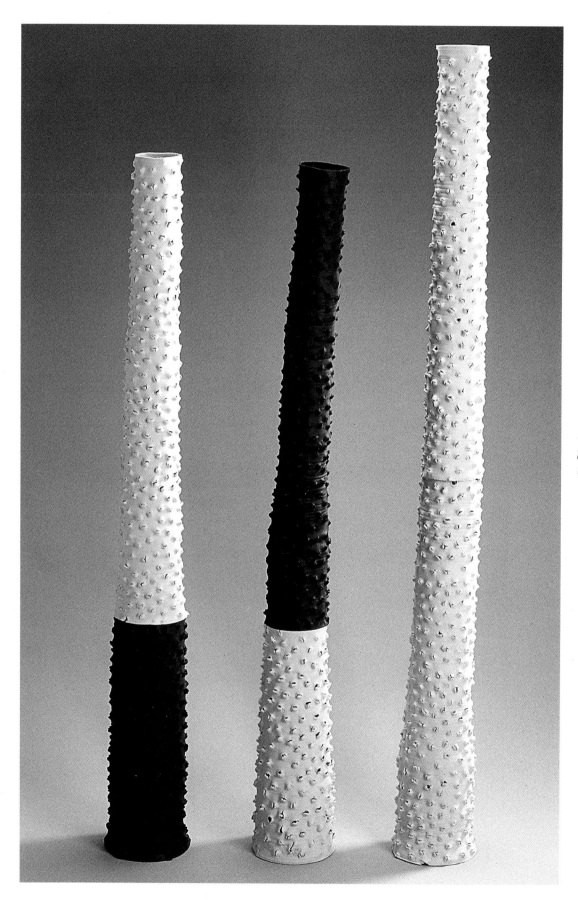

'Punctuated Cylinders'
by Mary Roehm.
(120–150cm h.) 2001.

has served me well as my springboard for personal expression. There are so many 'histories' that porcelain played a significant role in, this long-term investigation has provided and inspired much of the content in the work.

Besides the material itself, the history of porcelain, with the cultural and social roles it has played, are all factors which have influenced her work. The ritual and pomp that surrounded porcelain, plus the position and authority that was implied by owning a piece, have all contributed to her continuing fascination. 'From a formal perspective,' she writes, 'I am interested in articulating a "drawn line" three-dimensionally. I throw very quickly and very thinly and push the piece to collapse.'

After a pivotal experience as Guest Artist at the Shigaraki Ceramic Cultural Park in Japan, she produced a series of Punctuated Cylinders. These are the result of five years' experimentation with a black porcelain body which she developed to be vitreous, mature and to 'fit' well when married to the base porcelain body. The work is made from thrown parts that have been assembled and altered. The work is unglazed and fired to cone 9 (1280°C) in a lightly reduced gas kiln.

Turning

In many cases, porcelain is thrown thickly so that the process of turning enables the maker to refine and define the piece, as well as to achieve a smooth surface for decoration. The all-important translucent quality of porcelain can be achieved at this point if careful, considered turning is

carried out. However, this will involve removing the piece from the wheel several times to verify the thinness of the wall. It will also require careful repositioning to ensure recentring.

The porcelain needs to be at the right stage of firmness or leather-hard. If it is too soft, the tool will gather too much slurry, as well as there being the possibility of the piece distorting; too hard, and the porcelain will shave off in flakes, encouraging a dragging of the tool and the chance of hairline cracks on the rim. All turning tools need to be very sharp and resharpened regularly.

In order to visualize the finished form, many makers start to turn their pieces the right way up, whilst still attached to the bats. However, to finish bases and foot rings, the piece will naturally need to be turned upside down. Placing the piece directly on the wheel head should be avoided as the rim will be vulnerable. Therefore a practice used by several makers is to place the work on a hump of clay with the rim free from the wheel head. To avoid the inside of a damp piece sticking to the hump, cover it with a clean piece of cotton material. This method is also a solution for irregular-rimmed pieces.

Jack Doherty uses a method of improvised 'chucks' made from plastic containers filled with clay, with a pad of sponge or coil of soft clay on the top to protect the interior of the piece. The work can then be 'tap centred', secured with clay and easily removed to check on thickness.

Oval forms can also be made at this stage. Some makers will start the process while the piece is quite soft then refine it at the leather-hard stage. **Horst Göbbels** (Germany) turns his vessels to a remarkable 1mm thickness and occasionally thinner in some sections! When it is leather-hard he places it in a plaster chuck, then, by making the piece malleable using a sponge and water, he manipulates it into an oval (*see* pp. 28–29).

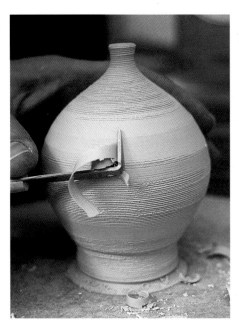 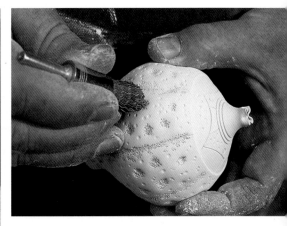

FAR LEFT: *Turning a form using a clay chuck.*

LEFT: *The finished turned form.*

ABOVE: *Applying texture to the leather-hard form. (All courtesy of Geoffrey Swindell)*

HORST GÖBBELS THROWING AND TURNING AN OVAL FORM.

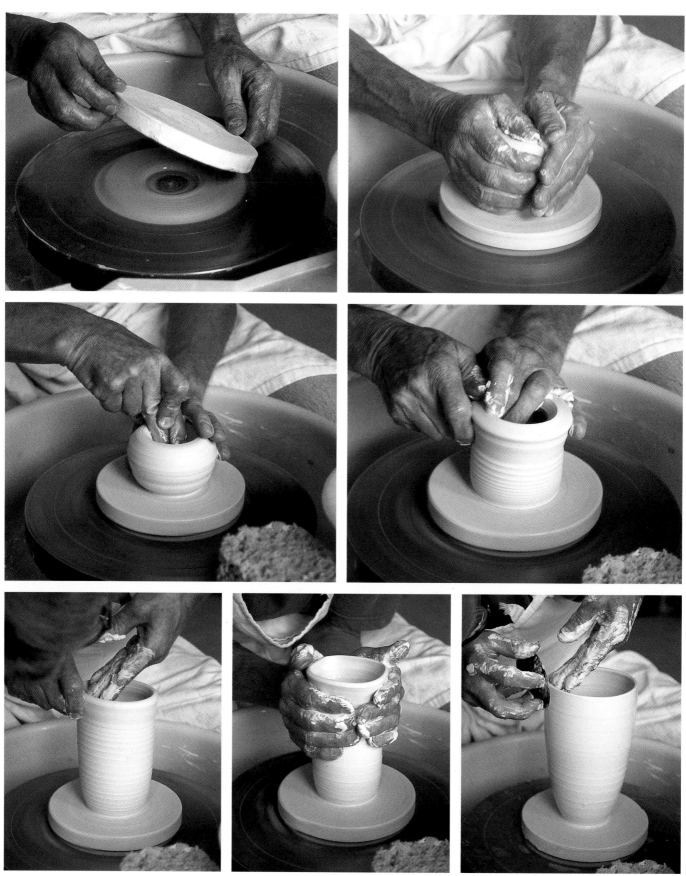

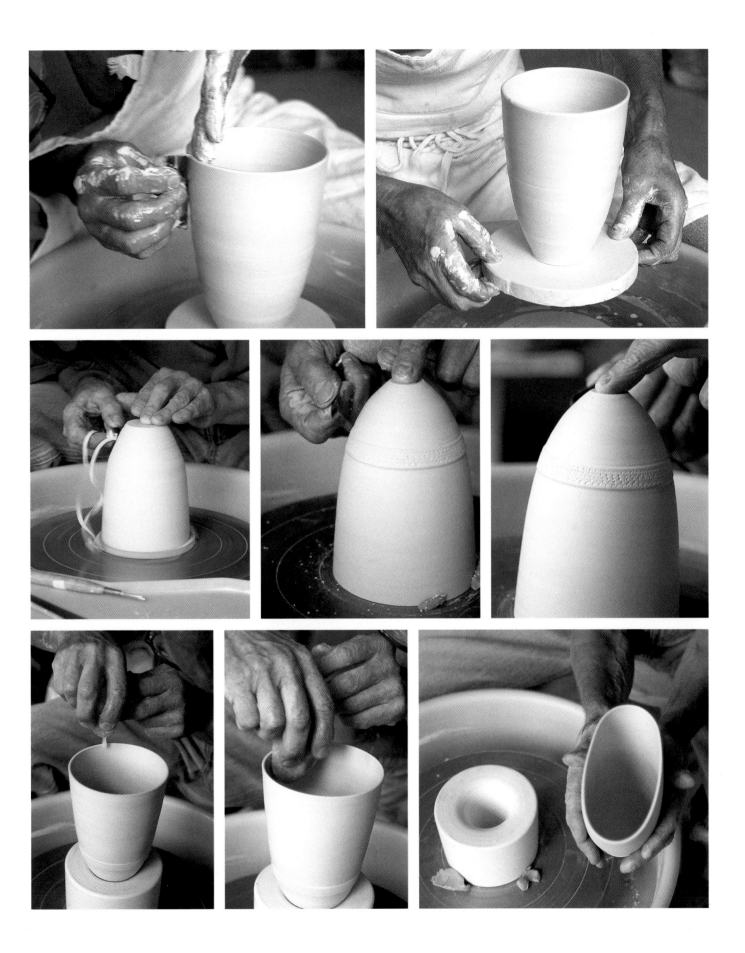

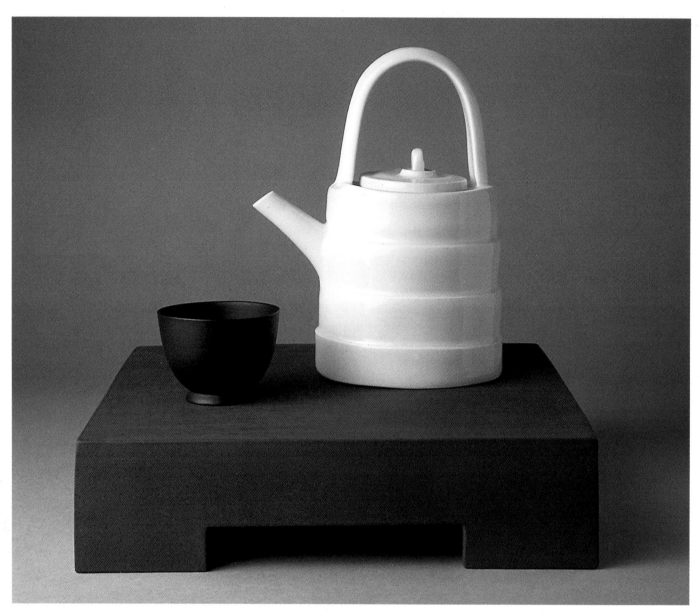

*Oval teapot and cup by **Julian Stair**. (32cm h.) Thrown and constructed porcelain teapot and thrown basalt cup with hand-built red stoneware ground. 2001.*

Impressing, Cutting and Assembling

A variety of processes can be carried out when the clay is at the leather-hard stage. Stamps, textures or impressions can be added at this point, as in the work of **Gilda Westermann** (Germany/UK), who, after turning her pieces, impresses her 'shell' trademark into the clay.

Porcelain can also be cut and reassembled when leatherhard. The work of **Sarah-Jane Selwood** (UK) illustrates this perfectly as she explores the tensions of rhythm, line and space in her vessels. As Tony Franks describes in a *Ceramic Review* article (no. 191, 2001), 'She has made use of the ray tracing program "POV-ray", which supports the creative exploration and rendering of inverted and intersected vessel forms from given parameters.' With this process she has been able to experiment and work more economically, by simulating her ideas through a computer before embarking on the clay. However, there is a simpler method that can be employed. This involves using a fixed light source and a fine thread. By this method, a shadow line can be cast across the surface of the piece at a pre-determined angle and, with the use of a swivel-stick and sharp blade attached, an accurate curve can be cut. The piece can then be assembled as usual.

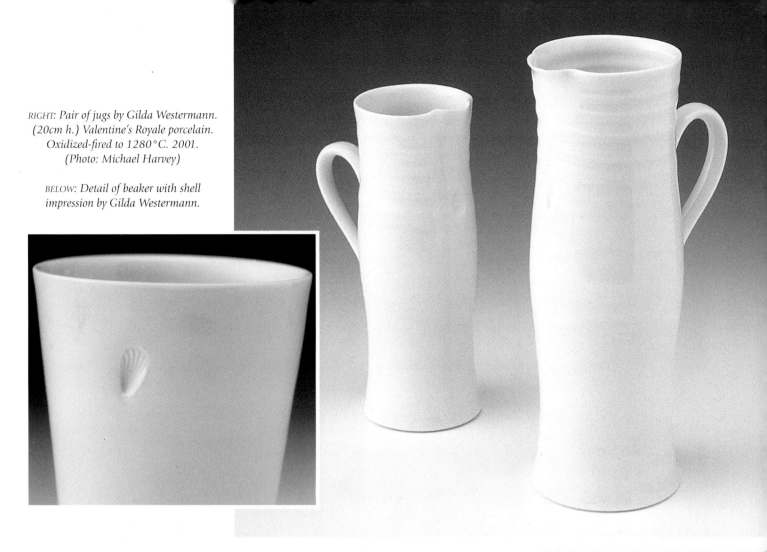

RIGHT: *Pair of jugs by Gilda Westermann.*
(20cm h.) Valentine's Royale porcelain.
Oxidized-fired to 1280°C. 2001.
(Photo: Michael Harvey)

BELOW: *Detail of beaker with shell*
impression by Gilda Westermann.

BELOW: *'Double Transposition' by Sarah-Jane Selwood. (14cm h. by 11cm w.)*
Thrown, cut and altered or intersected. Limoges porcelain. Reduction-fired to 1280°C. 2001.
(Photo: Shannon Tofts)

RIGHT: *'Composable' by Marco Mumenthaler (Switzerland). Thrown and assembled porcelain.*

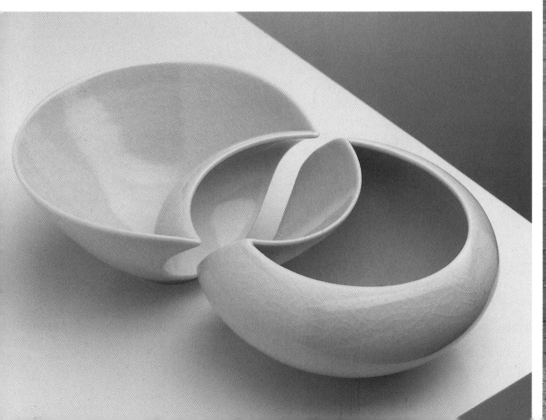

THROWN AND ASSEMBLED FORM BY KARIN BABLOK.

Piece is thrown without base.

Piece is turned and cut when leather-hard.

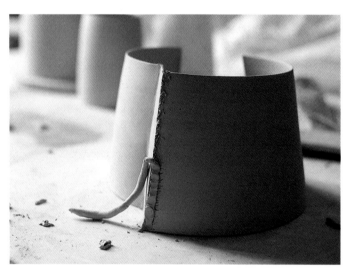

Sections are joined with coils of clay.

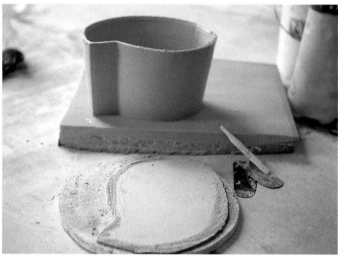

Base is prepared from slab.

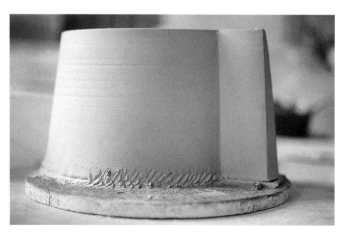

Base is joined to piece.

Karin Bablok (Germany) throws her wider porcelain vessels without bases and alters them when they are leather-hard. She turns them to 'sharpen' the form and to remove throwing lines so that subsequent inlay decoration is easier. The throwing lines reappear after firing, adding rhythm to the piece at that stage. A slab of porcelain, of the same consistency as the piece, is assembled to form the base. When almost dry, the pieces are sanded to define the joints and biscuit-fired to 980°C.

In some cases after throwing, Bablok deforms the vessel by 'paddling', a method whereby a flat piece of wood is used on the soft clay to achieve sharp edges and facets. After the biscuit firing, sanding will remove the paddling marks in preparation for the decoration, which is applied using a basalt glaze. The pieces are then fired in a gas kiln to 1280°C, reducing from 1060–1080°C.

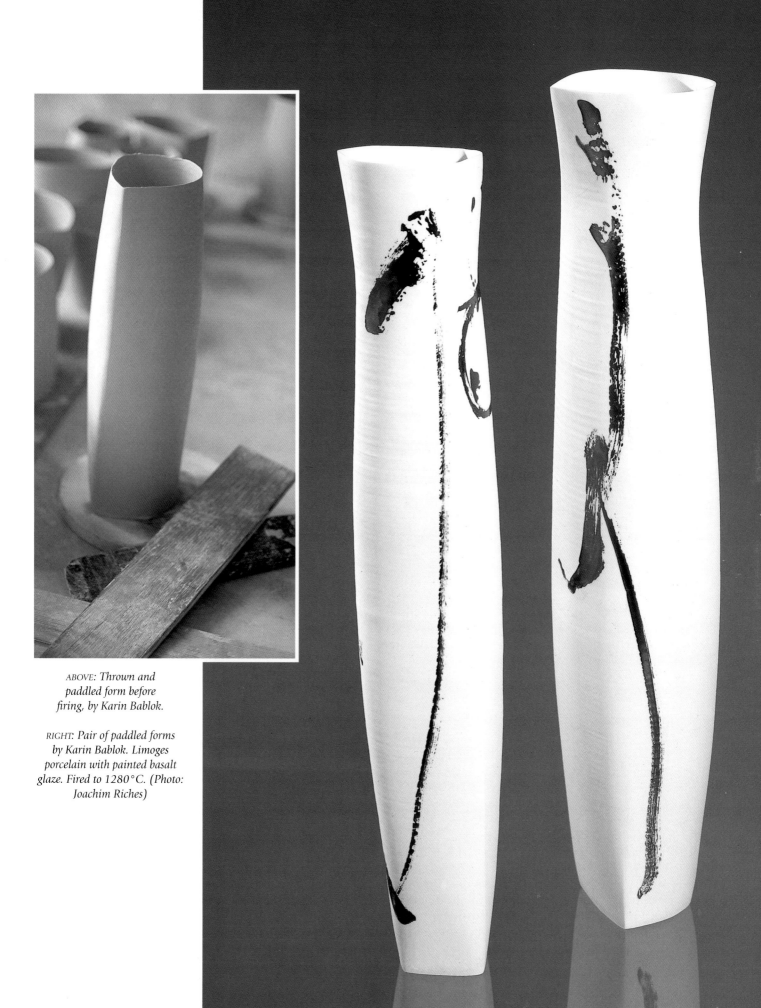

ABOVE: *Thrown and
paddled form before
firing, by Karin Bablok.*

RIGHT: *Pair of paddled forms
by Karin Bablok. Limoges
porcelain with painted basalt
glaze. Fired to 1280°C. (Photo:
Joachim Riches)*

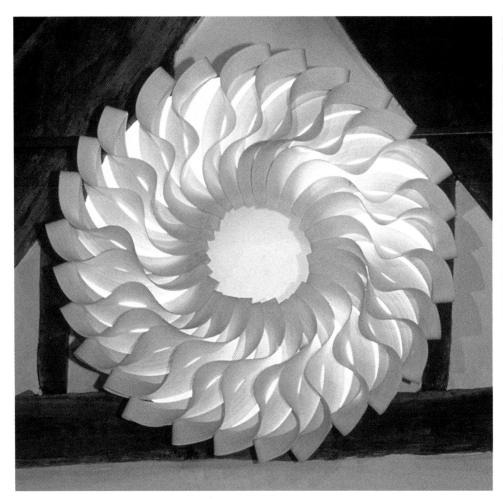

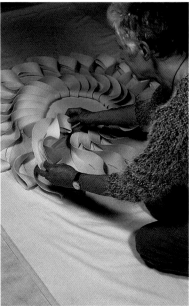

ABOVE: *Margaret O'Rorke assembling the fired pieces.*

LEFT: *'Big Wheel' by Margaret O'Rorke. (100cm diam.) Valentine's Audrey Blackman porcelain. Fired separately to 1300°C. 2001.*

Margaret O'Rorke (UK) (*see* Chapter 7) is someone who works by throwing but assembling her pieces after firing, as in her 'Big Wheel' light installation which consists of twenty-eight individually thrown reformed rings.

Drying

Slow and even drying is normally associated with porcelain. This is done to avoid distortion and cracks on assembled pieces such as handles and joins, therefore protection from excessive draughts and heat is advisable. However, there are those makers who have successfully exploited the drying process to their advantage. Daniel Fisher (UK), **Takeshi Yasuda** (Japan/UK) and **Sabine Kratzer** (Germany) are all makers who have adopted the 'upside-down' drying method.

Kratzer throws and turns her vessels as thinly as possible in the first instance, after which she holds them upside-down, with the rims dipping in water. Experience tells her the moment to reverse the piece to the upright position, at which point she pinches out the rims. They are then turned upside-down again to harden up slightly, until the porcelain has reached a workable condition to pinch out the rim tips some more. The pieces are then left to dry out completely; the dry slip on the rim is removed by carefully scratching it away with a knife.

In an article written by Judith Lesley in *Pottery in Australia* (October 2000), **Victor Greenaway** (Australia) describes his method whilst succinctly summing up the 'knife edge' which many makers experience when throwing with porcelain:

Once the pure form is thrown and while the wheel is still turning, I apply a special wooden tool or a single finger in a momentary gesture which, when successful, transforms the piece into a lively and mercurial expression of the moment. The creation can easily be lost, however, if excessive pressure is used during the gentle thrusting process of the tool, resulting in either no piece at all with the rim torn apart, or the piece slumped on the wheel. If too little pressure is used, it can result in a weak, unattractive 'runt'. The ultimate piece is when the result is just on the 'edge' of success or failure, retaining the vitality, energy and excitement of chance.

Gwyn Hanssen Pigott (Australia) has dedicated her working life as a maker to domestic ware, describing her fascination for the 'everyday pot' as such:

Pots, useful, everyday, ordinary pots, have for most of my life been my daily pleasure mines. Crowding the kitchen shelves, focusing the mind during a coffee conversation, letting the eye rest on the considered form, on tenuous line, on languidness, on simplicity, on offered optimism: inviting the hand to cup, the finger to outline a rim, the lip to brush. They have become, these known and loved objects, my companions; and each meal and coffee break I make a choice, inviting the pot like a friend, and seeing, perhaps, something about it I had forgotten or overlooked in the rush of things.

The still-life components are thrown, using Limoges porcelain, then turned, bisque-fired and glazed – the inside in one colour (then fettled) and the outside in another. The glazing is done by dipping and, where necessary, wax resist is used to keep the colours cleanly separate. The work is gas-fired in a strongly reduced atmosphere to 1300°C.

RIGHT: 'Dancing Soul', upside-down in Sabine Kratzer's studio.

BELOW: 'Group of Dancing Souls' by Sabine Kratzer. (15cm, 10cm and 7.5cm h.) Unpolished and unglazed porcelain. Fired to 1260°C. 2002. (Photo: Jürgen Nogai)

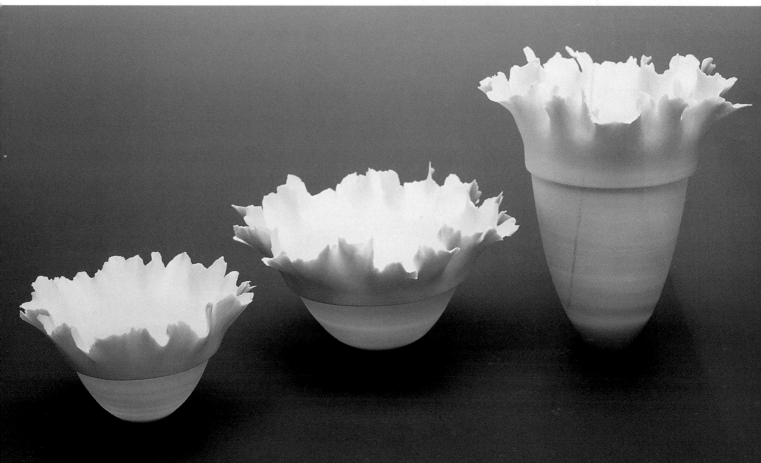

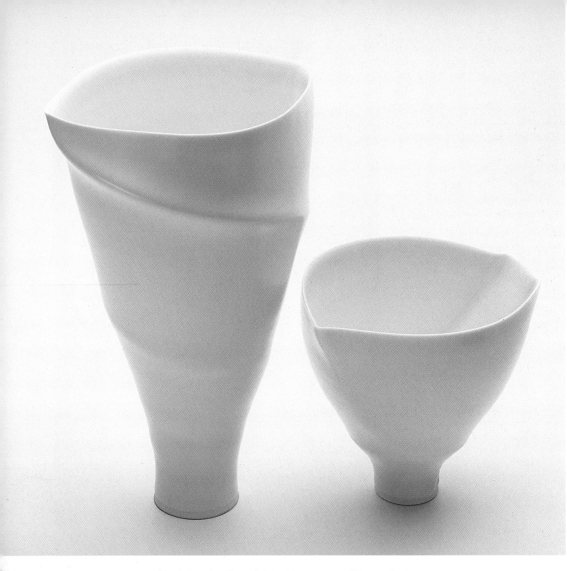

*Pair of porcelain
spiral-lipped forms by
Victor Greenaway.
(32cm and 16cm h.)
Limoges porcelain.
Fired to 1260°C.
(Photo: Terence Bogue)*

*BELOW: 'Frieze' by
Guyn Hanssen Pigott.
(27cm h. × 52cm l.)
Thrown Limoges porcelain.
Fired to 1300°C. 2001.
(Photo: Brian Hand)*

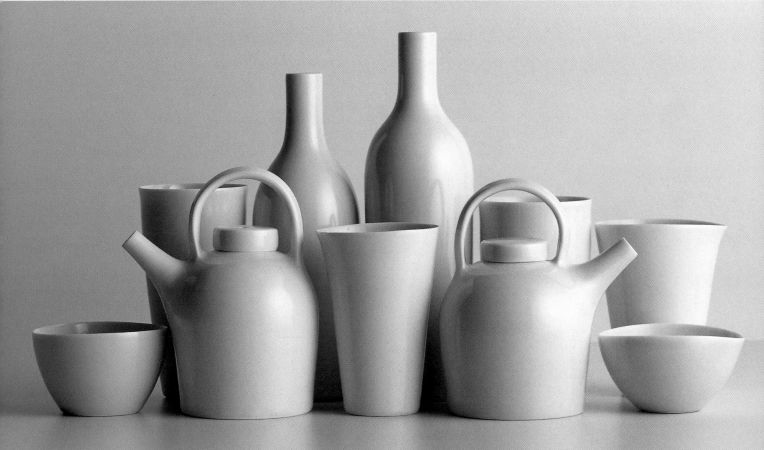

Bone China

Bone china is not normally associated with throwing as it contains very little clay content and is generally considered an 'industrial' material, that is, one used either within the ceramic industry or in conjunction with industrial processes. There is, however, an exception to this rule. For several years, Anne Hogg (UK) has used a bone china throwing body that was developed by her husband Christopher Hogg.

As quoted in Peter Lane's book, *Contemporary Porcelain*:

Anne Hogg has found no real disadvantage throwing with this bone china body. Experience has taught her how best to come to terms with its individual character and so to anticipate the results. She has found that thrown shapes which are tall and narrow survive better than those which are more open. Shorter, wider pots having a V-shaped section are less likely to slump or warp in the kiln than those having a U-shaped profile. Throwing, turning, trimming, carving and reshaping in the pre-bisque state can be carried out in much the same way as with a standard porcelain. She kneads the plastic china body in a spiral motion before making it into a very round ball and placing [rather than throwing] it on a bat on the wheel. Centring is done very quickly with hands and the clay well-lubricated with water because the clay must not be allowed to drag or spirals will appear in the fired pot. Sudden movements are to be avoided. Drying must be slow and gradual.

The work of **Fleur Schell** (Australia) illustrates the possibilities of working with a combination of techniques using either bone china or Limoges porcelain. She describes her work as:

a combination of cast and thrown Australian Fine China and recycled mixed media. Conceptually, I aim to produce artwork that goes beyond aesthetic considerations and stimulates audience interaction through sound and touch. The integration of sound into my work was initially inspired by my rich musical upbringing.

Each piece represents a multitude of defunct or obsolete recycled treasures combined with slip cast, wheel thrown and hand-built components. Often a piece begins as an abandoned mechanical object. It is transformed from the metal into porcelain or china using paper plaster moulds, resulting in a slip cast form. The cast forms are kept damp then embellished with wheel thrown or hand-built sections. Metal, wood, plastic and glass are added to the ceramic forms after the final high firing using epoxy resin and metal thread reinforcing.

Through these eclectic combinations, I aim to generate a curiosity that entices audiences to caress, fiddle, strike and blow into the objects, having the effect of triggering sound.

She describes her creation of a Theremin:

The Theremin is an electromagnetic sound instrument that is played without direct physical contact. It is based on the original Theremin, invented in 1919 by the Russian engineer Leon Theremin. His invention was the first electronic musical instrument and the only musical instrument to be played without touching. The Theremin I have built is designed to broadcast sound by the interference of body mass radio waves. The sound emanates from a speaker situated on the side of the form as one moves one's hands in the space around an aerial which protrudes from the top of the vessels. The aerial is wired to a circuit board inside the ceramic compartment containing two tiny oscillators. The componentry was built following a design down-loaded from the Internet. The pitch and volume are controlled by fluid hand movements around the aerial, hence making it difficult to achieve distinct intervals.

RIGHT: 'Theremin' by Fleur Schell.
Thrown and cast Australian Fine China.
Fired to 1270°C. 1999.

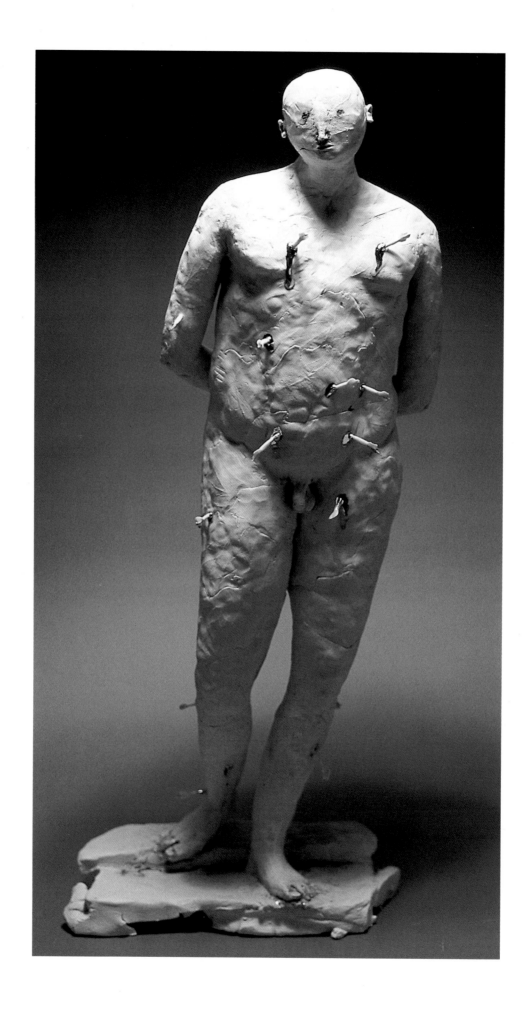

3

Making Methods
~
Hand Building

Surprisingly, both porcelain and, to a lesser extent, bone china can be used in the different hand-building processes of coiling, slab building, modelling, press-moulding and combinations thereof, providing certain factors such as joining and careful drying are respected.

As with most clays, the pieces to be joined should be of equal dampness. If one or other piece is too dry, the high shrinkage rate of porcelain will undoubtedly encourage cracking. Use a hacksaw blade to score both surfaces by cross-hatching and join them with a porcelain slip/slurry made from dry body scraps mixed with water. Some makers prefer to use vinegar, as its acid properties will soften the clay, whilst others use just water. Whichever the choice, apply an even pressure between the two pieces to be joined and dry carefully.

Most drying is done slowly, avoiding drafts and extremes of temperature. For smaller pieces, wrap the porcelain in polythene bags. For larger pieces and quantities, make a 'drying tent', which is simply sheets of polythene stapled to a frame construction. This way, the drying of the ware can be monitored.

Coiling

Although the traditional method of coiling is not often seen in contemporary porcelain, and even less so in bone china, it can be used as an extension to a piece that has been formed by other means. Coiling is not often used due to the difficulties encountered when joining individual coils, coupled with the fact that joins will show after firing. However, **Masamichi Yoshikawa** (Japan) has successfully worked with this method to achieve large coil pieces, using it to his advantage, whilst his wife, **Chikako Yoshikawa**, uses a combination of hand building and slip casting to produce her porcelain figures.

OPPOSITE PAGE:
'St Sebastian' by Claire Curneen. (58cm h.)
Hand built using Potclays Harry Fraser porcelain.
Fired to 1200°C.

THIS PAGE:
'Shizukuishi' by Masamichi Yoshikawa.
(90 × 95cm) Coil-built porcelain.
Fired between 1290–1300°C. 1999. (Photo: Tomoki Fujii)

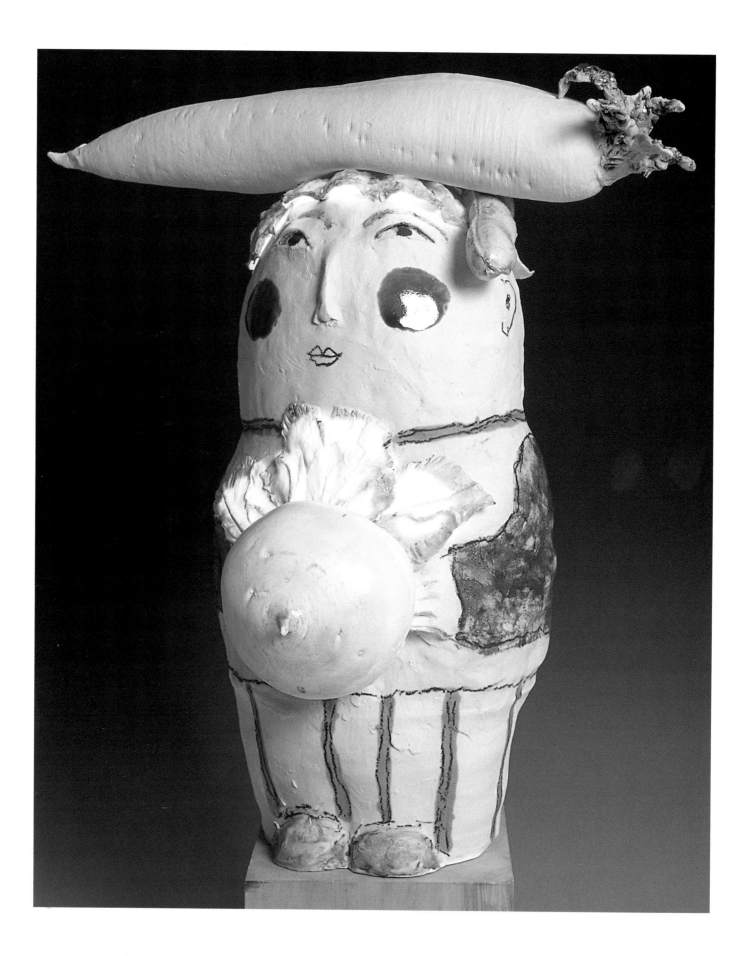

Márta Nagy (Hungary) (*see* Chapter 7) uses coiling to realize her 'Islands 2001' collection. These are large, flat, coiled sculptures combining porcelain and silk with deliberate finger impressions left on the clay.

OPPOSITE PAGE:
'Minori' by Chikako Yoshikawa. (35cm h.)
Hand built and cast porcelain. Fired to 1300°C. 2002.
(Photo: Tomoki Fujii)

THIS PAGE:
'Islands' by Márta Nagy. (Each approx. 77 × 12cm)
Porcelain and silk. 2001. (Photo: István Füzi)

Slab Building

This is a versatile method favoured by many makers, using both porcelain and bone china alike.

Preparation of the clay follows the same methods as for throwing, although some makers add between 5–10% molochite to porcelain when kneading. This is a pre-fired china clay that acts as a refractory grog, rendering the clay more stable and reducing shrinkage. Its disadvantage, however, is that it can affect the plasticity of the body, making it short and crumbly as well as altering the surface quality of the clay.

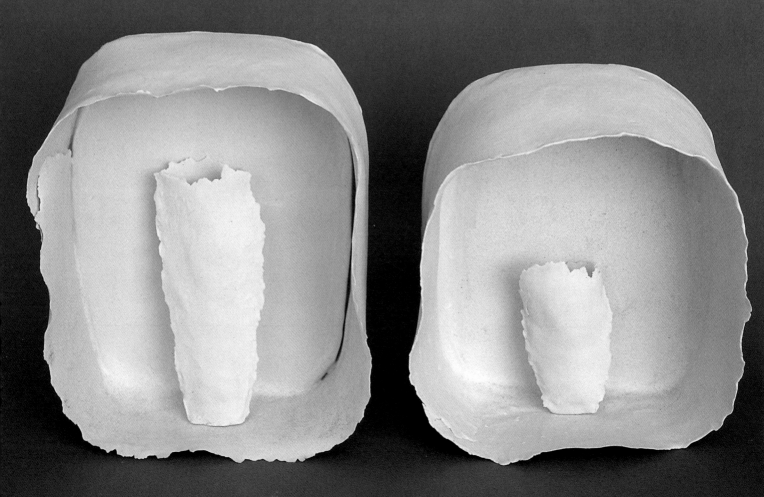

Maria Bofill (Spain) is one such maker. She mixes molochite into her porcelain to achieve a greater workability and to exploit the grainy surface of the clay for her 'Labyrinth' series. She also appreciates the small deformations that appear after the firing.

Paper pulp can be added to porcelain and bone china to make it more workable as a hand-building material (*see* Chapter 1). The recent work of **Angela Mellor** (UK/Australia) involves tearing sheets of textured bone china and paperclay. She places the sheets over a hump mould, joining them with water. When the form has stiffened a little, it is removed from the hump mould and placed in a press mould, then the inside joins are brushed with paper slip.

If distortion is to be avoided, careful rolling and drying are very important. For small slabs, the simplest method is hand-rolling. Use a rolling pin, a piece of clean, dry material and two guide sticks of the same required thickness to support the ends of the rolling pin. Avoid rolling out on non-absorbent surfaces as the clay will stick. Thin out the clay by rolling gradually, turning the cloth frequently – this will minimize stresses and tensions.

For larger slabs, a mechanical slab-roller is advisable. Sandwich the clay between two clean sheets of material and rotate it through 90 degrees after each rolling. This will lessen the risk of stress. The slabs can be assembled at the soft or leather-hard stage, depending on the desired end result. If the slabs are to be used in the leather-hard stage, store them on absorbent boards between newspaper and turn them frequently. Avoid drafts or excessive heat and wrap in polythene to monitor drying.

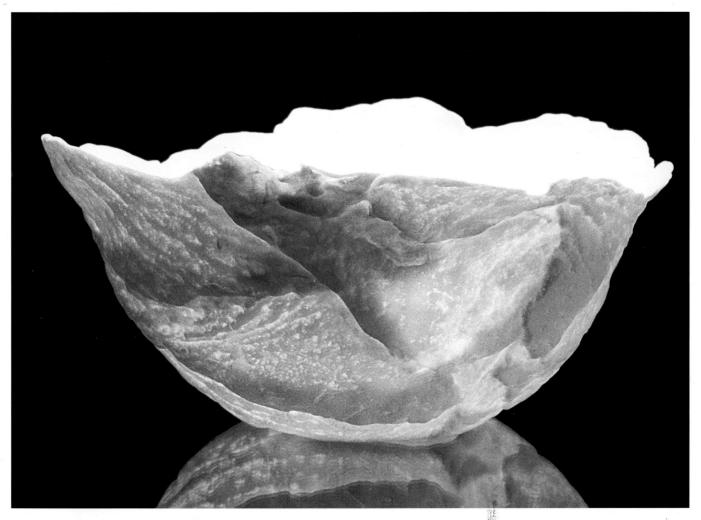

OPPOSITE PAGE:
TOP: *'Labyrinth' by Maria Bofill. (6 × 24 × 24cm) Slab-built porcelain. Fired to 1280°C, with liquid gold decoration fired to 815°C. 2002.*

BOTTOM: *Porcelain boxes by Maria Pallejá I Monné. (16 × 12 × 7cm) Slab-built porcelain. Fired to 1280°C. 2001.*

THIS PAGE:
'Lunar Light' by Angela Mellor. (12cm w. × 6cm h.) Bone china and paperclay. Fired to 1250°C. 2002. (Photo: Victor France)

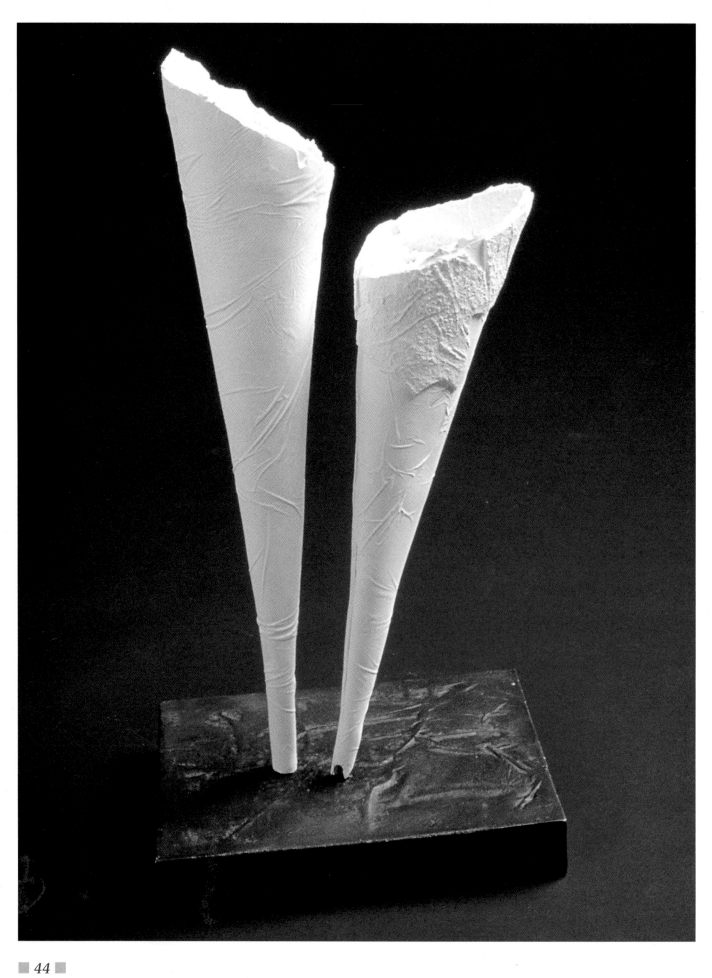

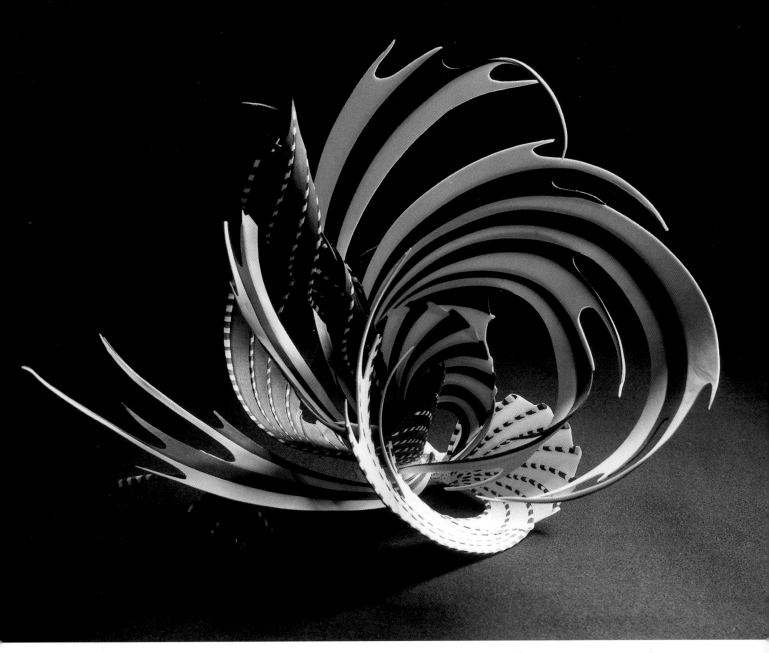

Andrea Hylands (Australia) is a maker who works in mixed media; her earlier work included rolling soft slabs of bone china onto polythene and forming them into cone shapes.

A particularly individual approach for producing extremely thin porcelain slabs is that of **Paula Bastiaansen** (Holland).

First of all, she makes a drawing on very thin tracing paper. This helps her to determine how to construct the pattern. If the piece is to be coloured, it is at this point that she introduces the stains. Extremely thin strips of clay, no wider than 1cm at most, are cut and placed meticulously one by one onto the paper pattern. Meanwhile, it is important that the clay retains its moisture. To ensure this she places cling film above and below the strips.

When the 'drawing' is completed, the piece can be laid into a previously made stoneware mould or former. This is a particularly important and decisive moment, for she will have spent several days preparing the work, and has only five minutes to place and construct it in the mould. After drying for a few days, the piece can be put directly into the kiln and fired to 1260°C. During the firing, the porcelain is allowed to distort and convolute.

Bastiaansen's latest pieces are more complicated than the above method, however, being made separately and assembled after firing.

Henk Wolvers (Holland) is another Dutch maker who pushes porcelain to its limits of thinness and delicacy. Whilst

WORKING PROCESS OF PAULA BASTIAANSEN.

Detail of drawing.

Placing the porcelain strips on to the pattern.

Making a drawing.

Flattening the porcelain strips on to the pattern.

Signing the object.

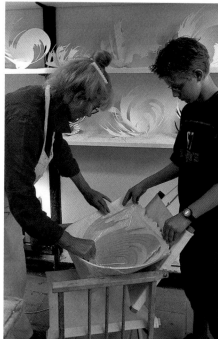

Form is placed into stoneware former.

Form is constructed in stoneware former.

Object is placed in kiln with former.

studying painting alongside ceramics, his pieces successfully combine the two disciplines, resulting in a 'porcelain canvas'.

After wedging and staining some of the clay with oxides or body stains, he rolls the porcelain into very thin, large slabs of only a few millimetres thick. In some cases, he will paint the surface with engobes at this stage. When leather-hard, the slabs are cut into varying sizes. The cut sections are either superimposed or placed adjacent to each other to form abstract or geometric patterns. Rolling the pieces again will unify the slabs and, depending on the design, textures can be introduced by rolling onto textured plaster moulds. The coloured slabs are then cut and assembled into a particular form and joined with porcelain slip. After complete drying, the pieces are fired in a gas reduction kiln to 1300°C.

Modelling

Porcelain can be modelled either solidly, then hollowed, or made hollow from the outset using a variety of hand-building methods. The main difficulty encountered is the risk of collapse with larger pieces. To avoid this, some makers often put a system of armatures in place.

The figurative work of maker **Claire Curneen** (Ireland/UK) can be described as having the figure grounded 'in the exploration of the human condition, focusing on aspects of the religious and the ceremonial. With semi-autobiographical references, the figure serves as a vessel for the physical and spiritual being.' (*See* Jane Waller, *The Human Form in Clay*, pp.147–50.)

Curneen builds her figures hollow, using thin clay slabs of porcelain which are pressed into her palm. The small sections of clay seem to be randomly placed, overlapping each other working from the base upwards and finishing at the finger tips. The holes and cracks which appear are where two sections of clay do not meet exactly. Not only do these indicate that the figure is hollow, but also reinforce Curneen's idea that the figure can be considered a vessel.

To avoid collapse, she incorporates a cross-piece inside the base, which acts as a support for the piece. However, there is no elaborate interior support structure or armature in the figure; rather, she uses exterior 'scaffolding' made from long pieces of wood, which serve to prop up the figures during the making process and prevent them from falling over.

The forms are placed in the kiln whilst still damp and supported again by the kiln wall. This ensures that the weight is

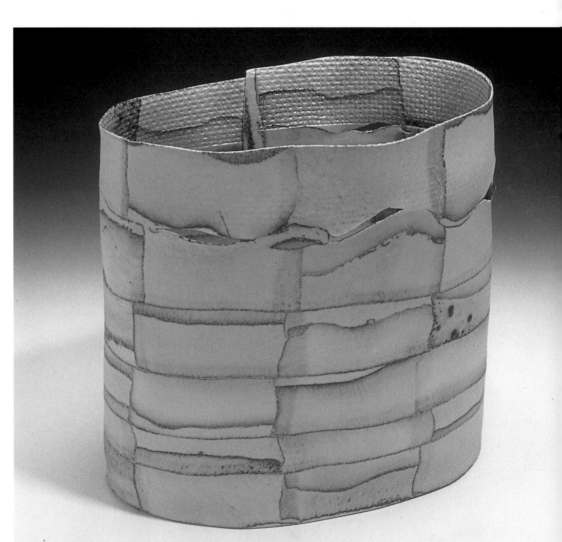

'Untitled' by Henk Wolvers. (22cm h.) Slab-built Limoges porcelain. Reduction-fired to 1300°C. (Photo: Ron Zylstra)

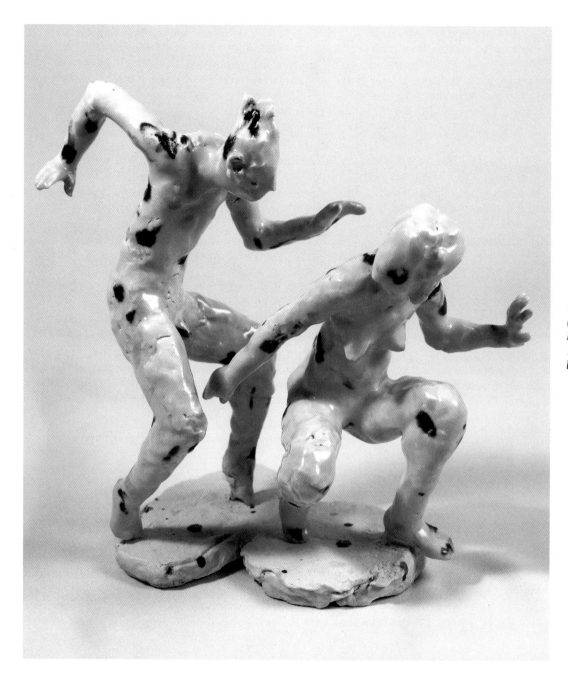

'Surprise' by Michael Flynn. (30cm h.) Hand built using Limoges porcelain. Fired to 1260°C. Decorated with body stains and glaze. 2001.

taken from the ankles, which are the most vulnerable area before firing. They are biscuit-fired to 1000°C, after which washes of stains are applied to the head, hands and feet with a clear glaze placed in small areas. A final firing to 1200°C finishes the figures, again using the kiln wall as a prop.

The figure of the martyr, St Sebastian (*see* Chapter opener), was the result of a residency at the Crawford Arts Centre, St Andrews, Scotland, in 2000. Here she was inspired by the imagery of Catholic Christianity in St Andrew's Cathedral.

Michael Flynn (Ireland/UK) is another figurative maker working in porcelain (*see* p. 148). His energetic work is described by Jane Waller in *The Human Form in Clay* as being

'very Irish in the way it picks up myth and magic, tragedy mitigated by comedy, and all embroidered in a poetry of his own particular style.'

His modelling methods are not dissimilar to Claire Curneen's in that the figures are built hollow and made by assembling pinched-out sections, such as torsos and limbs and so on. However, he often sticks dry pieces together with wet clay, depending on which porcelain he is using.

Despite the fact that **Takumi Sato** (Japan) was initially trained in the traditional art of pottery making in and around Kyoto, most of his work since the1980s has been sculptural. Life-size figurative installations, very large vessel forms and

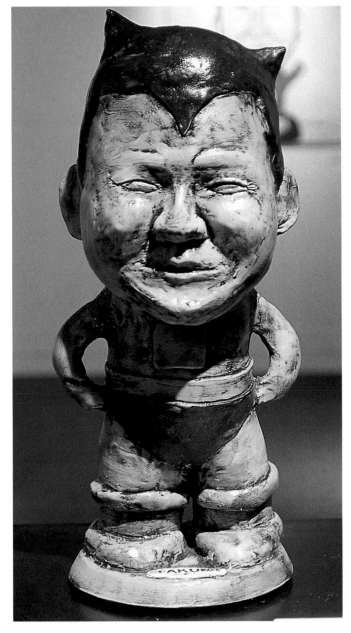

'Astro-takumi' (self-portrait) by Takumi Sato. (60cm h.) 2003.
Hand built and decorated with coloured porcelain slips.
Fired to 1230°C.

architectural commissions make up the majority of his practice, although more recently he has developed a fascination for daily objects such as cameras, radios, blenders and so on.

During a residency in Kutztown, New York, he was attracted to the cultural diversity that can co-exist in a small rural region such as this, for it is the home of urban graffiti artist Keith Haring, as well as being close to traditional Amish communities. This led to Sato's current work – a series of large, expressive self-portraits that explore aspects of his Japanese identity as he travelled through the American countryside.

Press Moulding

Used either on its own or in conjunction with other hand-building techniques, this method can be used to create small or large pieces, ranging from bowls and dishes to sculptural installations.

The basic preparation for press moulding follows the same principles as for slab building porcelain, that is, evenly rolling out the clay on a clean cloth with the appropriate guides. It is advisable to roll the clay 2–3cm larger than the edge of the mould to allow for trimming. To avoid distortion during firing, carefully lift the clay from the cloth and place it in the mould. Apply pressure with your hand, gently easing the clay in place. A rubber kidney (*see* Glossary) can then be used to smooth the surface and finally press the clay into the mould. Trim the excess off with a thin, sharp blade held parallel to the top of the mould. Allow the clay to harden up sufficiently to retain its shape before removing.

Taking the ground rules for press moulding as a starting point, makers such as **Arnold Annen** (Switzerland) and **Susan Nemeth** (UK) have developed their own diverse techniques of interpreting this method.

Arnold Annen pushes the boundaries of porcelain from one extreme to another, ranging from his wafer thin, blow-torched bowls (*see* Chapter 5) to his impressive, thick-walled installation pieces which he developed during an artist-in-residence programme in Seto, Japan, in 2001. These originated from a large two-piece press mould, with several subsidiary moulds.

After throwing a composite clay original on the wheel, a press mould is made. With a large piece, it is easier to build up layers of plaster onto the original until the desired thickness is reached (in this case approx. 3–4cm, so that the mould's weight is kept to a minimum). It is cut in two using a hacksaw blade whilst the wheel is revolving. The mould is then separated from the clay original and allowed to dry for a while. Annen uses a porcelain slip as a hand-building material by mixing in cork granules using a ratio of 1:1. Whilst pressing the clay mixture into the mould, pieces of charcoal are added at random intervals. These burn out during the firing resulting in holes. The piece is left in the press mould to harden up.

In the meantime, small clay cones are thrown, from which small press moulds are made. Once dry, the porcelain/cork body is pressed into these moulds and a final smoothing of them is done on the wheel. When the cones and the large piece are of equal leather-hard consistency, they are assembled using a porcelain slip. The piece is twice-fired – the first is a reduction firing to 1260°C, after which a slip is applied to the surface to simulate crocodile skin and the piece is refired to harden the slip on.

Nemeth's work is either press-moulded, for bowls and dishes, or slab-built, for vases, using an intricate method of inlaying coloured porcelain (*see* p. 78). She welcomes the

MAKING PROCESS FOR THE 'ARCHAEODICTYOMITRA' BY ARNOLD ANNEN.

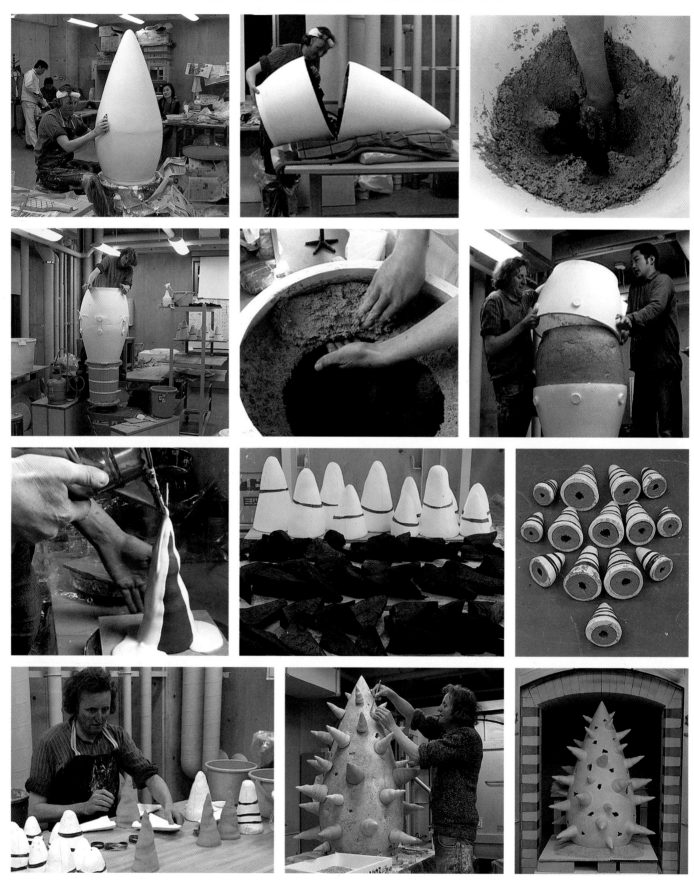

slight distortions between the surface decoration and the shape created during the rolling and press-moulding process. If a foot ring is to be included, it will be press-moulded initially, applied to the base, then turned to redefine it. After a soft firing to 1000°C, the pieces are 'wet' sanded, then refired to 1280°C in an electric kiln with the pieces buried in crank-coiled saggars filled with fine silica sand to prevent warping.

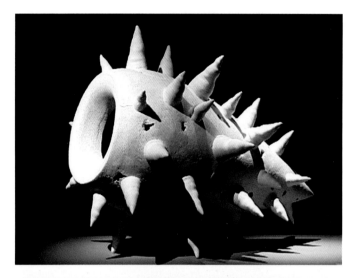

RIGHT: 'Archaeodictyomitra' by Arnold Annen. (2.2m l. × 75cm) Press-moulded using porcelain slip and cork. Fired to 1260°C. 1998–2001.

BELOW: Four slab-built porcelain vases by Susan Nemeth. (27–38cm h.) (Photo: Stephen Brayne)

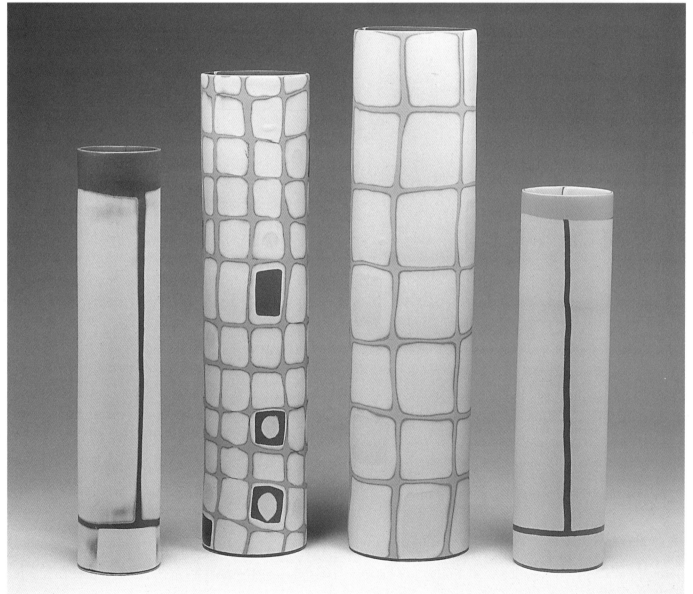

Press-moulded porcelain bowl by Susan Nemeth. (21cm diam.)
Using Potclays 1146 porcelain, coloured clays, slips and inlays. Fired to 1280°C. (Photo: Stephen Brayne)

The porcelain platters and vases made by **Lisa Rau** (UK) demonstrate another approach to working with a porcelain slip as though it were a hand-building material.

During a research fellowship at Bath Spa University College in 2000, she describes her work thus: 'Much of my time has been taken up investigating porcelain slip, the texture, density and fluidity of the slip being characteristics which profoundly affect my finished pieces. Obtaining and recreating a slip of specific character remains the starting point and key aspect of my work.'

Although not press-moulded, the porcelain is used in conjunction with plaster as a means of obtaining the right consistency, enabling it to be easily manipulated. The working process is as follows. The porcelain is dried out in small pieces, then crushed and emptied into a large container. Depending on the quantity to be made, water is added then left to slake for a few days. Once the porcelain has broken down, the surface water is siphoned off, leaving a porcelain silt below. This is mixed, then sieved to leave a thick slip.

Small patch tests are made to check the slip's consistency. If found to be too thick, small quantities of water are gradually added and mixed in. To remove air that may be trapped, the container is tapped repeatedly.

Large plaster bats of approx. 4cm thickness are covered with a fine cotton sheet, upon which porcelain coils of approx. 1.5cm thick are arranged to form a holding frame for the slip. The shape depends on the final form – square, circular or rectangular. The slip is poured into the frame and levelled. Surface qualities are made by pouring, dropping or flicking the slip itself, or by dragging or pushing an implement, such as a rubber kidney, onto the sheet of slip. Line, rhythm and almost edible qualities appear.

While fresh, the coiled frame is ripped away from the slip sheet. The direction in which it is pulled determines the nature of the edge. The decorated porcelain sheet is left until it is dry enough, so that, if moved, the marks will not be lost, but soft enough so that it can still be manipulated into the desired form.

If making a platter, the cotton sheet is held taught in all directions and lifted with the slip on top of a plaster mould. If making a vessel, the cotton sheet and slip are draped over a raised horizontal plaster column. They are left to dry until they can be lifted vertically and then wrapped into place. Base or feet are added at this stage.

The pieces are dried out very gradually under a polythene tent. This prevents anything adhering itself to the surface.

Once dry, the pieces are biscuit-fired slowly to 1000°C. The glazes used vary from the understated, chosen to reflect and enhance the slip in its wet state, to the bold and bright. Due to the shrinkage and warping that occurs in the final firing of such thick porcelain to 1260°C, the pieces are supported by saggars or ceramic wadding fibre.

Bone china can also be used in a similar process, provided that the clay is made more manageable by using an additive, such as paper pulp.

The work of **Frances Priest** (UK) illustrates an unexpected versatility not normally associated with this idiosyncratic material. She describes her work with bone china as follows:

Geometry, architecture and space are all elements which influence my final ideas. Constantly searching for the perfect form, the occupation and sculpting of space is as important as the physical object. The purity and refinement which can be achieved using bone china, combined with the material's inherent working difficulties, lend the pieces an ephemeral quality that is at odds with our expectations of this clay.

'Vessel' by Lisa Rau. (40cm h.)
Hand-built porcelain slip, using
Potclays HF1149 porcelain.
Fired to 1260°C.

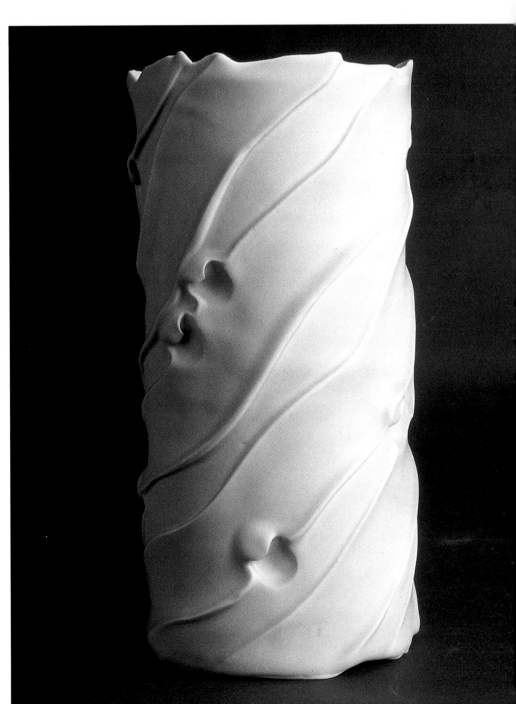

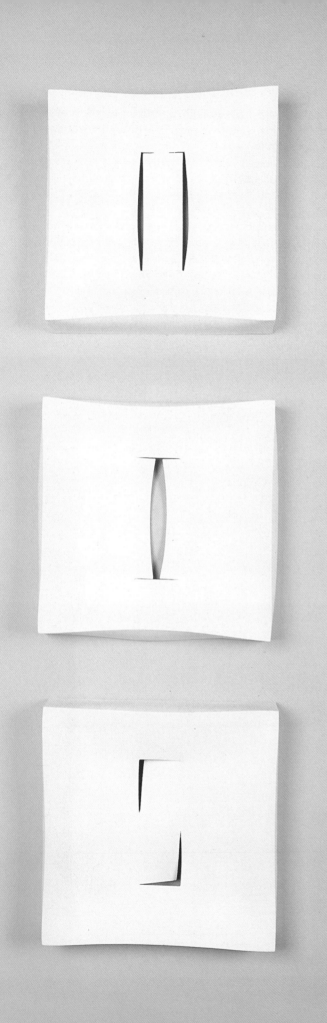

Her making process involves adding one-third volume of fine paper pulp to an already mixed standard bone china casting body. This is mixed until evenly distributed throughout the slip. Sheets of the material are cast onto plaster bats using hands and kidneys to smooth out. The thickness of the slip is kept constant by measuring the volume of the slip. Her pieces are either slumped on a former, or hand built. The hand-building process is as follows.

Using a metal ruler, set square and sharp scalpel blades, the bone china sheets are cut as soon as the cast is dry enough to remove from the plaster bat. It is important to ensure that shrinkage has been constant throughout. Cuts, or inlays, are made before assembling. All edges are mitred, then assembled and joined using a syringe filled with paperclay slip.

A setter is made to fit the work. This will control movement and prevent splitting during the 1260°C firing. The work is first bisque-fired to 1000°C, then sanded and finished using wet and dry paper. It is then refired to 1260°C, during which the form is allowed to slump gently. After firing, all the pieces are polished using wet and dry paper.

Another way of using casting slip in conjunction with hand-building techniques is illustrated in the work of **Helen Felcey** (UK). Here, the bowl is formed by using cloth soaked in porcelain casting slip, which is then wrapped around a newspaper former. During the firing, the paper and cloth burn away, leaving a hollow-formed bowl. The plate is slip cast, with the spoon being hand-formed by wrapping in cloth then dipping in porcelain slip. Black slip and rutile slip are sprayed onto the surface.

Kate Neal (UK) uses a variety of making techniques for her porcelain pieces. Some are carved from solid porcelain, while larger pieces are slab-built, then carved or slip cast and manipulated.

All of the work is very slowly dried in a static atmosphere, which reduces the risk of the work warping at the later stages. Following a low-bisque firing, the pieces are sanded then thoroughly washed and dried before glazing. She uses a variety of celadon glazes reduction-fired to 1300°C.

The finished work is displayed on glass mounts to create an individual sense of space.

THIS PAGE:
Wall-mounted bone china form in three parts by Frances Priest.
(30 × 30 × 8cm) Hand-built bone china. Fired to 1260°C. 2002.
(Photo: Lisa Prendergast)

OPPOSITE PAGE:
TOP: 'Wrapped bowl, unravelled spoon'
by Helen Felcey. Porcelain. 2001. (Photo: Steve Yates)

BOTTOM: 'Long White' by Kate Neal. (61 × 6cm)
Carved from solid porcelain. Reduction-fired to 1300°C. 2003.
(Photo: Bob Berry)

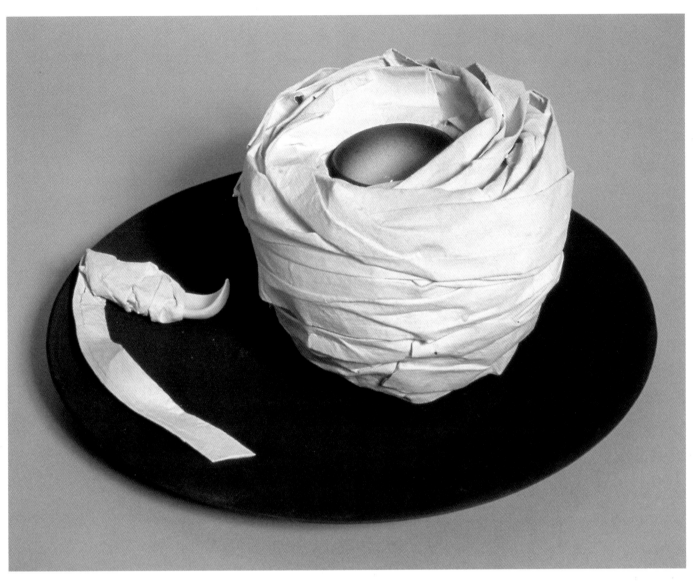

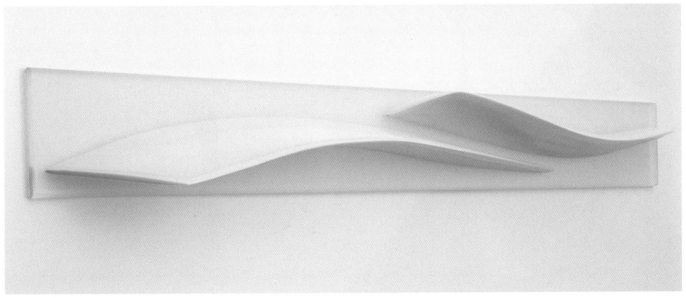

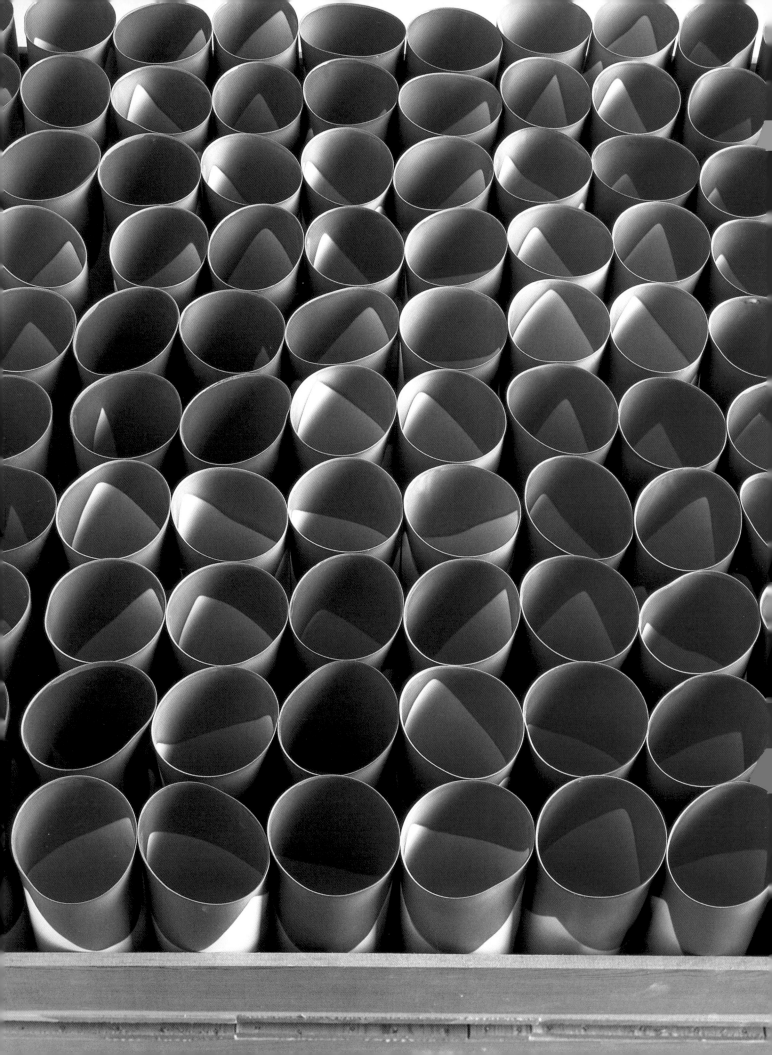

4
Making Methods
~
Slip Casting

The basic principle of slip casting involves filling liquid clay, or slip, into a dry, porous mould. The capillary action of a porous mould removes a proportion of the water from the slip, depositing a layer of clay on the inner surface of the mould. This remains when the excess slip is emptied. The resulting thickness of this layer, or cast, is determined by the length of time the slip remains in the mould. After the cast shrinks away from the mould, it can be removed and another cast can be made.

Before the discovery of plaster of Paris, which is now the most commonly used moulding material, the early Chinese used biscuit-fired moulds made from porcelain. Due to the smooth, close-grained nature of the clay, fine details were able to be picked up. The name 'plaster of Paris' originated from the discovery of gypsum deposits found at Montmartre in Paris in the Middle Ages. However, it was not until the mid1700s that it was first commercially mined, becoming an indispensable material in the production of ceramics.

In the mid-eighteenth century casting was done using a 'water clay slip'. This was a combination of water and the clay body mixed to a fluid consistency. However, there were some disadvantages with this slip. The high water content in the

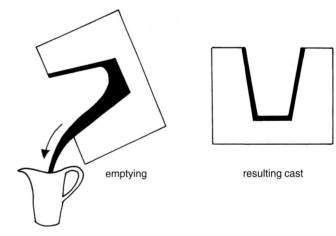

filling casting emptying resulting cast

OPPOSITE PAGE:
'100 Vessels' by Pieter Stockmans.
(Each 16cm h. in box 90 × 90 × 10cm)
Slip cast using hard-paste porcelain.
Fired to 1400°C. 1998.

THIS PAGE:
The principle of slip casting.

Blunger and coloured slips. Courtesy of Anne Lightwood.

paved the way for a significant development in the ceramic industry both in the UK as well as mainland Europe.

In the past, this method was considered to be primarily an industrial technique, which, by its very nature, could result in restricted and limited forms. However, when placed in the hands of resourceful and inquisitive makers, a wide spectrum of creative and innovative ceramics becomes entirely possible.

Belgian maker **Pieter Stockmans** (*see* Chapter 7 and p. 56) aptly describes contemporary slip casting as follows: 'A limited number of component elements which explore the potential for flexibility within the making process.'

In his studio, Stockmans uses traditional slip casting methods to realize small series work, as well as his 'art collection' pieces. Knowing that these pieces could not be viably mass-produced, he is able to command a higher value for the work by applying more and more processes in a studio production. He also experiments with porcelain by creating a number of products, of which part of the design is determined by the craftsman mass-producing it. In this way, he tries to give more meaning to the job of a production worker. Conversely, he has designed a number of products based on production faults – in this case, it is the designer who invents the idea, whilst it is the maker who ultimately decides on the form.

The work of **Philippe Barde** (Switzerland) also involves casting in multiples to form installation pieces. He has created a piece, approx. 1m square, that is made up of ninety-nine boxes, each with one open side. Focusing on the shrinkage aspect of porcelain, he made a mould from a stone, cast it in porcelain (with a percentage of nepheline syenite added) and fired it. Shrinkage was up to 16%. He repeated the operation nine times, resulting in nine identical casts with the given shrinkage, then cast another ten from each. After firing to 1250°C, the finished casts were installed to create an assembly of earthy-toned cubes.

slip resulted in completely saturated moulds, necessitating drying out between each cast. It also meant that the working life of the mould was reduced, due to water-soaked capillaries, plus the high shrinkage of the cast which resulted in distortion and loss.

A remedy was needed to reduce the water content yet still maintain fluidity.

This was done by deflocculation – a means of dispersing clay particles by holding them in suspension on the addition of an electrolyte (usually sodium). This has the effect of reducing shrinkage, as less water is needed, while fluidity is maintained. In the late eighteenth century in Belgium, an experiment by a Monsieur Bettignies, who added 3% of potassium carbonate to a soft-paste porcelain in his factory in Tournay, was considered an early attempt to alter the nature of the slip and render it more manageable.

It took until the beginning of the 1800s for deflocculated slips to develop fully and become stable. However, this discovery, coupled with the introduction of plaster of Paris,

Model

The original form or model can be made from a variety of materials prior to moulding. The decision on which to use is determined by the finished quality. For example, if the desired result comprises angled, precise forms – hard materials such as plaster, wood or perspex would be the most appropriate. Conversely, soft, sculpted forms such as figures or organic forms would require more malleable materials such as clay or plasticine. This is also useful for surface modelling and decoration on a model where clay would present a drying problem. If suitable, combinations of both hard and soft materials can sometimes offer the best solution. Some makers use styrofoam (expanded polystyrene foam),

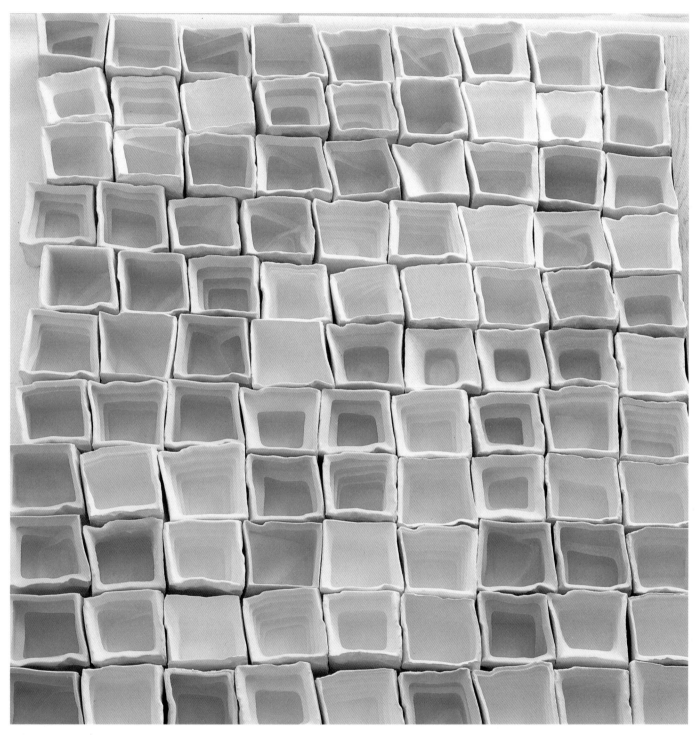

'Inside Porcelain, 99 Different Insides' by Philippe Barde.
(1m of cast porcelain and nepheline syenite.)
Fired to 1250°C. 2001. (Photo: Jean-Philippe Geizer)

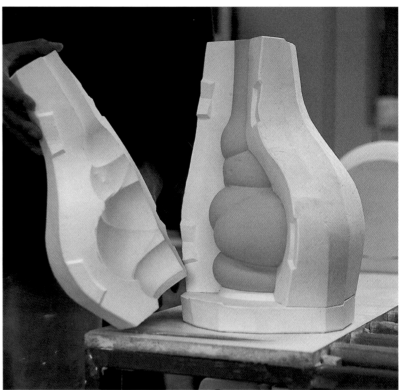

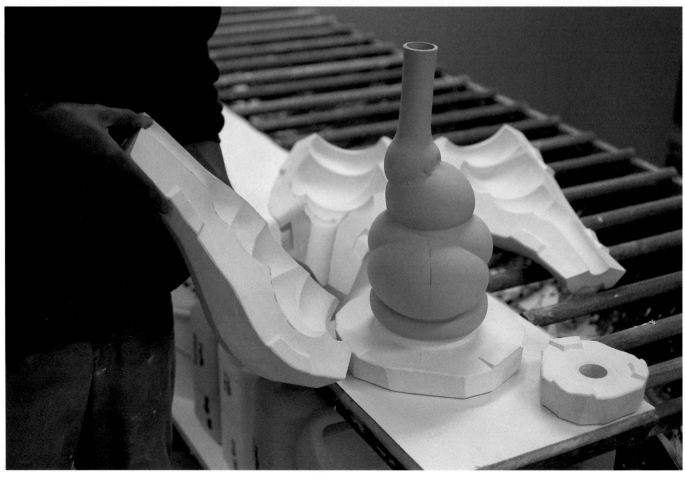

as this material can be carved using surforms, knives and rifflers. It can also be cut using a hot wire, but care must be taken as styrofoam emits toxic fumes when heated.

Soft Soap

If the model material is at all porous, a barrier or sealer will need to be applied.

If the model is made from wood, a few coats of primer will be needed, with some sanding in-between. With a styrofoam model, a coating of a water-based emulsion paint will be necessary. If made from plaster, the model will need to be sealed with a soft soap (available from most pottery suppliers). It is normally diluted with boiling water using 50% water to 50% soap. Non-porous materials such as perspex or glass do not require a barrier, and nor does damp clay.

Moulds

Although plaster is generally used as the main moulding material, relatively recent materials such as silicone rubbers and latex are used in conjunction with moulding techniques to offer more flexibility (*see* Suppliers). Moulds can range from simple drop-outs to more complex multi-piece ones, depending on the form of the original or model.

The key to mould making is being able to visualize the negative shape of the model and subsequently knowing how to form each section. A basic knowledge can be learnt from a variety of books on mould making, and, as in most cases, the fine skills will come with experience.

The carefully crafted moulds of Japanese maker **Yasuyuki Arioka** are fine examples of well-executed mould making. He teaches various exacting principles, which, when adhered to, can result in near-perfect moulds. He advocates stirring the plaster 'exactly 200' times and making the plaster mould 3cm thick, following the contours of the model. This will ensure even absorption when casting with the slip, as well as making a fairly lightweight mould. He is able to smooth, cut and carve the plaster using carefully honed pieces of bamboo rather than the usual bought implements.

As described in *Ceramics Technical* (no. 10, 2000), he details his model-making methods as follows:

I put plaster into a balloon using a small pump. It is settled between a flat surface and a board before hardening up. I then cut it apart using a hand saw. In making the three-part moulds, I make two holes on the part of the flat surface as an entrance for the slip. These works are piled up, revealing different linear

decoration. Another version of this form involves pushing a circular disc into the balloon shape. The disc creates an indent across the form. The cast balloon shapes act as legs, supporting the central disc.

Some models are made using balloons and string. Here, Arioka fills the balloons with plaster, as before, then ties string around the outside, transforming the shape by controlling the tension of the string. In his recent work, he has explored this technique with smaller objects – piling them up or aligning them side by side.

The moulds are made in two or three parts depending on the form.

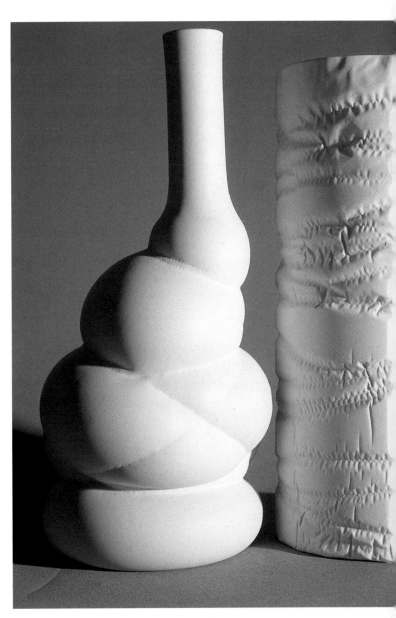

'Trace a witty memory' (26cm h.) by Yasuyuki Arioka. Slip cast bone china. Fired to 1180°C. 2000.

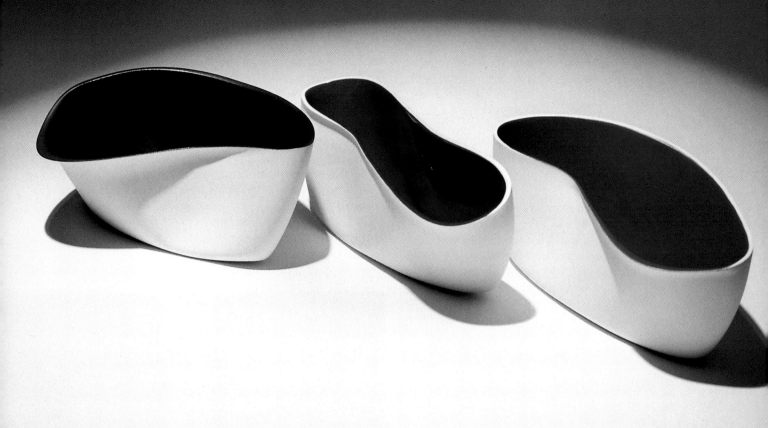

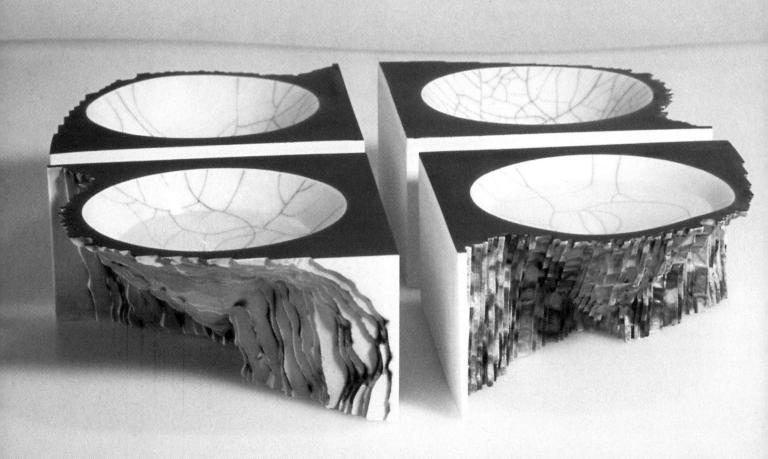

One maker who uses silicone rubber in his making process is **François Ruegg** (Switzerland). After having made a simple plaster model, he makes a silicone rubber mould of it. As the mould is flexible, he is able to deform it whilst he pours plaster back into the rubber mould. From this second, deformed model a working mould is made and cast as normal.

Venezuelan-born **Wolfgang Vegas**, who works in Switzerland, defies the normal procedures associated with slip casting. Instead of making a model, he only makes a mould (so

working in the negative space). It is a 'transformable mould', in that all of its parts are independent, giving the possibility of changing the order or of replacing the parts. He constructs the mould by making plaques of plaster of varying thickness, in some cases particularly thin, and assembles them with glue and adhesive tape. He then casts into the positive space created by the mould.

Simone van Bakel (Holland) uses slip casting as her main vehicle for realizing her porcelain objects. Sense of touch has always been an important theme in her work. In her earlier work, different elements or details that had been added to simple, plain forms would reveal themselves when touched or when light fell on them. This is illustrated in the 'Braille' series of cups.

The functional aspect of her work does not hold the same fascination for van Bakel that it once did, and she is now developing tactile qualities in her more sculptural pieces. Instead of just the addition of a decorated detail, relief and structures have become the main focus of her work. By capitalizing on the inherent marks and relief present on the human form, such as goosebumps, skin creases and bone structure, she casts body parts, then manipulates and arranges them in such a way that they are not easily recognizable.

OPPOSITE PAGE:
TOP: 'Lip bowls' by François Ruegg.
Slip cast porcelain. Fired to 1280°C. 2002.
Enamel decoration applied. (Photo: Gilles Boss)

BOTTOM: 'In Extinction' by Wolfgang Vegas.
(7.5 × 35 × 3cm) Slip cast porcelain using a transformable mould with oxides, engobes and glaze. Fired to 1280°C. 2000. (Photo: Gilles Boss)

THIS PAGE:
'Can you feel it?' by Simone van Bakel.
Slip cast porcelain. 2001.

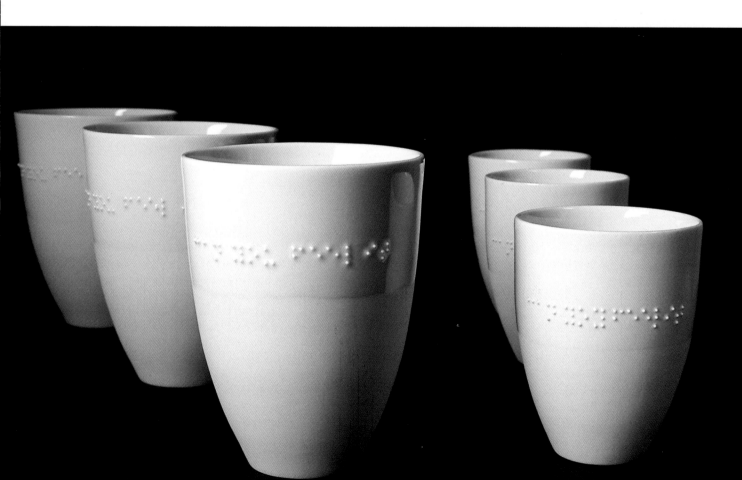

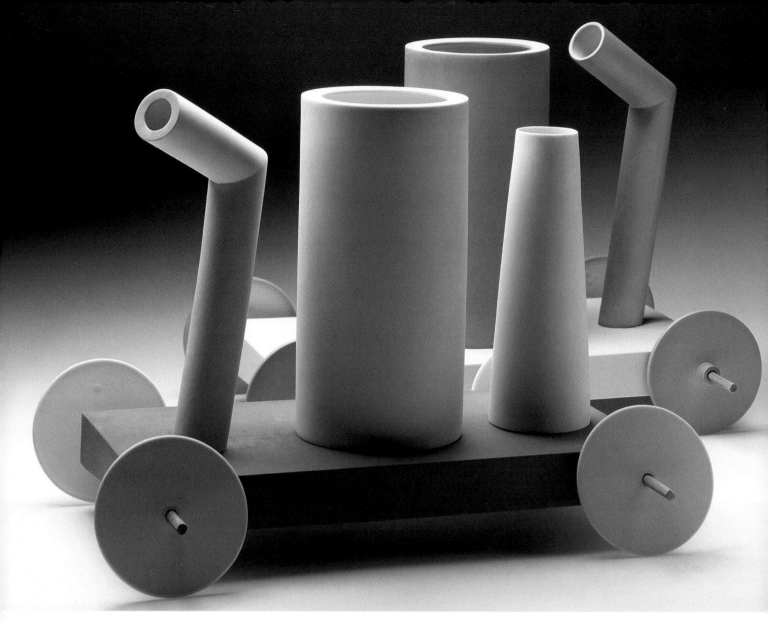

Two mobiles 'Reminiscence of a Pot' by Hubert Kittel. (29cm h.)
Slip cast elements, partly stained with a cobalt solution.
Unglazed and polished porcelain. Fired to 1400°C. 1999. (Photo: Klaus E. Göltz)

Her most recent work has evolved to include the actual implanting of porcelain/bio-ceramic pieces into the skin (*see* Chapter 8).

As well as his industrially produced work (*see* Chapter 7), **Hubert Kittel** (Germany) likes to play with the functional aspects of coffee pots or teapots to find new design solutions within his own work. Making slip cast elements using a hard-paste porcelain, he describes his work thus: 'Elements such as the body, spout, handle, lid and base are old, traditional images and standards of our tableware culture. Sometimes I need this interplay between nonsense and sense in designing new products. Here the non-functional, sculptural, ironic quality is getting the dominance.'

Translucency and thinness are synonymous with the work of **Bodil Manz** (Denmark). Her pieces demonstrate the extremes of these qualities that can be achieved by using porcelain with a slip casting process. She describes her long-term preoccupation: 'The cylinder – the simplest of forms, cast in translucent porcelain. Inner vertical lines, outer horizontal lines which form a common, quadratic pattern, or inner large dark squares that block the light, or inner delicate lines, outer delicate lines which float freely.'

Working with a porcelain slip that was specially developed by her husband, German-born ceramicist Richard Manz, Bodil casts particularly thinly 'so that the inside and outside decoration interact with the light, resulting in just one composition.' (*See* Chapter 5.)

Paradoxically, however, she has recently developed a series of sand-cast porcelain vessels which are *not* translucent. The characteristic body and surface of these oval-shaped vessels are formed by incorporating various types of natural sand, in addition to ilmenite, fine grog, black body stain, pieces of

RIGHT: *Oval vessel by Bodil Manz.*
(41cm h.) Sand-cast porcelain.
Fired to 1280°C. 2001.
(Photo: Brahl Fotografi)

BELOW: *Ribbed jug by*
Lorraine Ditchburn. (13cm h.)
Slip cast using Medcol porcelain.
Fired to 1260°C. 2000.

white glaze and so on, and mixing them into the slip prior to casting. The vessels are fired to 1280°C.

Distortion and warping are the main disadvantages when casting with porcelain or bone china. This is due to the fact that the 'memory' present in these high-firing clays exaggerates any fault or imperfection. An inadvertent knock or nudge at the damp stage will reappear after the firing, as will any seam line on a multi-piece mould, even if the piece has been sanded to remove it. This phenomenon is caused by the mica particles in the clay aligning themselves wherever there is an irregularity or gap, however small, in the mould. This alignment creates a thicker, or raised area, which cannot be avoided in high-firing clays.

Ways to avoid the seam lines showing is either to eliminate them altogether by designing a piece that will withdraw from the mould directly, as in the case of a drop-out mould, or, for a piece requiring a multi-piece mould, introduce twists and facets onto the model where a seam line could be 'hidden'.

Another method is to use decoration as a 'decoy', as in the case of **Lorraine Ditchburn** (UK). Her organic gourd-like vessels are produced by applying fabric to her solid model prior to moulding. As her shapes often necessitate a two-piece mould, the seam line can be successfully worked into the ribbed texture. As is often the case with unglazed work,

THIS PAGE:
'Vacuum' by Ruth Amstutz. (70cm h.)
Unglazed slip cast porcelain. Low-fired to
1100°C. 2000.

OPPOSITE PAGE:
ABOVE: *'China' by Pauline Hoeboer.*
(30cm h.) Unglazed slip cast porcelain.
Low-fired to 1100°C. 1998.
(Photo: Tom de Jong Boers)

BELOW: *Ruth Amstutz sealing her*
'Vacuum' mould in her studio.
(Photo: Martin Birrer)

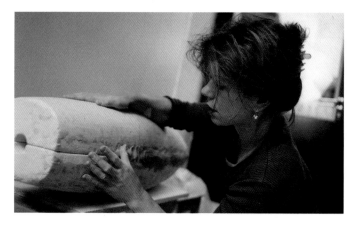

an initial bisque firing to 1000°C hardens the piece enough to withstand sanding before a final high firing to 1260°C.

Low-firing slip cast porcelain (1100°C) has the advantage of minimizing distortion and so remaining 'true to the form'. Although the body has by no means matured or become vitrified at this temperature, it remains white, possessing a 'chalky' surface quality. However, its characteristics of strength and translucency will not apply.

The work of makers **Ruth Amstutz** (Switzerland) and **Pauline Hoeboer** (Holland) fall into this category. Both work with slip cast porcelain on a relatively large scale, with the aim of keeping the form in place. Low-firing, in these cases, is an entirely appropriate method. Amstutz's large 'Vacuum' pieces

are cast, however, to achieve a 'sucked-in' appearance by deliberately interrupting the airflow when emptying out the slip. This causes a vacuum, pulling the cast away from the mould wall. It is normally regarded as a casting fault, but when used in such a considered way it becomes integral to the piece.

Pauline Hoeboer uses slip casting and press moulding to replicate parts of mannequins. Describing her work, she says: 'With the freedom to change and combine copied forms, I create my personal visual language. By taking everything apart and putting it back together, the world is moulded to my personal preference. Due to the polished and concise presentation, the sculptures show their underlying vulnerability only in the second instance.'

Her 'China' piece involves casting different parts of a mannequin, as well as a spout and lid from a traditional teapot. By combining these objects, she creates a type of china 'doll' that aims to highlight the human body's vulnerability. She plays on the contrast between the inside, which is full of emotions, and the outside, where handles, spouts and lids emphasize the body's role as a functional object. Also, where usually it is the names of body parts that are applied to functional ceramic objects, for example shoulder, neck, belly, she does the opposite by adding functional aspects such as a spout and handle to parts of the body.

Andreas Steinemann (Switzerland) demonstrates in the series of photos (p.68) how a specific mould-making technique can significantly reduce the appearance of seam lines.

SPLIT MOULDING A VASE BY ANDREAS STEINEMANN.

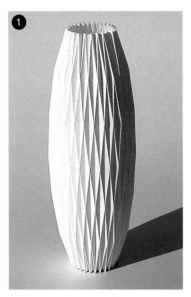

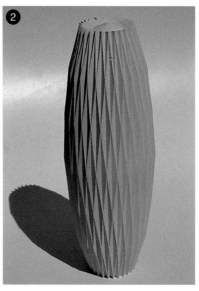

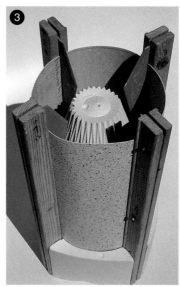

1. Model is first made from paper/card.

2. Final model is made from waste mould.

3. Production of casting mould with metal 'split' sheets in place. Consists of four to eight pieces; seams are split open to avoid seam lines.

4. Finished mould with cast inside.

5. Mould is removed segment by segment.

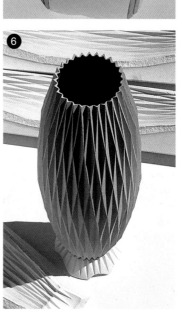

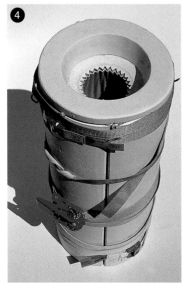

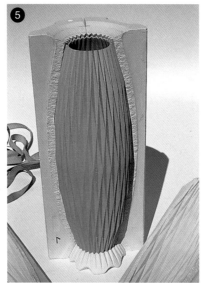

6. Resulting cast.

7. Mould segments.

8. Setter and mould.

9. Finished cast and setter.

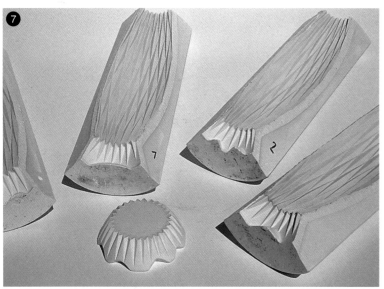

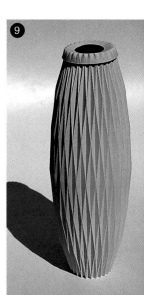

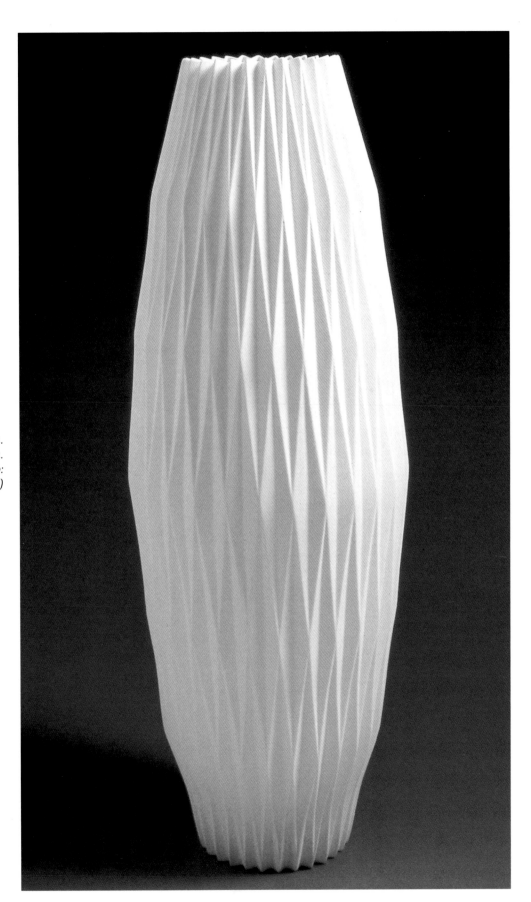

Folded vase by Andreas Steinemann. (42cm h.) Slip cast bone china. Fired to 1250°C. 2002. (Photo: Marlen Perez)

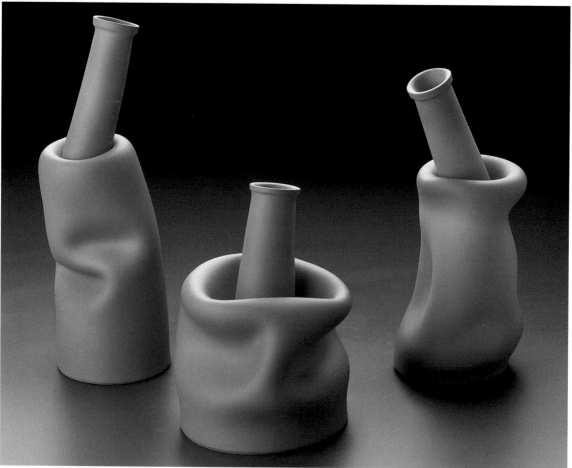

The inspiration for his most recent bone china pieces comes from his fascination for folded paper, lightness and translucency and the fine play of light and shade. Second to the aesthetic qualities of his pieces is his interest in their static aspect – the folds diminish the distortion during the firing process, yet at the same time give greater stability afterwards.

There are, however, makers who exploit the warping qualities of these fine clays using distortion to convey their ideas. The exhibition work of **Angela Verdon** (UK) and **Hubert Kittel** (Germany) (*see* Chapter 7) successfully illustrate this point. Verdon casts solidly using bone china. She removes the casts from the moulds whilst the slip is still flaccid, then purposely deforms them by dropping them. The fact that they are manipulated whilst still damp encourages slumping and distortion during the firing.

Alison Gautrey (UK) has combined both porcelain and bone china on the same piece, exploiting the inevitable distortions that occur. She is renowned for her 'spun' porcelain, a technique she developed by combining 'jigger and jolleying' with casting. The mould is placed in a jigger-head and, whilst it is revolving, an egg cup full of slip is poured into the mould. Centrifugal force moves the slip up the mould to the top edge. This process takes only four to five seconds, but results in an egg-shell thinness.

By adding bone china to the inside surface of the porcelain, a 'pulling' effect happens. This is due to differences in shrinkage, firing and a basic incompatibility between the two clays – bone china is traditionally fired between 1220–1260°C, whereas porcelain has a firing range of 1260–1400°C for hard-paste porcelain (*see* Chapter 1).

5

Decorating Techniques ~ From Raw to Onglaze

In addition to the many seductive qualities already possessed by porcelain and bone china, such as smoothness, whiteness and, of course, translucency, they are one of the few clays which are able to stand in their own right – without a glaze in many cases. These characteristics mean that there is even more choice of decoration available to those who work in porcelain and bone china. This chapter, therefore, aims to illustrate this diversity by using examples of standard techniques which have been given individual treatment, ranging from decoration at the raw, or green, stage to onglaze application.

On Greenware

Coloured Clays and Casting Slips

Various makers use metal oxides or body stains (commercially prepared and blended metal oxides) to colour their clays, whether it be in the plastic clay or casting body, or used as a decorating slip. Metal oxides tend to be stronger in colour intensity due to their purity, whereas commercially prepared colours, whilst offering a greater range of tone and colour, tend to be weaker in colour strength due to the manufacturing process.

A rough guide to the amount of stain needed to colour a white clay body is between 2–20%, depending on the

intensity of colour desired. Most manufacturers give an estimation and the maximum firing temperature of each colour, although it is always advisable to test beforehand. It is also worth bearing in mind that most oxides and darker stains, such as blues and blacks, are not suitable in high saturation as they can act as a flux, causing the body to bloat and vitrify.

A technique that is steeped in history yet lends itself to contemporary interpretation is agate ware. This is when a ceramic body has the appearance of marbled stone. It is achieved by layering different coloured clays, either by wedging or kneading them together, then throwing, coiling or hand-building with the mixture. A thrown agate piece will normally require turning to reveal the underlying pattern. It is advisable to use the same clay body to avoid variants in shrinkage.

Closely linked to agate is the *nériage* technique. It is described in Robert Fournier's *Illustrated Dictionary of Practical Pottery* as: 'A form of decoration originating in Japan. Slabs of contrasting clays are laid one on another, cut into strips, and rolled or folded into a block. These are sliced end-on so that a whorl or other design of marbled colour is obtained.'

Amongst those who colour their throwing bodies is **Marisa Arna** (Greece/UK). Her patterns are achieved by loosely wedging and kneading different coloured porcelains together. In this case, metal oxides are used to stain the porcelain. After throwing, the pieces are scraped and turned to reveal a random pattern on the exterior of the vessels. After a low-biscuit firing, glaze firing is at 1280°C, in an oxidized atmosphere using translucent or coloured semi-matt glazes. The exterior of the unglazed ware is polished after firing using wet and dry paper.

South African maker **Katherine Glenday** also uses a similar technique for her work. Having studied at Pietermaritzburg University in Natal (the only university in South Africa to offer a ceramics degree course as part of a Fine Arts

OPPOSITE PAGE:
'Opening Cylinder' by Astrid Gehartz. (17cm h.)
Thrown Limoges porcelain with water erosion
and metal salt decoration. Fired to 1280°C. 1999.
(Photo: Thomas Näthe)

degree), she became drawn to porcelain and its accompanying properties, in particular the whiteness and translucency.

After lightly wedging porcelain and black clay together, she throws her pieces, then turns them using the normal tools. However, very sharp blades are finally used to define the pattern and achieve extreme thinness. The rims are pulled, stretched and manipulated between damp cloths.

The simple graphic patterns on **Andreas Steinemann's** (Switzerland) vessels are achieved by a form of inlaying. After preparing both a black stained porcelain and a white, he cuts 7mm-thick sheets of black porcelain and embeds, or inlays, them into the white porcelain, joining them with water. With the help of templates, he assembles the pattern, then the completed sheets are hermetically sealed for a couple of days to ensure a good adhesion between the two clays. The sheet is placed in a plaster mould to harden up.

Once the right consistency has been reached, the piece, still in its mould, is turned on a wheel. After five to eight days of drying in the mould, it is removed and fired to 980°C. This hardens up the piece enough to wet-sand it using corundum paper until a thickness of approximately 2mm has been reached. The final pieces are fired in a type of saggar for a second time to 1250°C. This technique enables the pattern to be visible on the interior as well as the exterior of the vessel.

The sculptural bowls and vases of **Mieke Everaet** (Belgium) are made by using an intricate form of inlay. Here she describes her reasons for using this technique:

> A structure comes into being by means of thinly cut, coloured porcelain strips. The building component or fragment determines the design, the adornment of the work of art. The adornment becomes the structure in itself, the handwriting. By means of this mosaic, or inlay technique the design or adornment is fully integrated into the object – becoming the object itself. This implies that the work has to be carefully planned out. To me, this method of production, which is a creative process of form and ornament, is an abstract form of expression – such as music and dance …

For her pieces, Everaet uses a combination of David Leach, Audrey Blackman and Limoges porcelain. The powdered porcelain is mixed with 0.5–0.7% metal oxides or body stains. It is very important that the porcelains used have the

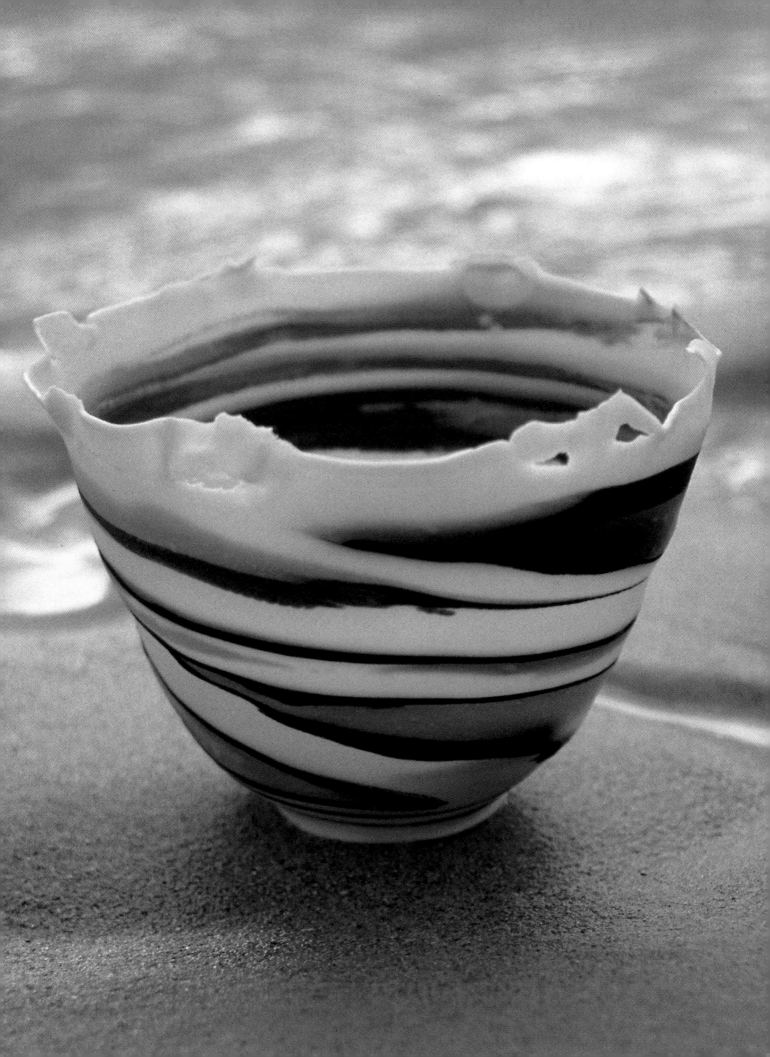

*Porcelain vase with inlaid decoration
by Andreas Steinemann. (30cm h.) 1999.*

MIEKE EVERAET'S INLAY TECHNIQUE.

Body stains and oxides.

Stained porcelain rolled out.

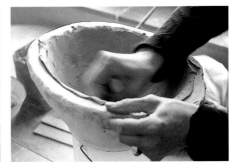

Applying a layer of porcelain slip into the press mould.

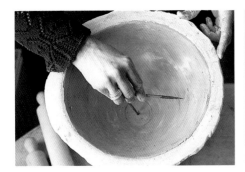

Measuring for the inlay.

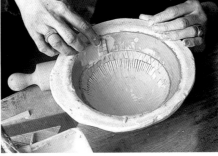

Fixing coloured porcelain strips with coloured porcelain slip.

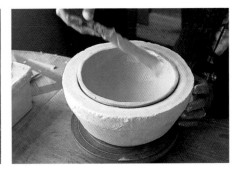

Painting coloured slip over the pattern.

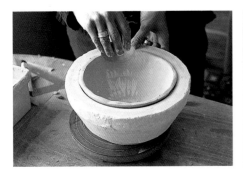

Scraping the inside of the piece when leather-hard – pattern is revealed on inside.

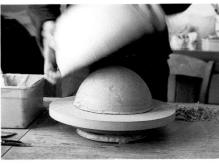

Removing the press mould.

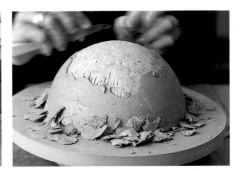

Removing the outer layer of slip with a knife – pattern is revealed on outside.

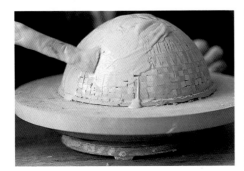

Applying slip to outside to fill up any holes.

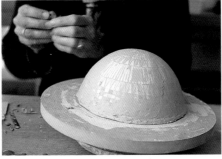

Using a razor blade to finish the outside when leather-hard.

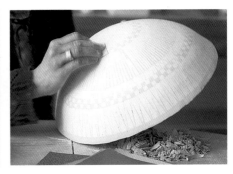

Sanding piece after soft bisque firing.

same shrinkage and that the colour is evenly mixed throughout, otherwise tensions will occur during the firing.

The plastic body and slip are prepared into a workable state. For larger pieces Everaet uses the following porcelain slip recipe to give greater viscosity and strength to the piece:

- 1kg dry porcelain
- 200g molochite
- 2g peptone (an enzyme which acts as a 'bactericide' used in conjunction with CMC)
- 2g CMC (an organic cellulose gum that acts as a binder and suspension agent).

First, Everaet rolls out thin sheets of coloured porcelain, from which fragments are cut. A layer of porcelain clay is laid into a mould, then the fragments are carefully pressed onto this layer using slip to join them. After the pattern has been arranged, a porcelain slip is painted over this, sandwiching the fragments between two layers.

Once the clay is leather-hard, the inner surface is scraped away to reveal the intricate patterns underneath. The mould is then removed and the same operation is applied to the exterior of the bowl. Once all of the 'holding' layer has been scraped away, another coating of slip is applied to fill up any gaps. After drying, the bowl is fired to 980°C, then polished. As there is no glaze, the bowl is fired in a silica-sand-filled saggar to 1260–1280°C, depending on the fluxing temperature of the added oxides.

The kiln is opened with trepidation because the process can induce a large failure rate. The paper-thin walls are a challenge to the heat; just a little tension can shatter a piece.

The imagery on **Susan Nemeth's** (UK) platters is derived from fabric designs of the 1950s and 1960s. She has successfully developed a 'drawing' technique using inlay decoration and describes the process as follows:

I stain porcelain with combinations of oxides and body stains, then roll these coloured clays into thin sheets.

A sheet of black porcelain is rolled out, then sheets of coloured porcelain are laminated onto each side. A thin layer of black slip is poured on top and allowed to dry. The inlays are cut from sheets of previously prepared coloured or white porcelain (with coloured slips on the reverse side), then rolled in to make the design.

The black slip is then washed off, leaving an outline around the pattern. Sometimes I 'draw' through the layers with a knife to add detail.

When I am happy with the design or image, I turn the whole lot over and roll it flat. Inlays are then added to the reverse side.

The pieces are generally press-moulded or slab-built (*see* Chapter 3).

Another maker who works with inlay and the drawn line is **Nicholas Homoky** (Hungary/UK). Introducing his work, he says: 'I work mainly with the vessel, exploring the visual, the functional and the sculptural through the practice and combination of drawing with the making process. To me form is represented in line – and line is represented in form. I interpret these as interchangeable concepts in order to allow ideas and images to flow between the two.'

He uses a combination of throwing, turning and handbuilding. The cylinders may be both rolled on a stick or thrown. The drawing is an inlay technique that starts from a pencil drawing onto the leather-hard clay. This is cut into using a knife and painting slip is applied into the cut drawing. The porcelain is unglazed and polished after firing. When asked why he uses porcelain, he replied: 'For two main reasons. The first because it is a magically self-glazing material, as can be seen when comparing a clear porcelain glaze recipe with a porcelain clay recipe. By itself, it is a pure vitreous and translucent material, only needing glazing for function. My function is visual so no glaze is necessary. The second reason is that its matt white surface becomes a metaphor for paper and lends itself readily to drawing.'

In 'Vessel with bent tubes' he admits that it was technically one of his most challenging pieces due to the risk of distortion

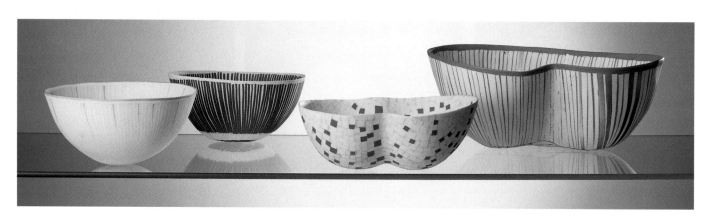

Group of porcelain bowls by Mieke Everaet. (8–18cm h.)
Porcelain composition inlay technique. (Photo: Hans Vos)

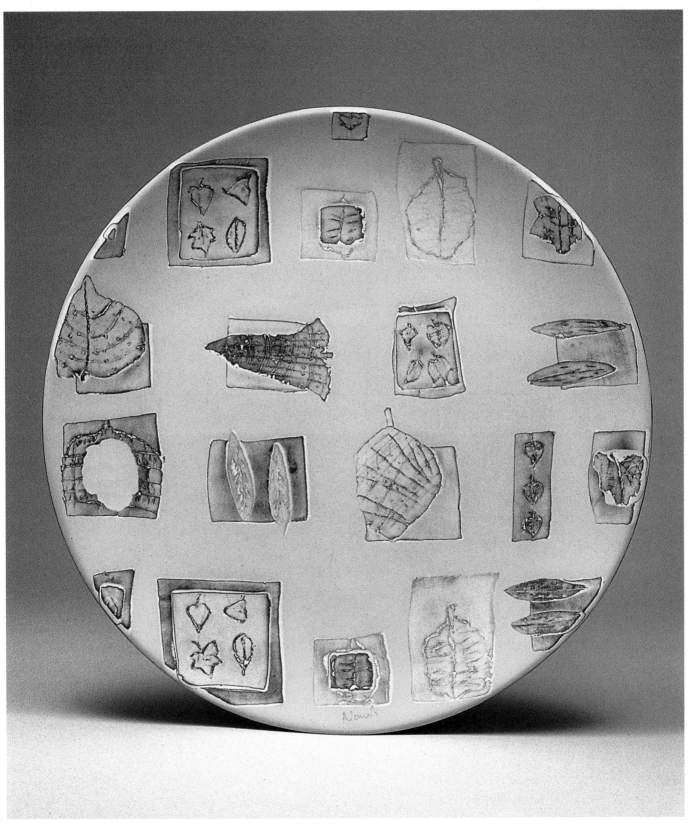

'Leaves' by Susan Nemeth. (31cm diam.)
Press-moulded porcelain plate using coloured
clays, slips, sgraffitto and inlays. 2000. (Photo: Stephen Brayne)

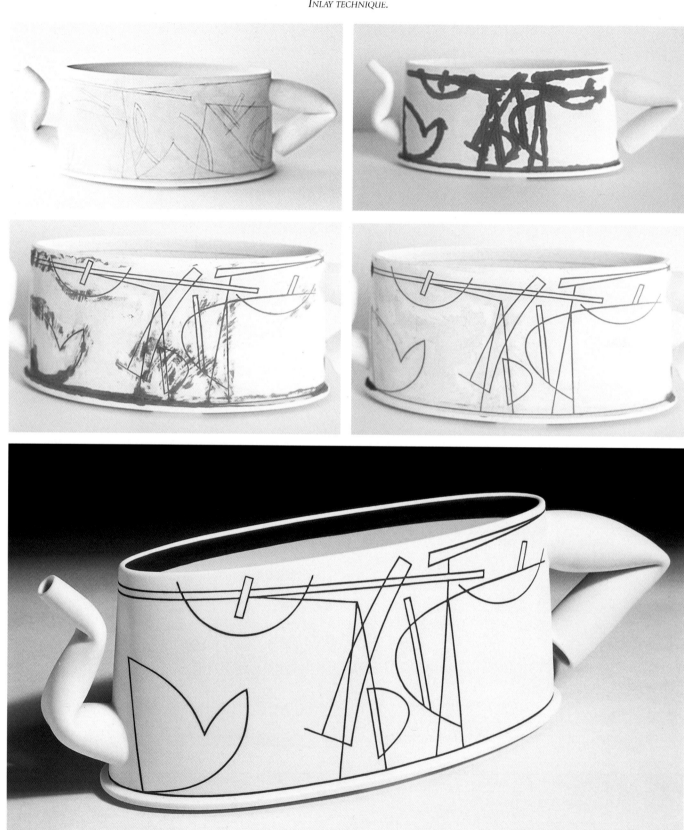

Vessel with bent tubes by Nicholas Homoky. Thrown and altered body with thrown slab base.
Tubular handle and spout thrown horizontally with a wooden dowel. Inlaid decoration. Fired to 1250°C.

Anne Leclercq inlaying coloured porcelain slip on the exterior of a bowl.
(Photo: Pierre Goossens)

of the rim. However, he wanted to see what would happen when the formal proportions of a teapot were significantly altered. The elongated form creates movement in the form, as well as the drawing, with the intention of exploring a large space for decoration between two ends. He is also interested in using the potter's wheel to make a continuous slab of clay and describes it as 'slab forming by throwing'.

Belgian maker **Anne Leclercq** follows the same principle of inlaying using a stained deflocculated porcelain slip as the inlaying clay for her elegant and refined pieces.

The earlier work of **Felicity Aylieff** (UK) demonstrates an effective use of painting with a decorating slip over a stained porcelain body. The porcelain used in the large press-moulded and hand-built piece shown here has been coloured

with seventeen parts black body stain to 100 parts clay. A grey porcelain slip was applied at the leather-hard stage, giving a superimposed effect similar to the French pâte-sur-pâte technique, in which designs are built up using layers of translucent slip.

The brightly coloured porcelain vases and bowls made by **Mary Vigor** (UK/France) are redolent of the south of France where she now lives and works. She slab-builds her pieces from Limoges porcelain, using a personal and modern interpretation of traditional decorating slip techniques. The clay is rolled out into a thin slab, then decorating slips (coloured with oxides or commercial stains) are applied onto the raw clay. The patterns are built up, on both sides of the clay, using collages of newspaper stencils and superimposed layers of painted slip. The fine detail is applied using a slip-trailer with a syringe added to the nozzle.

Once decorated, the slab is cut into pieces then reassembled over a biscuit-fired former or mould, where it is left to harden up. Although normally the golden rule when working with porcelain is careful, even drying, Vigor has recently discovered that for these pieces, the quicker she dries them, the better, and has even taken to drying them directly in the sun!

After a soft firing to 980°C, a thin layer of transparent glaze is applied, then they are refired to 1235°C.

Another maker using decorating slip in an innovative way is **Vicky Shaw** (UK). She has developed a method of mono-printing with slip and direct screen printing, with under-glaze colour, onto the raw clay.

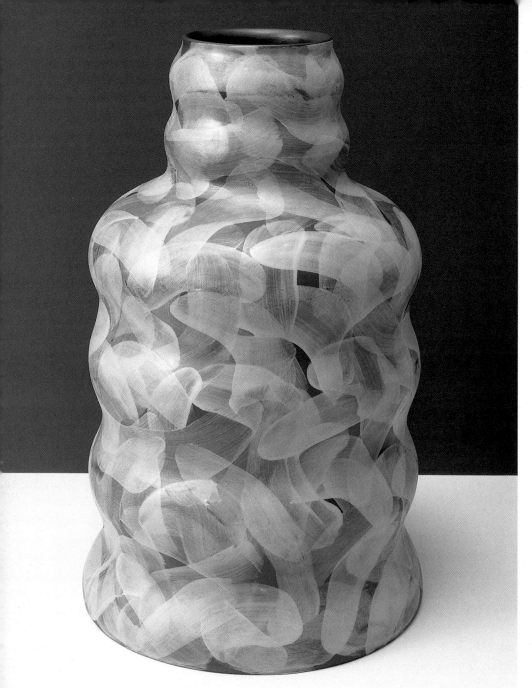

Here she describes the two techniques:

Direct screen printing can be done without the use of a professional printing bed. Simple stencils can be made from paper; these can be attached to the screen or positioned on the clay. Latex can be painted onto the clay surface to act as a resist. This technique allows for free painterly mark-making. Printing onto leather-hard clay enables the slabs to be formed after printing.

Mono-printing is a versatile technique, the basic principle of which is the transferring of a single image from one surface to another – in this case, clay. Designs from etching plates and lino can be transferred using pottery tissue. Newspaper and canvas will transfer coloured slips onto leather-hard clay. An image applied to a glass surface or plaster bat will work in the same way. All of these methods are possible in a normal work-shop situation with the minimum of basic equipment and will provide a range of interesting and unique qualities.

Shaw's porcelain bowls start out as flat slabs; once decorated using the above techniques, they are pressed over a plaster mould to form the shape. The work is fired to 900°C initially, then polished with wet and dry paper and diamond pads to achieve final shaping. The pieces are finally fired to 1200°C and polished again to achieve a smooth surface.

Jeannie Mah (Canada) has devised a way of applying photocopied images onto porcelain at the raw stage. After slab-building her porcelain pieces, she wets the photocopied image on both sides, then rolls it into the raw surface. The paper burns out in the bisque firing, leaving the image on the clay. In her experience, Mah has discovered

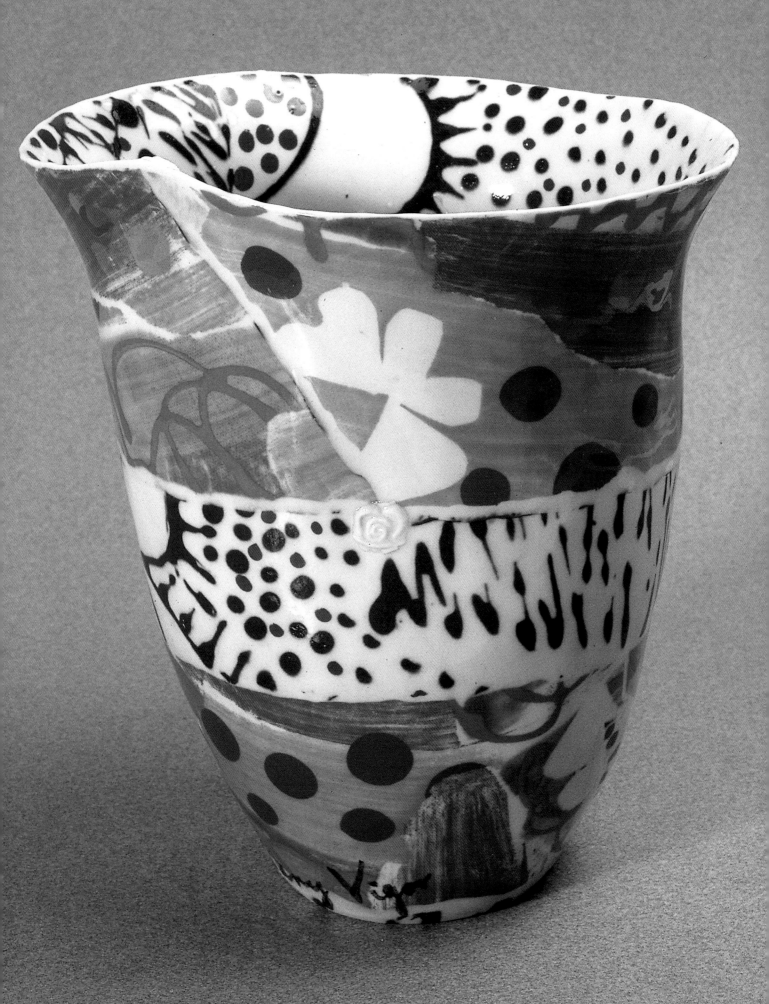

Individual Jasper bowls by Vicky Shaw. (8–22cm diam.)
Press-moulded porcelain with monoprinted slips.
Fired to 1200°C. 2001. (Photo: Rod Dorling)

Detail of 'Mother and Brother' by Jeannie Mah. (28cm h.)
Slab-built porcelain with photocopied decoration.

that successful prints are all dependent on the toner of the photocopier – she uses an early 1990s Canon one.

She introduces a wash of colour to the piece by wiping off an application of Duncan Easy-Stroke underglaze colour, purposely over-firing it to 1260°C in an oxidizing firing.

There are several makers who use coloured casting slips as an integral part of their decoration. One such maker is **Kathryn Hearn** (UK), who uses two casting processes to make her porcelain, and most recently her Jasper ware pieces. (Jasper ware is the name given by Wedgwood to a fine-grained, vitreous, stained stoneware.) She describes them in *Ceramic Review* (no.188) as follows:

The first step is to cast a pot in layers of coloured deflocculated slips and carve through the layers to reveal integral surfaces [*see* Chapter 7]. The second is to make laminated inclusions – from cast slabs cut into sheets and pressed together – and apply these to the inside of the mould, then cast layers of coloured slips over them. This creates sharp images on the outside of a form and soft hallowed qualities inside. The inclusions are applied to the plaster mould with the same slip which is poured on the top of them; this part of the process must be done quickly so that the inclusions do not separate from the mould. For multi-casting, the slip is left in the mould until the surface has lost its sheen, when it is ready for the next layer.

Following the manufacturing process, I allow the pots to dry completely, then carve the surfaces with either a metal kidney or tool. Afterwards the surface is refined with a fine wire wool and a range of materials depending on the clay body – usually knitted gloves, potter's tow, tee-shirting and paper towels, the intention being to achieve as mark-free a surface as possible. This is obviously a hazardous process, creating an enormous amount of dust, so an appropriate mask, all-over overalls and good ventilation are essential.

The firing process is very slow for this body to 1183°C.

Detail of Jasper Portland and pale blue shallow dish with crosses
by Kathryn Hearn. Slip cast Jasper ware. Fired to 1183°C. 2002.
(Photo: Andrew Watson)

Swiss maker **Lea Georg** uses a multi-layering casting technique in her work.

Working with contrasting colours, as well as positive and negative forms, she casts two layers of porcelain slip – white then black, or the reverse. At the leather-hard to dry stage, she scores through the outside layer with a hacksaw blade to reveal the inner one. The pieces are soft fired to 1000°C, after which a transparent glaze is applied to the inside. They are finally fired in an electric kiln to 1260°C.

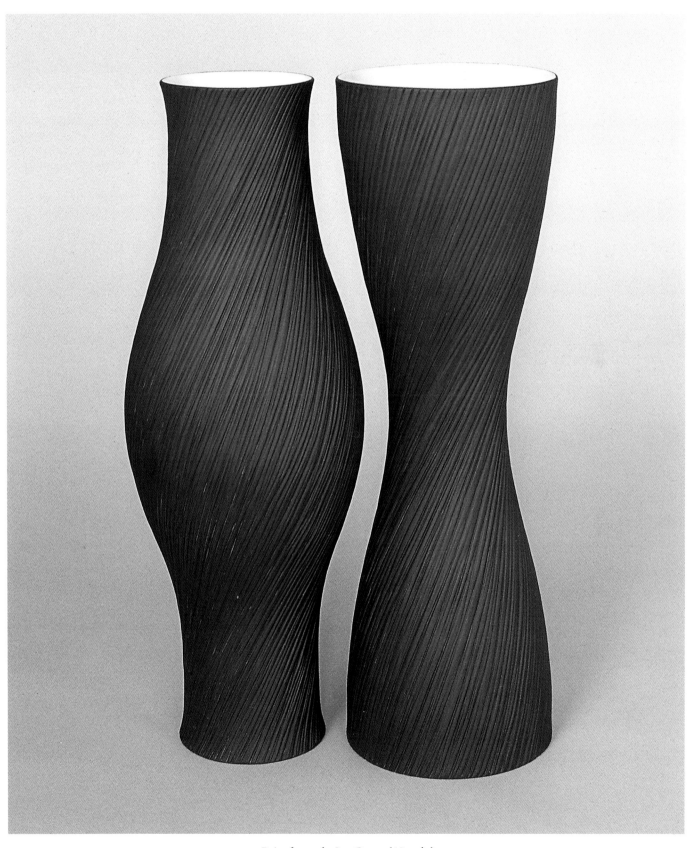

Pair of vases by Lea Georg. (40cm h.)
Double-layered cast porcelain. Fired to 1260°C. 2001.

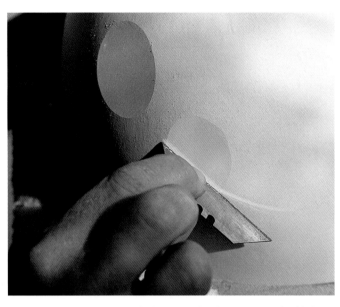

ABOVE: *Paring down a multi-layer cast bowl using a Stanley blade.*
(Photo: Peter Scott)

BELOW: *Blue and white faceted bowls by Sasha Wardell. (9cm h.)*
Multi-layered and sliced bone china. Fired to 1260°C. 2004.
(Photo: Graham Murrell)

Layering and Slicing Technique

In 1998 I personally became interested in the multi-layer casting technique after looking at glass-making techniques, in particular that of Murano glass. The fact that this method took advantage of the inherent qualities of bone china, without the need to apply decoration, appealed to me at the point I had reached in my work. The whiteness (some would say 'coldness') of the body offered a completely blank canvas for any addition of colour, however small, so coupled with its translucent properties, it served as a perfect material for colour experimentation. My techniques are described as follows.

Using commercial body stains to colour the bone china, one layer is poured into a mould and emptied immediately. As soon as the sheen has disappeared, a different coloured layer is added and so on, until the desired number of layers has been achieved (normally three or four).

When the piece is bone dry, it is removed from the mould. A sharp Stanley blade is then used gradually to pare down random areas on the curved surface of the piece, revealing little by little the underlying colours, until the interior, or in some instances the last, layer is exposed. The clay is extremely thin and vulnerable at this point.

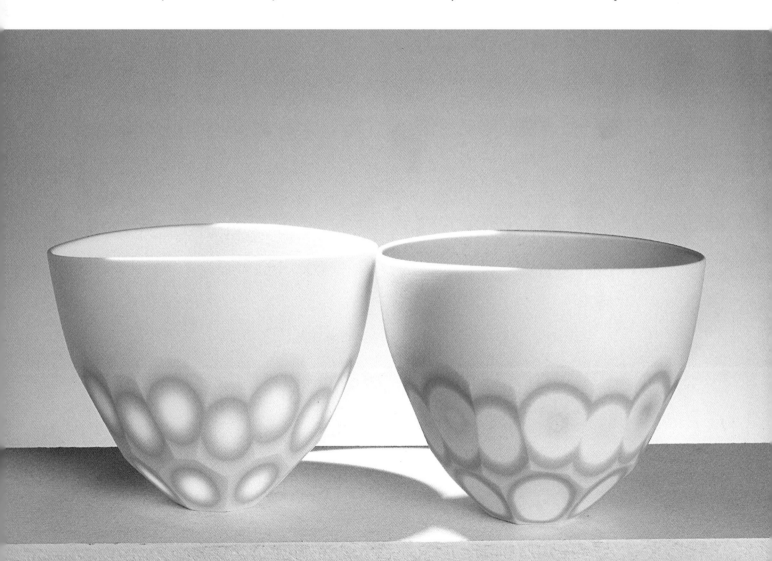

The piece is soft-fired to 1000°C, after which it is wet-sanded using 240 grade wet and dry paper wrapped around blocks of wood or plaster. This gives the piece its 'cut-glass' appearance.

The piece is fired a second time to 1260°C, with a one and a half hour soak. The soak ensures the heat is distributed evenly throughout, resulting in optimum translucency. Finally, it is polished with wet and dry paper to achieve a satin-matt appearance.

Layering and Incising Technique

This approach follows the same process as far as the multi-layer casting is concerned. However, the pieces are removed from the mould whilst they are still quite soft. A loop tool is used to incise or gouge through the layers. This has the same effect of revealing the underlying colours until the last layer is exposed. Great care is needed to avoid going right through, as the piece is particularly vulnerable at this stage.

RIGHT: Multi-layer casting with bone china.

FAR RIGHT: Incising through the layers with a loop tool. (Photos: Peter Scott)

BELOW: Pair of incised bone china vessels by Sasha Wardell. (22cm and 10cm h.) 2003. (Photo: Stephen Brayne)

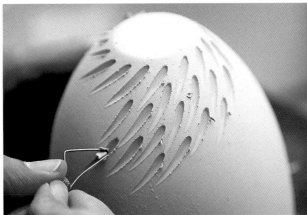
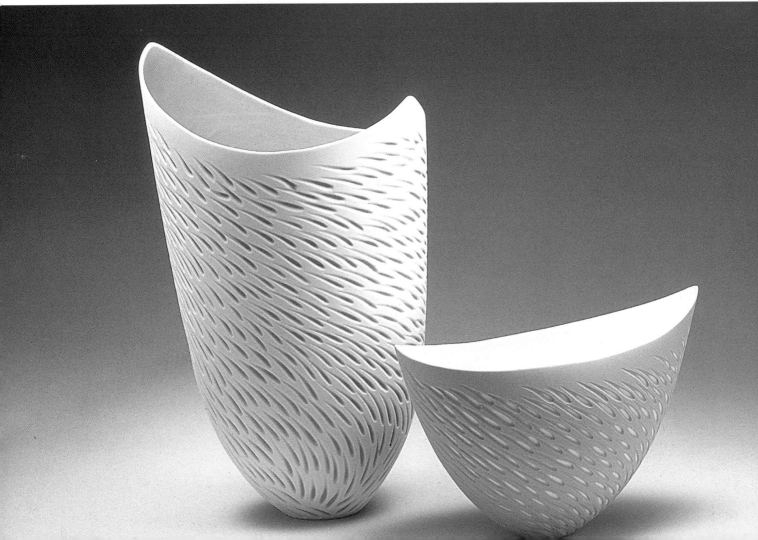

These pieces undergo the same sanding, polishing and firings as the sliced ware.

Scottish maker **Caroline Harvie** works in bone china and uses multi-layering in a slightly different way – applying it onto bisque ware. Her new range of work involves stretching and distorting functional textures found in everyday objects.

Taking and stretching latex impressions of textures such as perforated metal shelving, foot plates of metal ladders, vents on hairdryers and so on, she makes a plaster model then a mould. After a single cast of bone china, the pieces are low-biscuit-fired to 850°C. Stained slips are applied to the soft-bisque ware, which are refired for each coat before being sanded back to reveal the underlying layers, echoing natural geological processes suggesting gentle erosion.

The pieces are finally fired to 1260°C, with a one-hour soak, after which they are polished with fine silicon carbide paper to produce a smooth stone-like finish.

RECIPE FOR STAINED DIPPING SLIP (TO ADHERE TO BISCUIT WARE)

- 4 pints of casting slip
- 2–3 pints of water
- 100g of body stain
- a few drops of calcium chloride
- a few drops of sodium Dispex and/or more water if required.

METHOD

Add the body stain to a little water then mix with the slip. Add a couple of drops of calcium chloride solution – this will make the slip thicken and go lumpy – leave for five minutes, or so, then mix well. Add the rest of the water gradually by pouring or brushing it through a fine mesh. A little more Dispex can be added, but too much will neutralize the suspension effect of the calcium chloride. The pint weight should ideally be around 26 fl oz.

If applying to low-bisque ware or bone-dry greenware, the piece is sprayed with a fine mist of water before dipping in the slip. The slip should dry in a few seconds. Too much calcium chloride slows down the drying – a few drops of Dispex will speed it up.

Piercing and Carving

It is understood that both porcelain and bone china have exceptional translucent qualities; nevertheless, there are several makers who exploit these qualities even further. Piercing and carving into the leather-hard surface can be cautiously carried out and, although the clay wall appears thin and vulnerable, it is surprisingly strong in the green stage, although porcelain is stronger than bone china in its raw state.

The series of photographs (*right*) shows **Horst Göbbels** (Germany) method of piercing into leather-hard porcelain.

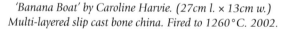

'Banana Boat' by Caroline Harvie. (27cm l. × 13cm w.)
Multi-layered slip cast bone china. Fired to 1260°C. 2002.

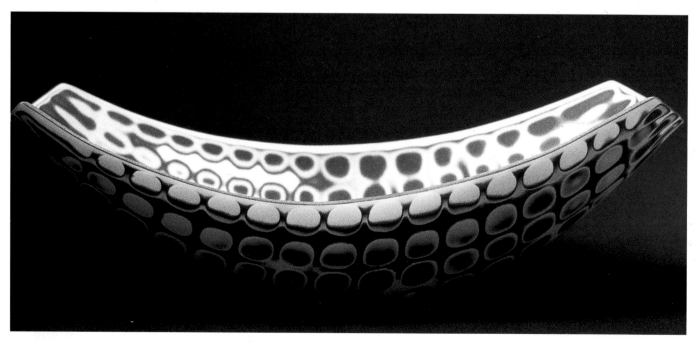

HORST GÖBBELS PIERCING AT THE LEATHER-HARD STAGE USING A FRETSAW BLADE AND TWIST DRILLS.

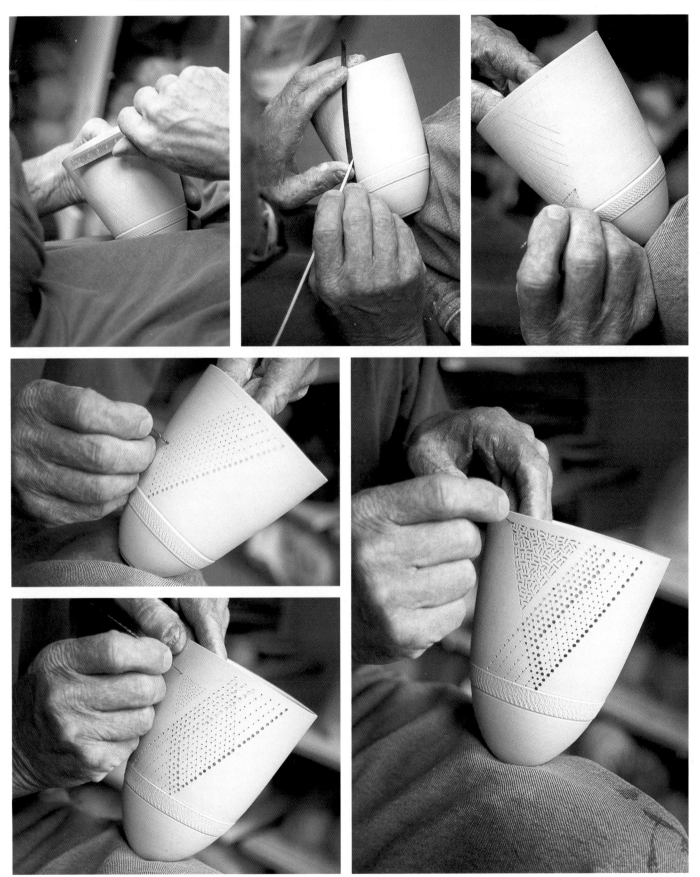

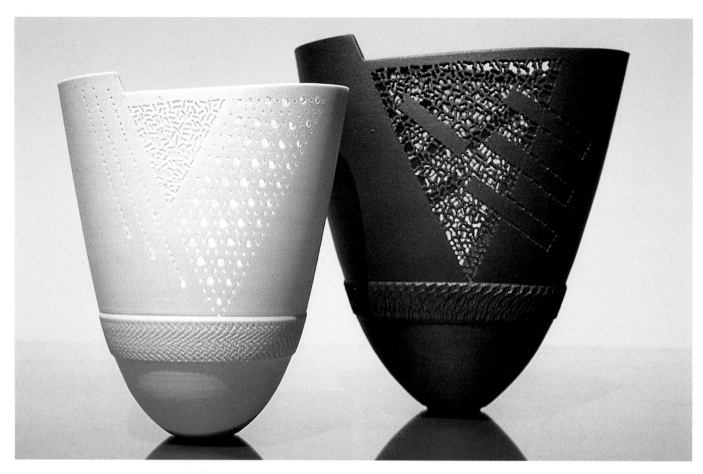

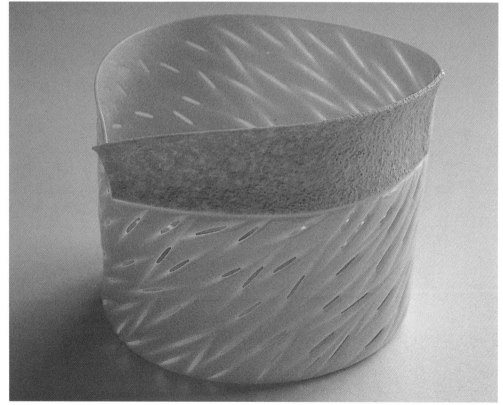

ABOVE: *Black and white pierced porcelain vessels by Horst Göbbels.*

LEFT: *'Transform Bambus' by Gabriele Hain. (6.5cm h.) Cast and pierced Limoges porcelain. Fired to 1230°C. 2002.*

Austrian maker **Gabriele Hain** has developed a piercing technique in which, after casting a thin layer of porcelain, she initially works on the bone-dry piece, finishing it off after a soft firing.

She outlines the area where a coloured decorating slip is to be applied using a sgraffito needle – these lines will become translucent after firing. Using a three-edged file, she gradually works through the wall until reaching the other side.

The pieces are then soft-fired to 550°C, after which they are strong enough to handle. The piercing is refined using a series of finer files and sandpaper. The coloured slip is then applied with a sponge, and the piece is fired to 980°C. A translucent glaze is sprayed onto the piece and, where it covers the coloured area, it is removed to leave a matt surface. The piece is finally fired to 1230°C in an electric kiln.

It should be noted that, during firing, the coloured, unglazed part has a different surface tension and therefore the shape is transformed from a circle to a triangle. If there were two opposite fields, for example, it would turn into a more square-like shape.

Since tension during shrinkage is very high, the pieces easily split along the vertical lines. Depending on how this happens, it can either spoil or enhance the piece by adding movement.

Penny Fowler (UK) slip casts her bone china forms for between one and five minutes, depending on the size of the piece. After removing the cast from the mould, she draws her pattern on the leather-hard to dry surface with a 6B pencil, then uses a variety of well-sharpened metal sculpture tools and surgical blades to carve into the piece. After a biscuit firing to 1000°C, the pieces are stronger so can be carved more, if necessary, and sanded with various grades of wet and dry paper. The piece is fired to 1220°C, with a one-hour soak, then it is finally polished to achieve a smooth, pebble-like quality.

Sandra Black (Australia) works with either porcelain or bone china using a number of different making and decorating techniques. Here she describes her pierced slip cast work using American Doll casting porcelains: Lady White and Ebony, made by Seelys (available from hobby ceramic suppliers). From an article she wrote in *Ceramics Technical* (no.6, 1998), she says:

> Care must be taken if the cast piece is damp because sections of the wall have a tendency to collapse, exacerbated by the vibration of the drill. Alternatively, if the clay is too dry, it will crack and pit. I use a Dremel drill and have a collection of fine drill bits. Cleaning up takes place at the dry stage when the surface is sanded smooth. This is best done with fine steel wool. Use a compressor to blow the dust out of the holes. Use a dust mask for this process. Further polishing is necessary after a bisque firing and the piece is then soaked in water to eliminate dust and then polished with wet and dry paper grades 300 and 600.

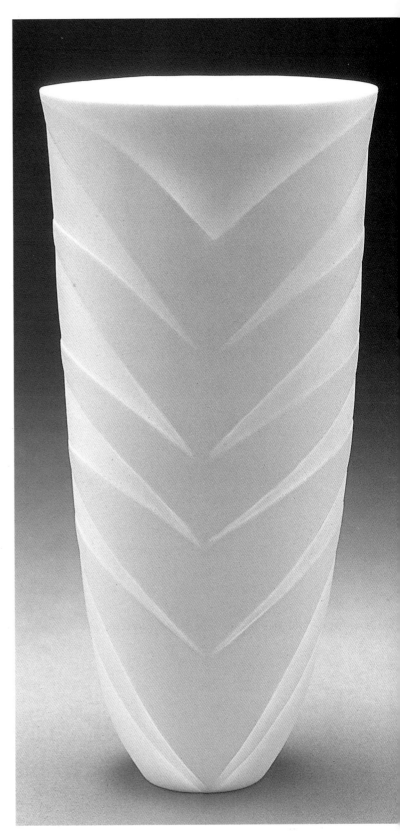

Bone china form with leaves by Penny Fowler. (15cm h.)
Slip cast and hand carved. Fired to 1220°C. 2001.
(Photo: Stephen Brayne)

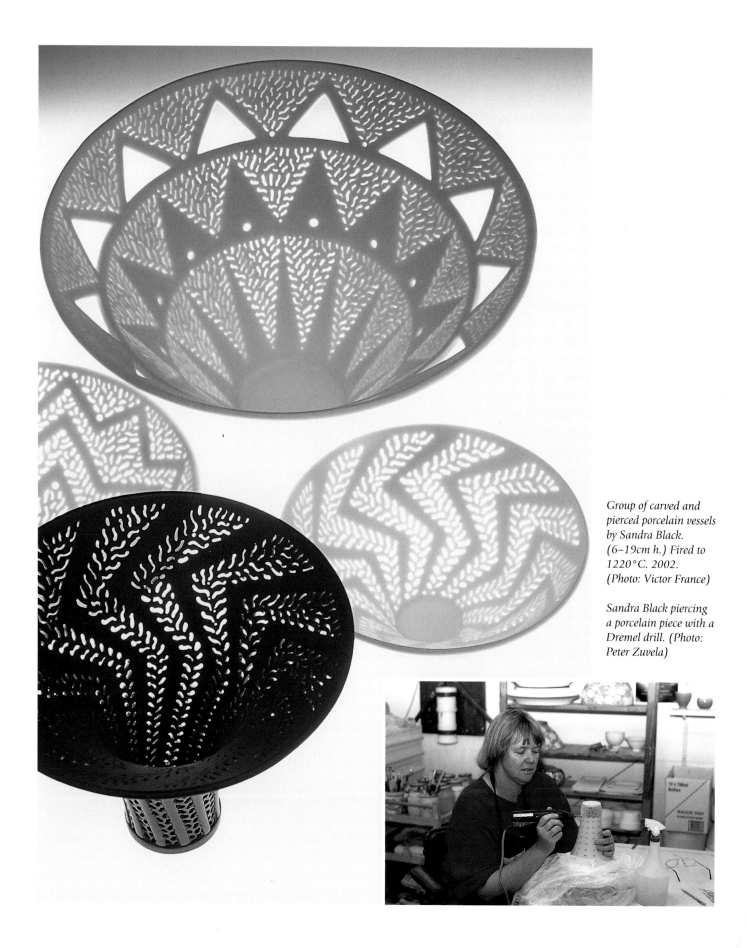

Group of carved and pierced porcelain vessels by Sandra Black. (6–19cm h.) Fired to 1220°C. 2002. (Photo: Victor France)

Sandra Black piercing a porcelain piece with a Dremel drill. (Photo: Peter Zuvela)

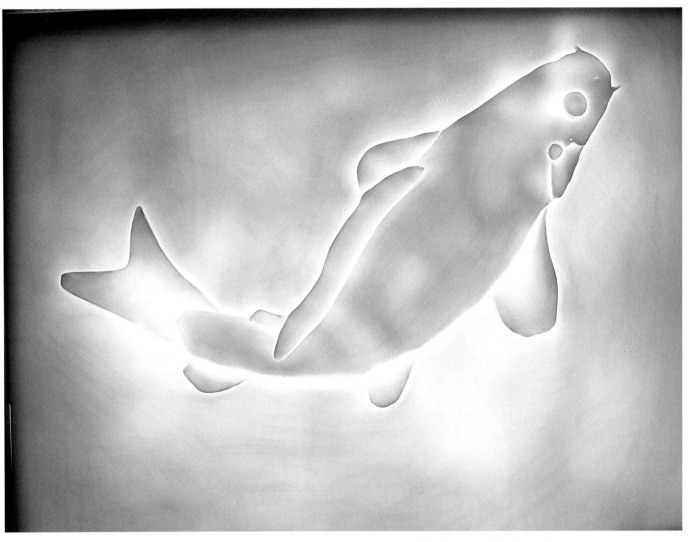

Detail of bone china panel by Angela Verdon. (23 × 30cm each.) Slip cast and hand carved.
Part of the bone china window at Royal Crown Derby. 2001. (See Chapter 7).

The pieces are then fired to the appropriate temperature and finally repolished.

Water Erosion

This technique is also known by other titles, such as Shellac resist, deep-etching, wash-back and so on; however, I feel 'water erosion' describes the process fairly accurately.

A number of makers working with this method, including **Les Blakebrough** (*see* Chapter 7) and **Peter Lane** (UK) use different resist media, the most commonly used being either Shellac or Liquitex (a medium for acrylic paints) on greenware. Other masking media, such as Copydex, latex or wax, can be used on biscuit ware in conjunction with resisting colours or glaze and so on.

In my experience, I have found the following method to be the most successful. After casting a single layer of slip, thicker than usual, the piece is allowed to dry out completely. A pattern is then painted onto the raw cast using Liquitex mixed with a vegetable dye. A damp dottle sponge is passed all over the piece about four to five times, as evenly as possible, to ensure there is no irregular warping. Care must be taken to allow the piece to dry out between 'spongings', so as to minimize it being weakened by continual dampening.

German makers **Astrid Gehartz** and **Stefanie Hering** both use Shellac as the favoured resist medium on their porcelain pieces. Gehartz (*see* the Chapter opening illustration) uses a combination of water erosion and metal salts as decoration. Her process begins with painting Shellac on the dry and unfired exterior and interior of the vessel. The surface is then washed with a sponge and water several times. This can be repeated in other areas, building up a many layered relief.

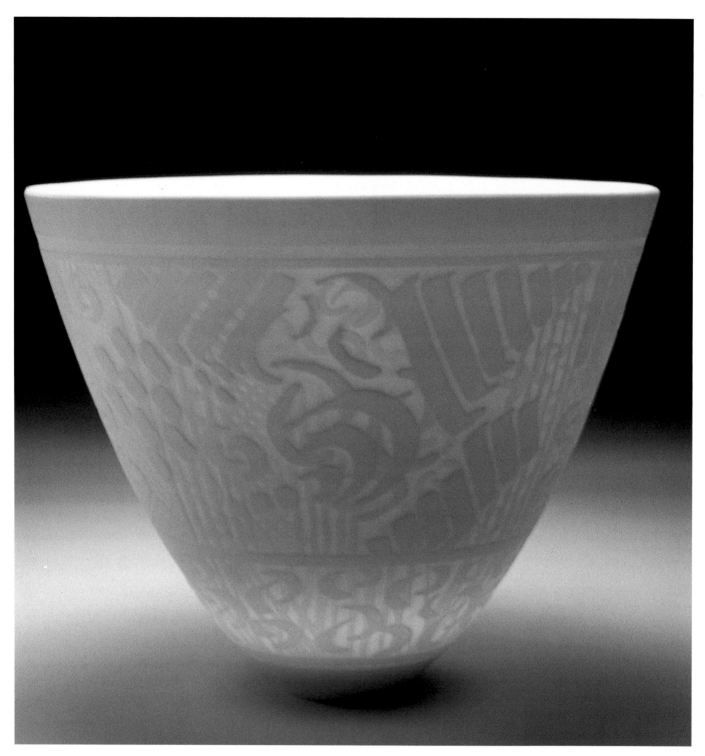

'Arabic Garden' by Peter Lane. (16cm h.)
Thrown with water erosion decoration using Southern Ice porcelain.
Fired to 1280°C.

Painting vegetable-dyed Liquitex on to the dry surface.
(Photo: Peter Scott)

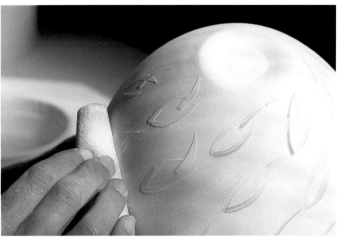

Eroding the surface using a damp dottle sponge.
(Photo: Peter Scott)

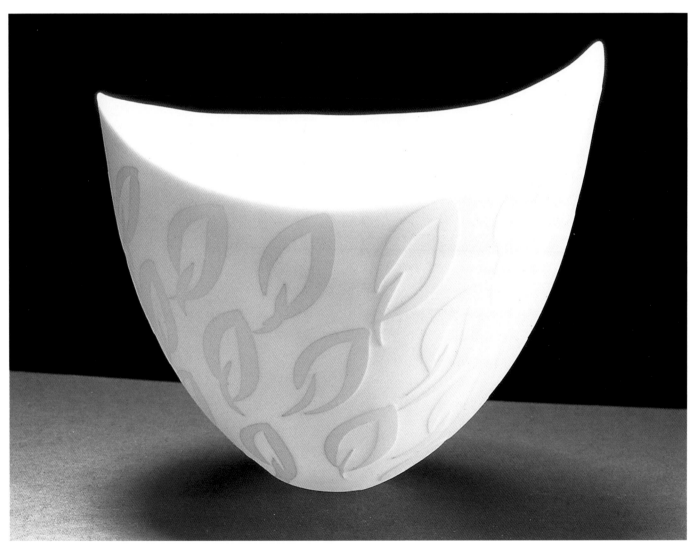

Bone china bowl by Sasha Wardell. (16cm h.)
Slip cast, with water erosion decoration. 2002. (Photo: Mark Lawrence)

ASTRID GEHARTZ: WATER EROSION AND METAL SALT DECORATION.

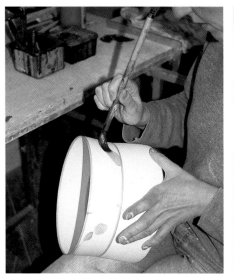

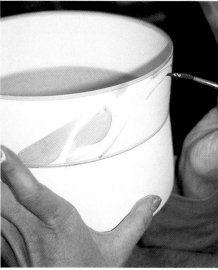

Shellac is painted on to dry, unfired ware.

Sponging the surface.

Metal salt solution is applied over the pattern.

After bisque firing, the Shellac has burnt out and the rest of the piece is painted with metal salts.

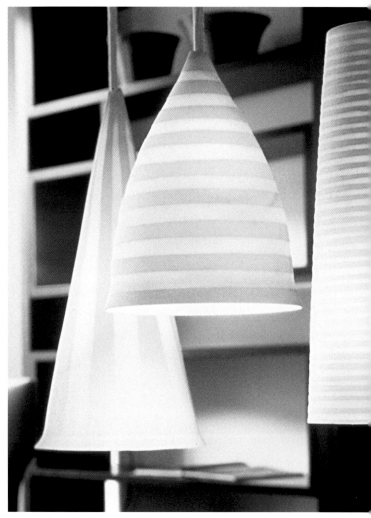

Porcelain lamps by Stefanie Hering. Slip cast porcelain with water erosion decoration. Fired to 1300°C.

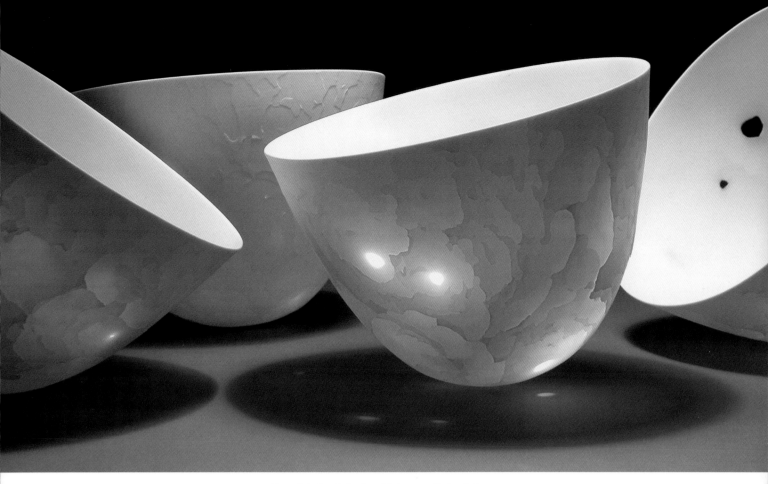

Porcelain bowls by Arnold Annen. (16cm h.)
Slip cast with blowtorch decoration. 2000.

Before biscuit firing, some pieces have a basic colour added and Shellac is used again as a resist, which leaves some areas white. The colours are metal salts dissolved in water. The salts used are chlorates of cobalt, iron, copper, gold and nickel. *Gehartz advises that it is necessary for any user to be well-informed about these chemicals as some are toxic and/or corrosive.*

After biscuit firing, the Shellac disappears, whereupon more translucent colours are added – their strength becoming apparent after the glaze firing. This is done in a gas-fired reduction firing to 1280°C.

Swiss maker **Arnold Annen** has developed a highly individual way of decorating the surface of his porcelain vessels. Given the dramatic treatment his pieces are subjected to in the decorating stage, he designs the top of his bowls with an enclosed ledge or return, so that the rim is not left free. This gives them the necessary additional support and strength. After casting into a revolving mould, he empties the slip out, then adds water back into the mould. Quickly siphoning it out, he is left with a very smooth interior without any drips.

Once removed from the mould, the casts are put into a kiln to dry – after which he blasts them with a blowtorch! This has the extraordinary effect of flaking off thin layers of the cast, then, at times, piercing through deliberately to form a hole. After a soft firing, the top part of the bowl is sliced off using a hacksaw blade, whilst the bowl revolves on a wheel. The pieces are then placed upside down on a setter (*see* Chapter 6) and fired to 1280°C, after which they are finally polished with diamond paper.

On Biscuit Ware

After a soft biscuit firing, the ware is strong enough for a number of decorating methods with firing temperatures ranging between 950–1050°C, depending on the particular porcelain or bone china used.

Some makers prefer to pierce or carve at this stage, as in the case of the earlier work of Angela Verdon. She found that bone china has a tendency to be weaker than porcelain at the green stage, and so her intricately pierced bone china bowls of the early 1990s were all soft biscuit-fired before any piercing took place. After changing to work with Limoges porcelain, she found it offered greater strength at the green stage, thereby allowing for larger-scale carved pieces.

LEFT: *Detail of masked and sand-blasted piece by Martha Zettler.*

BELOW: *Bone china form by Martha Zettler. (13cm h.) Slip cast and sand-blasted. Fired to 1240°C. 2002. (Photo: Chad Morillion)*

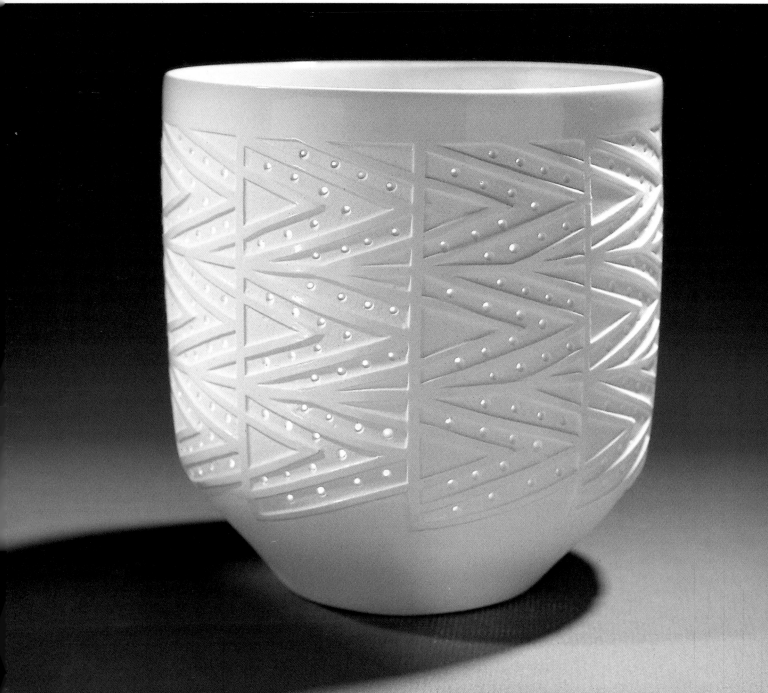

Sand Blasting

This technique can be used on the soft bisque-fired surface to give texture and to reduce the wall thickness, as well as on glazed ware, on which it has a matting effect.

German-born **Martha Zettler**, who lives and works in South Africa, has used this method for a number of years on her bone china (which she imports from England).

She slip casts then soft bisque fires to 1000°C, after which the ware is strong enough to withstand sand-blasting. After sanding the piece, she draws on the surface with a pencil, then, depending on the design, painstakingly cuts out thin strips of masking tape which are applied to the biscuit ware. The piece is then sand-blasted. After removing the tapes, holes are drilled with a Dremel drill.

Each piece is placed in a high-fired stoneware pot or saggar and packed with calcined alumina to avoid distortion during the firing to 1240°C. The inside, rim and areas of relief are then painted with a transparent glaze and fired again to 1100°C.

Thrown porcelain bowl by Horst Göbbels.
Metal salt decoration with sand-blasted glaze.

Horst Göbbels uses sand-blasting to pattern the glaze, giving a subtle, ethereal effect to the surface.

Metal Salts

This method of decoration involves using metal nitrates and chlorides as colouring agents. However, these materials are toxic in their raw state, therefore extreme care and specialist equipment are necessary in their application. One of the main exponents of this method is Norwegian maker Arne Åse, who has written extensively on this matter in his book *Water Colours on Porcelain*, and it is advisable to refer to this publication for comprehensive use and safety details.

There are, however, other makers working in this area. One in particular is **Les Blakebrough** (Australia), who became interested in this technique in the mid-1990s after meeting Arne Åse. Writing in *Ceramics Technical* (no. 1, 1995), he describes the effects achieved with metallic salts during a research project with Ben Richardson at the Ceramic Research Unit in Hobart, Tasmania:

> The area of chloride/nitrate reaction chosen for our investigation was the development of the halo effect, which is caused by a reaction of the metal solutions when they are

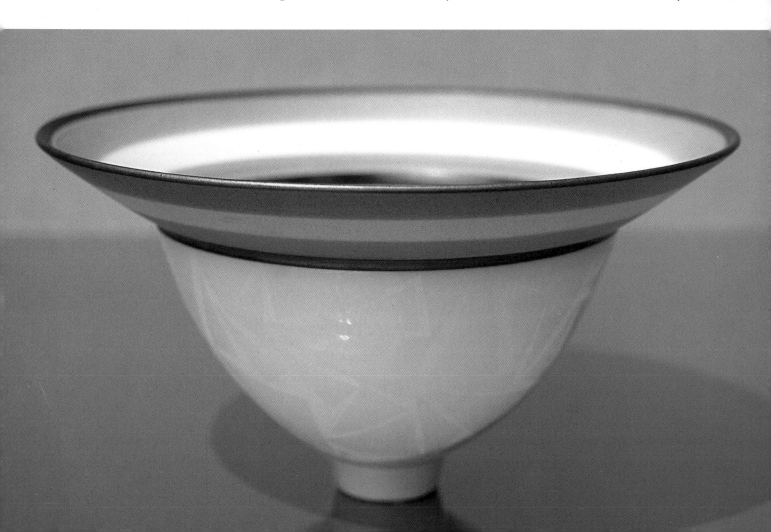

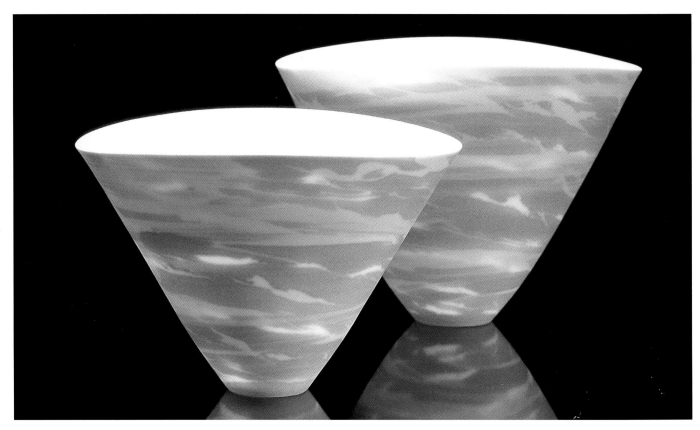

'Sea Bowls' by Angela Mellor. (10cm h.) Slip cast bone china with metal salt solutions painted over acrylic and latex resists. Fired to 1250°C. 2002. (Photo: Victor France)

applied to the surface of the clay object over a resist material, or when another solution is introduced, causing the under-lying coating of salts to migrate and accumulate in a heavier concentration.

Summing up the results from his research, Blakebrough highlights the following points:

From this initial series of testing there were indications drawn:

It was difficult to achieve results on raw ware because the salts would migrate easily. Another difficulty was that phosphoric acid causes some dramatic effects by pulling the ware apart in the firing process.

All subsequent tests were carried out on bisque ware.

That areas of normal resist with wax, or Shellac, provided a concentration of salts adjacent to the resist to give a soft halo effect.

That many of the metal salts require a stronger solution to give a more pronounced colour, or a heavier application of the solution. The application of the salts becomes much less an exact science and more intuitive in controlling the thickness of the solutions.

That a combination of solution over solution produces results that vary greatly from the single application. The most significant results came from the use of phosphoric acid. This acid has the ability to cause a migration of salts to the edges of its application, causing a concentration of metal, hence a pronounced halo effect.

Examples of metal salt decoration in this publication can be seen on the work of Astrid Gehartz (*see* the Chapter opening illustration), Horst Göbbels and Angela Mellor.

Underglaze Decoration

The application of underglaze colours (as an oxide or in a commercially-produced form) to biscuit ware can range from simple painting or spraying to more complex methods, prior to applying a glaze.

Jeannie Mah (Canada) uses underglaze monoprints on some of her pieces. She has developed a method of printing commercial underglaze colours onto paper, then pressing them onto the soft bisque-fired ware. The paper burns away

'Hypothèse No. 5' by Jeannie Mah. (64cm h. × 64cm w. × 20cm d.)
Wood, gesso, paint, underglazes and porcelain. Fired to 1260°C. 1997.

as the colours impregnate the surface. By over-firing the colours to 1260°C, instead of the recommended 1005°C, the colours become a more muted, integral part of the piece.

Deriving inspiration from the Cretian Kamares ware of the fourteenth century BC and eighteenth-century French Sèvres porcelain, the resulting piece is a culmination of the two cultures from a wry perspective. Made as part of an exhibition 'Ouvrez les guillemets…' in 1997, in Regina, Canada, she considers this piece to be a comment on the French porcelain industry of the eighteenth and nineteenth centuries, with painted facsimiles of historical documents as the background and an oversized 'cup' in the foreground.

Russell Coates (UK) adheres as closely as possible to the traditional 'underglaze blue technique' made famous by the Japanese with their Kutani ware. Having studied the tradi-

tional art of mixing his own 'underglaze blue' and enamels in Japan in the early 1980s, he applies these same techniques when decorating his thrown porcelain plates.

After throwing with a 50/50 mix of Potclays and Valentine's porcelain, the piece is biscuit-fired. The edges of the plate are dipped into a stoneware glaze and biscuit-fired again to harden-on the glaze.

For geometric patterns, the outline of the design is traced with a biro onto Japanese tissue paper, with the underside of the paper being painted with fine-ground charcoal mixed with water. The paper is pressed onto the biscuit ware so that a light outline of the image is transferred onto the plate. Birds, animals and fish are drawn freehand in pencil. The biscuit plate is dampened beforehand to reduce porosity, thus preventing the brushstrokes dragging.

Underglaze blue and enamelled dish by Russell Coates. (43cm w.)

*'Time and Space' by Takahiro Kondo. (17cm h. × 21cm w. × 14cm d.)
Amakusa porcelain. Fired to 1270°C. 1999.*

The silhouettes are then overpainted using Coates' own mixture of fine-ground underglaze blue combined with a green-tea painting medium. The following recipe reduces the 'bleeding' that would occur if *pure* cobalt oxide was used:

- 50% calcined china clay
- 20% cobalt oxide
- 20% manganese oxide
- 6% iron oxide
- 5% nickel oxide
- 5% copper oxide.

This mixture is calcined in a biscuit porcelain dish to 1100°C for two hours, after which it is ground to a fine powder. If fired in a reduction atmosphere it turns blue; however, it will turn black in an oxidized firing.

The plate is then glazed with a clear lime-balanced alkaline glaze, which is generally known as a 'white glaze' in Japan, and is then reduction-fired to 1270°C. After this, the enamels are applied (*see* enamels in 'Onglaze Decorations').

The slab-built forms of **Takahiro Kondo** (Japan) are decorated with the underglaze blue technique, using cobalt as the colouring oxide.

Spraying and Masking

A technique most commonly associated with graphic artists, but which translates successfully in ceramic terms, is that of airbrushing. Given that the body has already received a soft biscuit firing, there will be a certain degree of strength and solidity that allows for the placing of adhesive tape masks, as well as direct cutting onto the piece, if necessary.

An airbrush is normally used for specific, directional spraying, whereas small glaze guns or 'colour cups' are used for more general spraying over a larger surface area.

Generally, it is underglaze colours and glaze stains that are sprayed in conjunction with a glaze. However, in some instances, body stains can be used in the same manner, even though, technically, they are designed to colour the clay

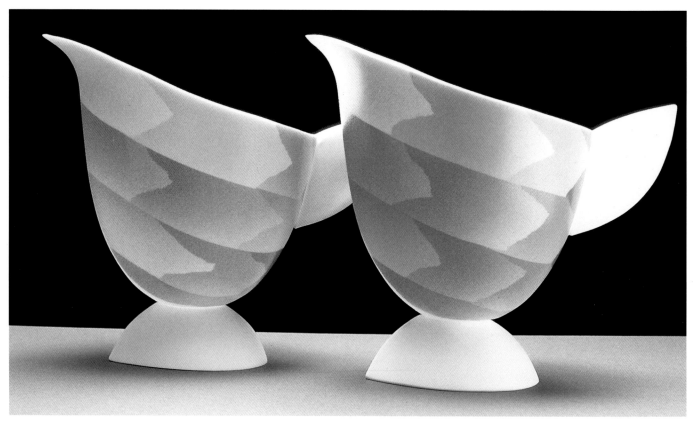

Pair of wing jugs by Sasha Wardell. (11 cm h.)
Slip cast and airbrushed bone china. Fired to 1260°C. 1998. (Photo: Sebastian Mylius)

body. If a piece is to be glazed, some people prefer to spray the underglaze colour first, using an underglaze medium to fix the colour, then spray a glaze over the top, whilst others mix a transparent glaze with the colour and spray them together. In this instance, it is imperative that the glaze is prepared in the same way as the underglaze colours.

If using an underglaze medium, this should be mixed with the colour and sieved through a 200s mesh to ensure an even mix and dispersal of any lumps. In my experience, as I do not use a medium, I have found it best to dissolve the colours in a little boiling water first and then sieve through a 200s mesh, finally adding them to the glaze. The entire solution is then sieved again.

As airbrushes have very fine nozzles, there is always the chance that they will block (particularly when combining with a glaze) so, in some instances, the dry colour and glaze can be ground together beforehand, then made into a solution and sieved.

Amongst the makers who have used this method of decoration over several years is **Peter Lane** (UK). He describes in comprehensive detail his method and how to use an airbrush in his book *Contemporary Porcelain*. All his pieces are thrown on an electric wheel using Walker's Superior White

porcelain. After a soft firing to 1000°C, he applies colours from the Reward Velvet underglaze range. These are prepared stains supplied ready for use in a suitable medium. He says: 'They can be blended together to make many different hues, but for airbrushing they must be thinned with water and carefully sieved (200s mesh) to ensure even consistency.'

He uses a trigger action, Holbein (Toricon-Y series) gravity feed airbrush and ensures it is thoroughly flushed through with water after each colour change.

Using masking tape, placed and removed in a particular order on the pot, he gradually builds up his decoration, spraying the lightest colour first and ending with the darkest. As deposits of wet colour can build up on the tapes before they are removed, causing 'runs', he uses a hot-air gun to dry the colour in-between applications.

Once finished, the piece is fired between 1260°C–1280°C in a top-loader electric kiln (Lane having discovered that the colours appear generally fresher when fired with electricity). After firing, the piece is polished (wet) using silicon carbide paper (1000s mesh) to achieve a satin matt finish.

John A. Murphy (USA) sprays a dry, black glaze onto his biscuit-fired, slip cast porcelain pieces. The glaze was originally a slip formula for low-firing; however, after

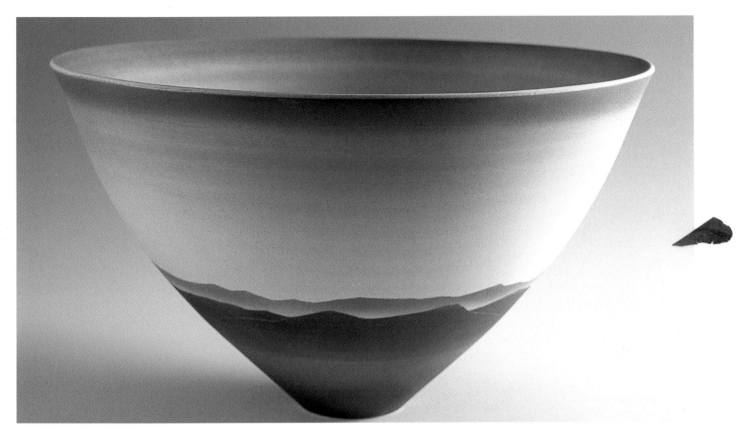

ABOVE: *'Mountain Sky; Evening' by Peter Lane. (28cm diam.)*
Thrown and airbrushed bowl using Walker's Superior
White porcelain. Fired to 1270°C.

RIGHT: *John Murphy spraying a black glaze*
on to the masked inside surface.

experimenting with different temperatures, Murphy was pleased with the matt results obtained at 1200°C. (Fired any higher, to 1300°C for example, it becomes semi-gloss.)

Used as an all-purpose glaze, its recipe is as follows:

- 25% china clay
- 25% ball clay
- 15% ferro frit 3195
- 20% flint
- 5% talc
- 5% Superpax (tradename for zirconium silicate).

Additions of between 10–30% black Mason Color stain will result in a rich dark colour.

Interested in the subtle effects that are achieved by decorating with dark colours onto translucent porcelain, Murphy decorates either the inside or outside of a piece to obtain a 'bleeding' effect through the thin wall.

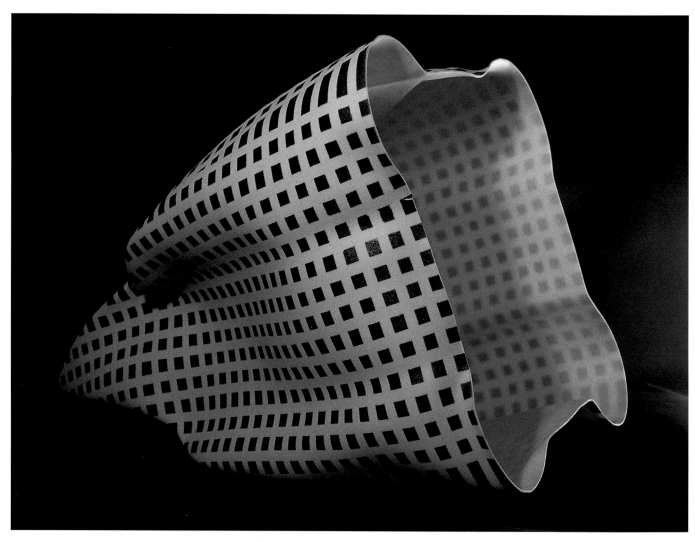

'Farewell Columbia 2003' by John Murphy. (38cm h.)
Slip cast porcelain, masking tape stencilling. Fired to 1200°C.

Engobes can also be sprayed on. These are very similar to decorating slips yet contain very little plastic clay, being largely composed of materials normally associated with glazes such as feldspars, flint, opacifiers and fluxes. They offer a white base for colouring oxides and have the added advantage of being suitable for use with biscuit ware. For further information and recipes refer to Daniel Rhodes, *Clay and Glazes for the Potter.*

One maker who uses engobe decoration for his work is **Velimir Vukicević** (Serbia and Montenegro). Working with Limoges porcelain, he creates his pieces either by slab-building or throwing and rolling them (using a slab roller). After construction, he applies the engobes, having devised a method whereby application is at several stages, ranging from the raw to biscuit state, with intermediary firings. The engobes are a mixture of commercial stains, powdered porcelain body and 10% transparent glaze.

Once dry, the work is sanded and any area not requiring colour is masked out with latex. Small areas of engobe can be applied on the raw clay without cracking. However, a larger area would need to be biscuit-fired to 800°C before spraying another colour. Once sprayed, the piece is fired again, to 1000°C this time.

Following this second firing, the engobes are protected whilst he sprays a matt grey glaze to the edges and fires again to 1250°C. Shadows are added using a grey onglaze colour and fired very slowly, for the final time, to 760°C.

The column of the piece is coloured porcelain, mixed with grog and sawdust, to give a texture. After a first firing, blue engobe is applied to the crevices and high-fired. The pieces are finally assembled after firing using Araldite and a supporting metal rod through the column.

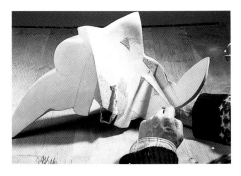

Removing latex resist after grey engobe has been sprayed on to raw clay.

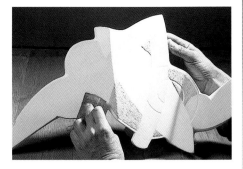

Sanding engobe after 800°C firing.

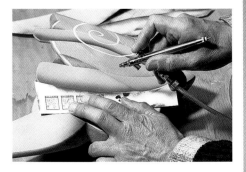

Spraying matt grey glaze on to edges with an airbrush before 1250°C firing.

RIGHT: *'The sign' by Velimir Vukicević. (65cm h.) Slab-built Limoges porcelain with airbrushed engobe decoration. 2003. (Photo: Vlada Popović)*

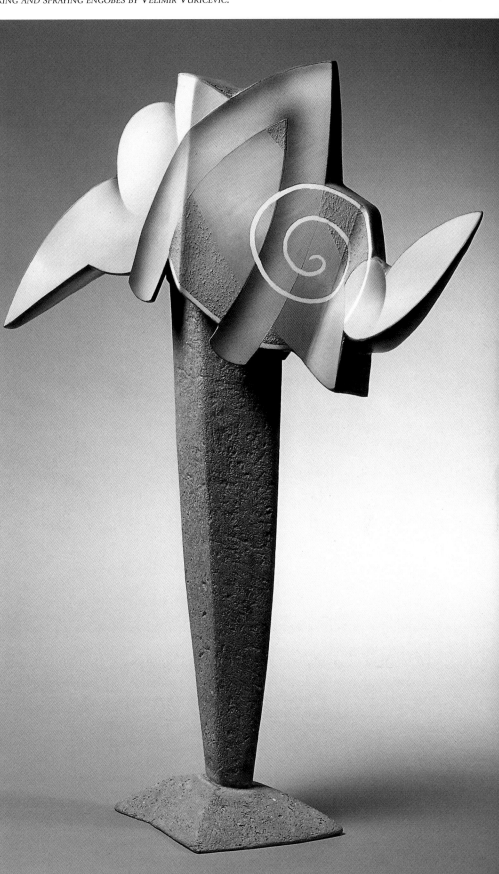

Onglaze Decoration

Decoration at this stage normally involves applying metal oxide pigments to pre-fired ceramic ware, generally on top of a glaze, then low-firing it, in some cases for a third time. True onglaze or enamel pigments adhere to the glaze rather than penetrate it. There are, however, always exceptions to the rule, for example when makers have experimented with higher temperatures to give a more 'fused' effect, as in the case of **Bodil Manz**. However, testing is advisable, as some colours will burn out if fired too high.

Lustres can also be applied. These are deposits of thin metallic coatings of precious metals such as gold, silver and platinum, which, when painted or sprayed onto a glaze, leave an iridescent effect. Firing is generally to 800°C. For further information on lustres refer to *The Potter's Dictionary of Materials and Techniques* by F. & J. Hamer.

Enamels have the advantage that they are very bright and clean, offering a wide range of colours. Strong reds, which are not normally possible at higher temperatures, can be obtained. The disadvantage for functional ware is that because the enamels 'sit' on the surface of a glaze, they can easily be damaged by scourers and dishwashers.

Enamels can be applied by painting, spraying or printing, using silk screen or lithographic techniques, with some makers preferring to mix up their own enamels to traditional recipes, as in the case of Russell Coates. It is possible to buy ready made ones that are used in conjunction with a prepared medium (most commercial colours are intermixable, except for certain reds).

Enamels should be fired very slowly up to 500°C with plenty of ventilation to allow any organic materials present to burn off before the fluxing process starts. The final temperature will vary depending on the colour (follow suppliers' recommendations), although the temperature tends to range between 700–900°C. Depending on the different colours used, several firings may be necessary, as the higher temperature colours are applied first, with lower temperature colours, such as reds and golds, being applied latterly. Equally, there is a difference in the firing temperature depending on whether the enamels are applied to porcelain or bone china. In the latter case, the firings tend to be approximately 20°C lower.

Cleanliness is of the utmost importance when working with enamels, as dust and dirt on the surface of the ware will cause the enamel to flake off during firing. **Russell Coates** prepares his ware by wiping a gelatine-soaked cloth over the glazed plate. This removes any grease caused by fingermarks and leaves a slightly 'gluey' surface to which the enamels can adhere. He uses either the Japanese paper-transfer technique, or outlines his already drafted design using a solution of manganese dioxide mixed with the liquid strained from a green-tea infusion. This is allowed to dry for a day, after which the enamels are applied. He uses five carefully prepared and ground colours – red, yellow, blue, green and purple,

using a tri-axial blending method (*see* Robert Fournier's *Illustrated Dictionary of Practical Pottery* for further details).

The red used is a deep Kutani red, which can contain anything from 5–40% of red iron oxide. It results in a dense, opaque colour when applied thickly, or pink when painted as a thin wash. It is mixed with a green-tea painting medium. The yellow, blue, green and purple are semi-transparent colours that are used in conjunction with a Japanese seaweed medium. This medium allows for a thicker deposit of colour, more like a painting 'syrup', which means that painting can be carried out on a vertical surface and still remain in place. After painting, the plates are fired to 840°C on their edges. This causes a gravity pull that enhances the thicker areas of colour, thus resembling shadows.

Another maker who uses this intricate method of decoration is **Peter Faust** (Switzerland). Having originally trained as a painter in and around Zurich, he now solely concentrates on classical porcelain painting, deriving his inspiration from nature.

Working generally on porcelain, but occasionally on bone china, Faust's pieces are painted with enamels, lustres and thicker deposits of precious metals. When using combinations such as these, it is important to work out their application in descending order of firing, beginning with the materials that have the highest firing temperatures.

Starting from a tracing of his drawing, Faust uses graphite paper or wax paper to transfer the image onto the ware. He prefers to apply the lustres first, as it is more difficult to ascertain the result due to them being brown before firing, whereas it is easier to alter the strength of the enamels. Therefore all of the areas that are not to receive any lustre are masked off with a red water-based resist. When this has dried, the lustre is applied using the 'flow' technique. This involves adding a few drops of two or three different lustres, mixed with a lot of thinners or turpentine, onto the ware and allowing the different lustres to run into and mix with each other. The entire piece is then dried using a hair dryer and fired to 800°C.

The other techniques used, such as raised paste, enamel painting (applied by brush, pen, sponge or airbrush), gilding with bright and/or burnishing gold, platinum or silver, marbling and shading are subsequently applied, each one requiring a firing to 800°C in-between applications, with the exception of the gold and silver, which are fired to 770°C.

Bodil Manz (Denmark) uses transfers on her paper-thin cast porcelain cylinders. She says of her technique:

> It is important that my pieces are thin and translucent because the inside and the outside decoration interact with the light

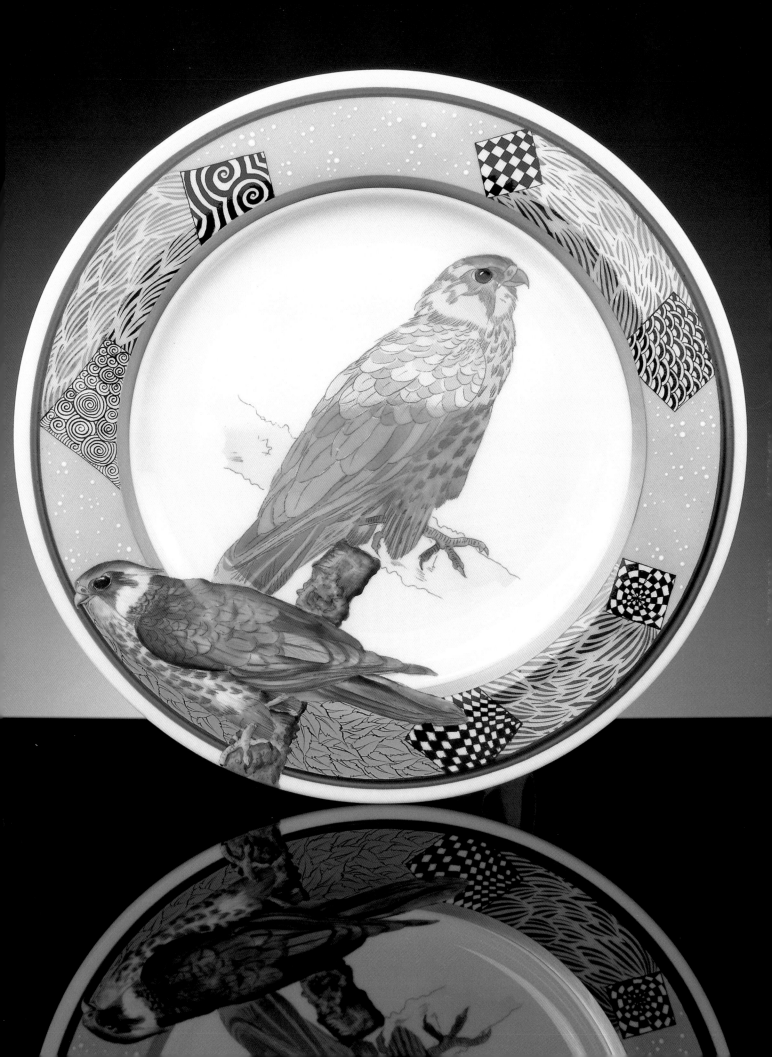

APPLYING LUSTRE AND ENAMEL TO A PORCELAIN TILE BY PETER FAUST.

Graphite-traced image on tile.

Red water-based resist applied.

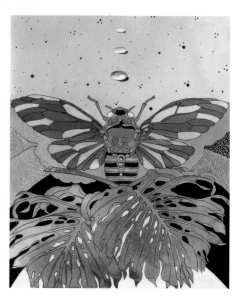

Gold, enamel and lustre applied.

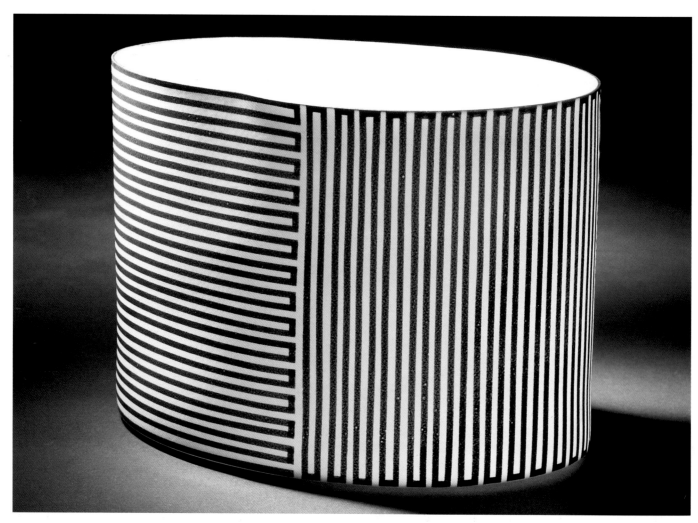

Oval form with black stripes by Bodil Manz. (22cm h.)
Slip cast porcelain with black transfer decoration. (Photo: Ole Akhøj)

so it becomes one composition. The decorative elements are drawn on paper, which are then made into transfers. All the colours, except the red, are fired with the 'down-burning' technique [high-fired in a gas kiln to 1300°C, reduction atmosphere], which means the colour goes right down the glaze through to the clay body. The pieces to which the 'Japan Red' colour is added have an extra firing to 760°C in an electric kiln. I often high-fire my pieces up to three or four times, because they become more transparent, but it is more dangerous for possibility of collapsing.

Norwegian maker **Anna Stina Naess** uses onglaze enamels in an energetic manner by splashing them onto her hand-built porcelain cylinders, without the paintbrush actually touching the piece.

Claire Curneen (*see* Chapter 3) uses blue-flowered transfers on her shiny, clear-glazed figures. Described in *The Figure in Fired Clay* by Betty Blandino: 'It is as if the flowers were growing all over the body or emerging, flowing from it, spilling over the base on which the torso rests – flowers beautiful but short-lived, a symbol of life and death.'

South African-born **Daniel Kruger**, who now lives and works in Germany, originally trained as a goldsmith. Although jewellery remains his main occupation, in 1984 he became interested in ceramics and, since then, has worked in both disciplines, using porcelain as the ceramic medium. Inspired by the early Meissen versions of Chinese prototypes, he describes the imagery on his work as '… representing people and situations in a way with which we are familiar today. The topics are, however, the same as in former times. They are graceful, poetic, stimulating, titillating, amusing or sentimental.' In the majority of cases, these are newspaper photographs translated into transfers, with onglaze enamel additions placed on classical forms.

Alma Boyes (UK) applies lithographic transfers of newsprint using onglaze enamel to her bone china pieces.

Lithographic transfers differ from silk-screen ones, not only by their method of production, but also by the colour deposit. With lithographic transfer printing, pastel or subtle shades of colour with a transparent quality can be obtained, whereas silk-screen transfers tend to be denser or bolder, with an opaque-like quality.

Lithography, in ceramics, tends to be used in industry or in large print workshops as the machinery is very expensive. In simple terms, a transfer is made by drawing or painting with a greasy medium or varnish onto a specially prepared plate. The transfer or decal paper is passed through the litho press, whereupon it picks up the greasy medium. The paper is then dusted with powdered onglaze enamel pigment adhering only to the greasy areas. Once dried, the image can be overprinted, if necessary.

Covercoat, which is a type of clear varnish of plastic substance, is printed over the entire image, acting as the 'transfer'. When placed in warm water, the backing transfer paper peels

Porcelain cylinders with Anna Stina Naess. (40cm h.) Hand-built porcelain. Fired to 1260°C with splashed enamel decoration fired to 800°C. 2001. (Photo: Jeff Henry)

away, leaving the printed image on a thin sheet of plastic film. This is applied to the ware and carefully smoothed down with a rubber kidney to expel any air. During the firing process the Covercoat burns away, leaving the image on the ware.

The basic principle of silk-screen printing in ceramics involves making 'stencil-like' screens using photo-sensitive emulsions to make the image. Ceramic colour is mixed with a printing medium, then printed through a screen onto a special gummed paper. Covercoat is applied over this in the same way as with litho printing and fired in accordance to the particular colour's temperature range (between 700–850°C).

For further detailed information on printing, refer to *Ceramics and Print* by Paul Scott.

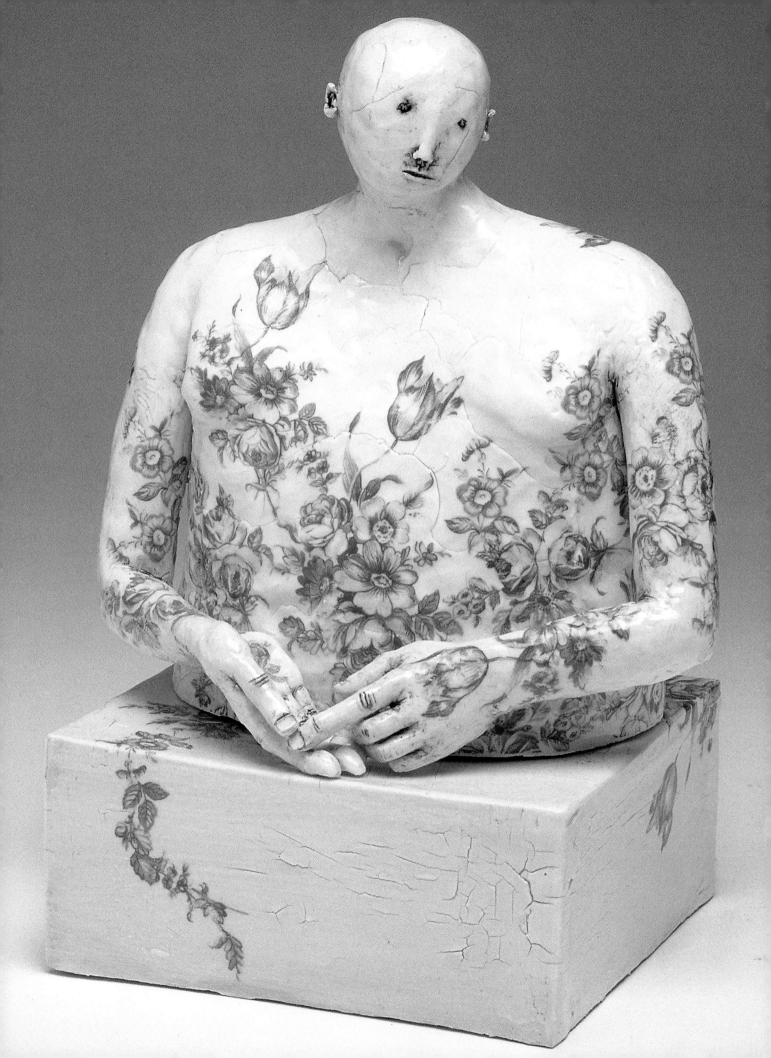

OPPOSITE PAGE:
'Blue Series' by Claire Curneen. (45cm h.) Hand-built porcelain with blue transfer decoration.

THIS PAGE (RIGHT):
'Wrestler couple with strawberries' by Daniel Kruger. (34cm diam.) Slip cast porcelain platter. Fired to 1260°C, with transfer and onglaze enamel decoration fired to 750°C. 1997. (Photo: Peer van der Knuis)

BELOW: *Bone china tea set by Alma Boyes. Slip cast coloured bone china with lithographic transfer decoration. Fired to 1240°C then 780°C.*

6

Glazes and
Firing Processes

Glazes

When porcelain and bone china are in their vitrified states, from a functional point of view glaze is not strictly necessary, apart from the issue of staining. However, porcelain cannot be denied the sumptuous qualities, for example, of a celadon or crystalline glaze, quite apart from the wide-ranging effects made possible using barium and vanadium glazes and so on that are illustrated in this chapter.

The similarity between the composition of a porcelain body (*see* Chapter 1) and that of its glaze means that there is an integration of the two surfaces rather than a layer of glaze which simply lies on the clay, as encountered in earthenware bodies. This fusion renders the ware particularly strong, as well as creating a real depth to transparent and semi-opaque glazes.

Bone china, on the other hand, has much less of a range. Traditionally, in industry this material has had a high biscuit firing to approximately 1250°C and a low glaze firing to approximately 1080°C. This was due to a combination of economic and technical reasons – with the majority of losses occurring at the high temperature, subsequent treatment would not be necessary. The technical constraints were such that, if the firing order were reversed – low biscuit and high glaze firings – there would be more chance of wastage and distortion. As the body moves to a great extent at the high bisque stage, becoming progressively more vitreous, this would be vastly exaggerated by the addition of glaze, therefore causing extra tensions and strains.

Due to the vitreous nature of this clay, pouring and dipping can be very difficult as there is no porosity in the body, hence no absorption to help the glaze adhere to the ware. To counteract this, 1–2% of gum arabic can be added to the glaze, and the ware can also be heated to 150°C to assist in the glaze 'pick

OPPOSITE PAGE:
'Sun, light and shadow' by Pippin Drysdale. (41cm h.)
Thrown porcelain vessel (Southern Ice) with incised and inlaid glaze
decoration. Fired to 1220°C. 2002. (Photo: Robert Frith)

THIS PAGE:
Pedestal jug by Sasha Wardell. (12cm h.)
Slip cast bone china with water erosion decoration. Fired to 1260°C.
Interior glazed and fired to 1020°C. 2001. (Photo: Steve Hook)

up'. Care is needed not to overheat the ware, as this would cause a thermal shock, resulting in cracking or splitting.

Earthenware temperature glazes within 1020–1080°C are suitable, provided the high biscuit-firing has been sufficient, otherwise misfitting and crazing will occur. Most makers who work with bone china omit the glaze as a covering (unless function or onglaze decoration is an issue), preferring to accentuate the vitreous surface qualities by sanding and polishing.

Porcelain Glazes

There is a great deal of published information on glazes. This provides excellent reference for those who are less interested in the theoretical side of glaze practice (*see* Bibliography). For a very basic understanding, however, it is useful to know a little about the materials and properties involved in the process. A glaze is composed of the following three elements: silica, the 'glass-former', which contributes to the bulk of a glaze; alumina, the main source being in the form of clay, which aids glaze suspension and increases unfired strength; and a flux, which lowers the melting point of both silica and alumina. Silica is found in quartz and flint, alumina is present in china clay, ball clay and bentonite, and there is a variety of fluxes, including whiting or lime, soda and potash feldspars.

For those who are interested in making up their own glazes, **Jack Doherty** suggests in his book *Porcelain* the following experiments with mixtures of the clay body you are using and a flux, then firing to 1250°C:

- ■ 60% porcelain clay
- ■ 40% feldspar

- ■ 60% porcelain clay
- ■ 40% petalite

- ■ 60% porcelain clay
- ■ 40% wollastonite

- ■ 60% porcelain clay
- ■ 40% nepheline syenite.

(For more detailed and specific recipes please refer to the Appendix.)

To illustrate the range of possibilities achievable when working with porcelain glazes, the following examples demonstrate a small but diverse selection of makers and their individual approaches.

Pippin Drysdale (Australia) has developed an innovative technique in which she applies several layers of bright barium glazes, then, after incising horizontal lines into these layers, inlays more glaze (*see* the Chapter opening illustration). Deriving inspiration from the Tanami desert in north-western Australia, she has recently produced a collection of work based on the remote landscape she witnessed following an aeroplane flight over this region.

Aptly naming this body of work 'Tanami Traces - Series I', she has managed to capture these natural effects through an intricate and complex process of spraying high-barium coloured glazes, three or four layers at a time. To her base glaze she adds 20–30% stain and, in some cases, small percentages of oxides. The barium-rich glaze accentuates the colours, producing bright colours with a resonant satin surface.

After the initial spraying, horizontal lines are incised into the glaze surface using sharp blades. Liquitex painting medium is also used as a resist to ensure more accuracy at this stage. Once incised, special dry brushes are used to brush out the grooves ready for the application and inlaying of a thick coloured glaze. This glaze has a paste-like consistency and is rubbed into the lines; however, it is a slow process, taking several days to complete one piece as only a small part of the surface can be worked at one time.

The inside of the vessel has an evenly coloured glaze. This is achieved by half-filling it with glaze then swirling it around until a perfectly graduated colour is obtained. Finally, in

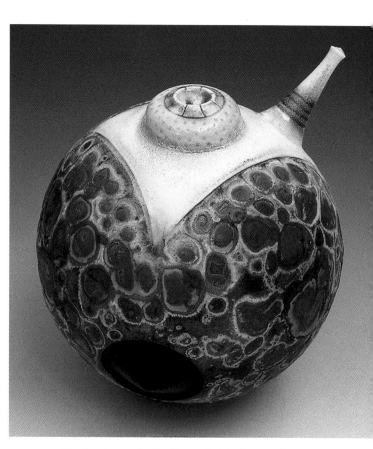

'Egg form' vessel by Geoffrey Swindell. (13cm h.) Thrown porcelain with oxide and glaze decoration. Fired to 1260°C. 2002.

GEOFFREY SWINDELL APPLYING VANADIUM OXIDE AND LUSTRE.

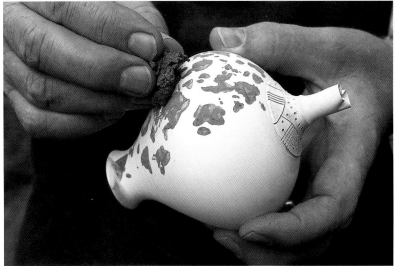

Applying vanadium oxide with sponge.

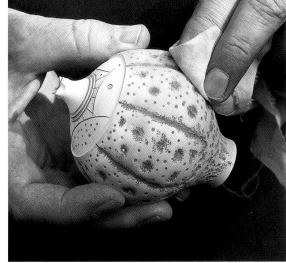

Rubbing vanadium oxide into surface.

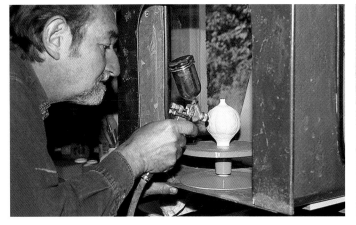

Spraying lustre.

Spraying glaze.

some cases, a transparent glaze is rubbed over the surface, then, in a single firing, the piece is fired to 1220°C. The firing temperature can be altered to between 1196–1240°C, depending on the percentage of frit used (20–30%).

The thrown porcelain vessels of **Geoffrey Swindell** (*see* Chapter 2) are a result of years of focusing on the exacting nature of making small-scale objects using a combination of oxides, glazes and lustres to achieve surface textures with marine-like qualities.

Describing his work, Swindell states:

Current visual sources of inspiration include illustrations of marine creatures and science-fiction hardware, fossils, tin plate toys and eroded objects. By extracting essential elements from these sources and reflecting them in my own imagery, I hope to create a vessel with an ambiguous, mysterious 'presence'. The structure is accurately engineered on a potter's wheel, then softened by coloured glazes to make the

finished object appear as a synthesis of mechanical and organic qualities.

After biscuit firing to 1000°C, he squirts glaze into the interior of the piece using a slip trailer, because the tops of the pieces are so small. However, although the interior cannot be seen, it is important to glaze the inside as well as the outside to avoid 'dunting' (cracking on cooling), which would occur if only the exterior of the piece was glazed.

Swindell applies a number of glazes, often laying one over another, or over various oxides. The textured pieces have vanadium oxide rubbed into the surface, followed by sprays of rutile, chrome or copper oxide and then the glaze. The smooth surface pieces are given their particular quality by thickly sponging on vanadium oxide, then spraying on glaze and either rutile or chrome oxide.

The pieces are fired in an oxidized firing to 1260°C. The vanadium oxide interrupts the flow of the glaze as it fluxes

at high temperature, making the glaze and colours variegate and so forming a physical as well as a visual texture. Those pieces receiving a lustre are subsequently fired to 750°C in an oxidized firing. The lustre is painted onto the fired glaze surface. After firing, this would normally produce an iridescent effect, but Swindell chooses to interfere with this by dropping spots of detergent, paraffin or cellulose thinners onto the lustre prior to firing, causing the surface to break up. The streaky quality is the result of two or three different colours 'marbling' together.

After the final firing, some of the shiny glazed pieces are ground with abrasive paper to make the surface matt. This also enhances the colour qualities of the glaze. The last operation is to clean off the residue from the lustre firing. This is done with cellulose thinners and Groom, which is a commercial product used for cleaning carpets. Pieces that have been sanded will be warmed up and a thin layer of wax polish applied.

Historically, the use of crystalline glazes was confined to the French ceramic industry of the mid-nineteenth century, where they were first developed. Although becoming popular in Europe and America in the 1880s, they have been used only sporadically until recently. Over the past twenty years, due to developments in kiln technology coupled with a renewed interest, there has been a resurgence of their use within the studio ceramics world.

Several distinguished makers work with these glazes, including Derek Clarkson, Peter Ilsley and Hein Severijns. **Peter Wilson** (Australia) in particular is an expert in this field, having carried out recent extensive research. Following a research period at Charles Sturt University in Bathurst, Australia, he published a paper relating to factors affecting crystal growth in high-temperature glazes. For a full account of his findings, refer to the *Australasian Journal of Ceramics*; however, for a basic understanding of this process, his results are summarized here.

During his experiments, Wilson established five primary factors that are directly linked to successful crystal growth in a glaze:

- The type of clay body – dense, porcellanous bodies were more suited to crystal development, the white body giving better colour responses.
- The form of the pot – crystals on vertical surfaces were smaller than on oblique or flatter ones. Due to the fluidity of the molten glaze, this left less glaze at the top of a pot for the crystals to grow in.
- The glaze ingredients – potash feldspar, silica and alkaline frits were tested as glass-formers. Barium, zinc oxide, sodium, magnesium and lithium acted as fluxes. All glazes need to contain at least 20% zinc oxide for crystals to develop in conjunction with similar amounts of silica. A form of zinc-silicate crystals are grown by the combination of these materials. Titanium oxide and

bentonite were present in small amounts, as were colouring oxides.
- The thickness of glaze application – the thickness varied according to the type of glaze being used. Glazes can be brushed, dipped, poured or sprayed onto the ware. For this study, spraying offered a more precise method of obtaining the correct thickness. For crystalline matt glazes (those containing barium and feldspar), thicknesses of between 1–2mm were needed. Other fritted glazes required a minimum of 2–3mm.
- The firing conditions – oxidized or neutral atmospheres in the kiln provided the best conditions, whilst reduction atmospheres inhibited growth. Fired up to between 1280–1315°C, the kiln is then cooled to the zone of crystallization between 1020–1140°C. The shape of the crystals is determined by the chosen temperature within this range, the size being determined by the length of time the temperature is held.

The conclusion, therefore, is that crystals are formed in high-temperature glazes by selective molecular bonding. The molecules of certain dominant colourants (oxides) are drawn into the zinc-silicate crystals as they form in the glaze, to the exclusion of all other molecules, which subsequently form the glaze background.

The family of glazes known as celadons is perhaps the most well known and frequently aspired to by contemporary porcelain makers. Originating in China with the Yueh wares of the Han Dynasty and later the Song, celadon is the general name given to glazes ranging from subtle greens to blue-greys. This colour range is achieved by adding small percentages of iron oxide (0.5–3%) into a base glaze and firing in a reduction atmosphere. Iron and titanium oxide will produce a green when combined; blues are obtained by glaze materials with a low titanium content, or those with a higher iron content to titanium. Smaller quantities of iron will produce paler hues. Due to the subtlety and purity of colour, these glazes are shown at their best on white-bodied clays such as porcelain, or pale-bodied stonewares. (For particular glaze recipes, *see* the Appendix.)

The porcelain vessels of **Chris Keenan** (UK) are fine examples of celadon glazes. Having spent an inspirational two-year apprenticeship with **Edmund de Waal** (UK) in the mid-1990s after a career change, Keenan became an accomplished thrower and developed a deep appreciation of the finer characteristics of both celadon and tenmoku glazes. Of his time spent with De Waal (himself having served an apprenticeship with Geoffrey Whiting in the early 1980s), Keenan said:

One of the great things about my apprenticeship had been that, in terms of my progress as a potter, I never felt that I

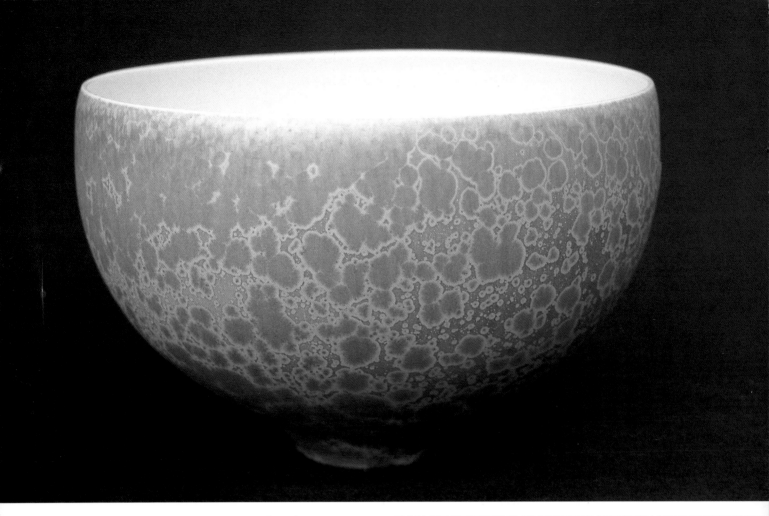

ABOVE: *Porcelain bowl with matt crystalline glaze by Peter Wilson. (32cm w. × 17cm h.) 2002. (Photo: J. Barnes)*

RIGHT: *Waisted vessels by Chris Keenan. (16.5cm h.) Tenmoku and celadon glazes. Fired to 1260°C. 2001. (Photo: Michael Harvey)*

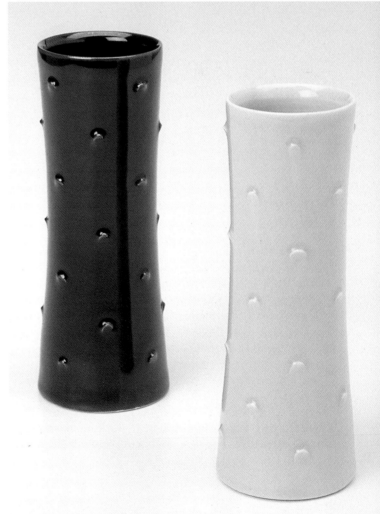

should have been at any point other than where I was – not ahead nor behind – a tribute to Edmund's skill as a teacher. He once said that my pots would always be cousins to his pots and this is a relationship with which I am very happy.

All of Keenan's work is thrown using Limoges porcelain, the 'thorns' being applied after turning. The work is bisque-fired to 1000°C, then glazed using a combination of tenmoku and celadon (at times, tenmoku is used as an underglaze and the celadon as an overglaze), then reduction-fired in a propane gas kiln to 1260°C (Orton cone 9).

Australian maker **Victor Greenaway** (*see* Chapter 2) also uses celadons at times on his thrown porcelain pieces: 'I look for glaze surfaces to enhance the form and lines by creating light and shade, adding dynamic energy to the piece. I often find glossy glazes to be too distracting, so tend to select ones that are more satin and matt. Celadon is particularly nice due to its subtle colours and tendency to pool in the grooves.'

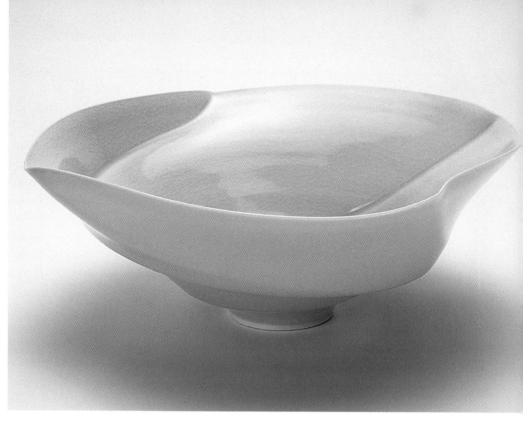

LEFT: *Lidded jar by Edmund de Waal. (65cm h.)*
Thrown porcelain, celadon glaze with red mark. 2002.

ABOVE: *Multi-lipped bowl by Victor Greenaway. (14cm h.)*
Thrown Limoges porcelain with blue-green celadon glaze.
Fired to 1260°C. 2002. (Photo: Terence Bogue)

Firing Processes

Porcelain and bone china follow different firing patterns, which will, in turn, be determined by the type of body used (refer to suppliers' recommendations).

Porcelain

Although most porcelain is low biscuit-fired before applying a glaze, there are some cases where only a single firing is necessary (*see* 'Soda Glazing' below). In this instance, the ware must be bone dry with strong foot rings for holding.

Quite apart from the vast range of glazes achievable in either oxidizing or reduction firings, there are several high-firing techniques available to the porcelain maker. Amongst those that feature prominently are soda or vapour glazing, wood, raku and sawdust firings.

The main distinction to mention here is the difference between oxidized and reduction firing:

'Oxidized' refers to the atmosphere in the kiln, in which, in simple terms, there is a clear 'fire' with plenty of air intake.

Any oxides present will remain unaltered and porcelain clay bodies will be a warmer, creamier colour due to the small amounts of iron present in the material.

'**Reduction**' basically means starving the oxygen from the metal oxides that are present in the kiln's atmosphere. This, in turn, creates carbon monoxide and hydrocarbon gases (the former, being poisonous, means that good ventilation is necessary within the kiln room). In order for carbon monoxide to change to carbon dioxide, it removes the oxygen from the metal oxides present in the clay, glaze or decorating materials, significantly altering their colours in some cases, the most notable ones being red iron and copper oxide. In oxidization, red iron produces colours ranging from yellows to browns, whereas in reduction it creates pale blues to dark greens (as in the celadons). Copper, which gives greens to turquoises in oxidization, will change to pink or red in reduction (as in the famous Chinese *sang de boeuf* or copper-red glazes).

Electric kilns, as opposed to fuel-burning flame kilns, are clean and safe to use for oxidizing, producing the ideal atmosphere for ceramic colouring pigments. It is possible to reduce in an electric kiln, but wear and tear on the elements will occur, so this is not normal practice.

Given that a lot depends on the type of kiln and burner system, as well as the particular clay and glazes used, there are no hard and fast rules on how to conduct a reduction cycle. However, most fuel-burning kilns are propane gas-fired and follow a basic guideline as described by Jack Doherty:

- controlled climbing of 100°C per hour to cone 06 (999°C)
- light reduction at 1000°C by pushing in the slide damper until a gentle flame is visible
- four twenty-minute periods of heavy reduction at intervals of 50°C: 1050°C, 1100°C, 1200°C, and 1250°C, when the cone 10 (1300°C) is flat.
- soak for fifteen minutes, then switch off, place bungs and cool slowly.

Bone China

As previously mentioned, the development of bone china's firing cycle was due, historically, to economic and technical constraints. This resulted in the norm being a high biscuit-firing between 1220–1260°C, with a low glaze between 1020–1080°C. Porcelain, on the other hand, receives a low biscuit-firing to 1000°C, with a high glaze between 1250–1400°C (for hard-paste porcelain).

Given that there is little or no silica present in bone china, and it is generally made thin, it is unusual in that it can be quickly fired up to and over the quartz inversion temperature of 573°C. It is possible, in fact, to fire it to maturity in two hours (as is sometimes done in industry). However, the deterioration to the kiln's elements would discourage the studio ceramicist and so, after several firing experiments, I have found a reliable high biscuit-firing cycle for Valentine's bone china casting slip as follows:

- controlled climbing of 100°C per hour to 550°C
- bungs in at 550°C, then kiln climbs at own rate to 1230°C
- soaked at this temperature for one hour thirty minutes (where temperature rises to 1260°C – cone 8 as a guide)
- cooling at own rate and kiln opened at approx. 150°C.

Experiments with the firing cycles proved the following:

- Fired to the lower end of the range (1220°C) meant that the forms retained their shape very well, due to very little, or no, movement at the top temperature. However, there was also very little translucency, if any. The body had a slight pinkish hue, which is a reliable indication of under-firing, and something

to be avoided, particularly if glaze is required, as crazing will occur

- Fired to the higher end of the range (1260°C and above) distortion was dramatically increased (even whilst using setters). Translucency, however, was extreme. Small, flatter pieces could be successfully fired, if packed in alumina to prevent distortion.

Soaking, or holding, the temperature at a given point for a given length of time is the key to obtaining a mature, white, translucent body. The low glaze cycle follows that of earthenware temperatures, with application as previously described.

Soda or Vapour Glazing

Jack Doherty has been working with porcelain for over twenty-five years. He is less interested in the finer, translucent qualities of the material, preferring to concentrate on thicker, functional forms, whose surfaces are more akin to glass.

All of his work is once-fired in a soda kiln (for the design and construction of this, refer to Ruthanne Tudball, *Soda Glazing*). Soda or vapour glazing is when sodium chloride, carbonate or bicarbonate are introduced into the kiln. The soda vapour produces a thin glaze surface that does not obliterate the delicacy of the clay, as is sometimes the case with thick glaze applications. Doherty combines his own recipes of different stained and coloured clays with white porcelain, frequently using copper-stained clays on the inside of the forms. The copper migrates through the wall of the pots, reacting with the soda, to produce subtle 'flashing' marks.

Due to the absence of glaze on the exterior of a piece, the firing plays an important role in determining its overall look. When the kiln has reached 'white heat', a mixture of bicarbonate of soda and water is sprayed into it. Doherty describes the firing procedure as follows:

> I fire to cone 10 (1300°C) with a light reduction from 1000°C until the end of the firing. The sodium solution is sprayed through eight ports, which are built into the back and the front of the kiln. I use 1.5kg of sodium bicarbonate mixed with 9 litres of boiling water. The spraying begins just as cone 8 (1250°C) bends. This amount of soda added over a two-hour period gives a lightly glazed 'flashed' surface, which enhances the quality of the coloured clay. The firing is completed with a soak of thirty minutes.

Soda, or salt, glazing depends on the reaction between the sodium (flux) and the silica (glass-former) present in the clays, slips and glazes. Therefore porcelain clays with a high

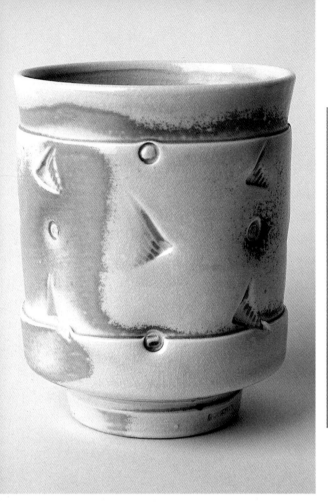

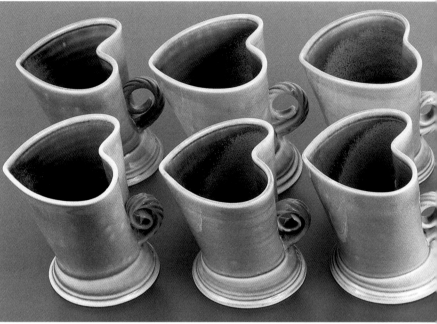

LEFT: *Pink teacup by Jack Doherty. (12cm h.) Thrown porcelain with soda glazing. Once-fired to 1300°C. (Photo: Sue Packer)*

ABOVE: *'Heart jugs' by Jane Hamlyn. Salt-glazed porcelain. 2002.*

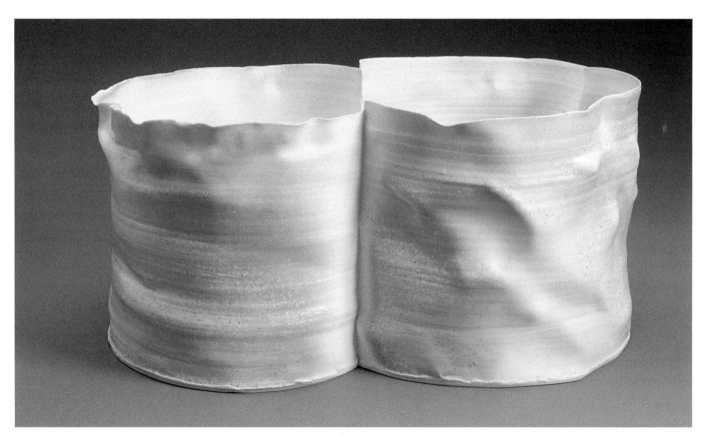

'Double Pot' by Mary Roehm. (18 × 36 × 21cm)
Thrown and constructed porcelain. Wood-fired to cone 12 (1350°C). 2002.

silica content will produce shiny, finely crazed glazed surfaces, whereas those with a certain amount of iron will have more matt surfaces.

It is necessary to be aware that the salt splits into two elements (chlorine and sodium) during the firing process. Whilst the sodium reacts with the clay surface to form a glaze, the chlorine is a poisonous gas that needs to be vented off. For this reason, the kiln must be both outside and sited away from urban areas.

The characteristic 'orange peel' effect of salt-glazing is also well-illustrated in the porcelain work of **Jane Hamlyn** (UK).

Wood Firing

When the wood-firing process is used correctly, it can result in unique, subtle qualities, such as those demonstrated in the wood-fired pieces of **Mary Roehm** and **Bruce Cochrane** (*see* Chapter 2). The 'glaze' is achieved by the fine deposits of wood ash that settle on the ware, changing the tone of the body as well as showing the traces of the flame.

Raku and Sawdust Firing

Originating in Japan, this is a technique in which the clay is subjected to a rapid firing cycle, the pieces being placed in and removed from the kiln at, or near, the optimum firing temperature. Its Japanese symbol translates as 'enjoyment', and in Bernard Leach's words describes a 'conscious return to the direct and primitive treatment of clay'.

Cruet set and stand by Bruce Cochrane.
(12cm h.) Thrown and manipulated porcelain.
Wood-fired with terra sigillata and Saino Glaze to 1300°C.
(Photo: Peter Hogan)

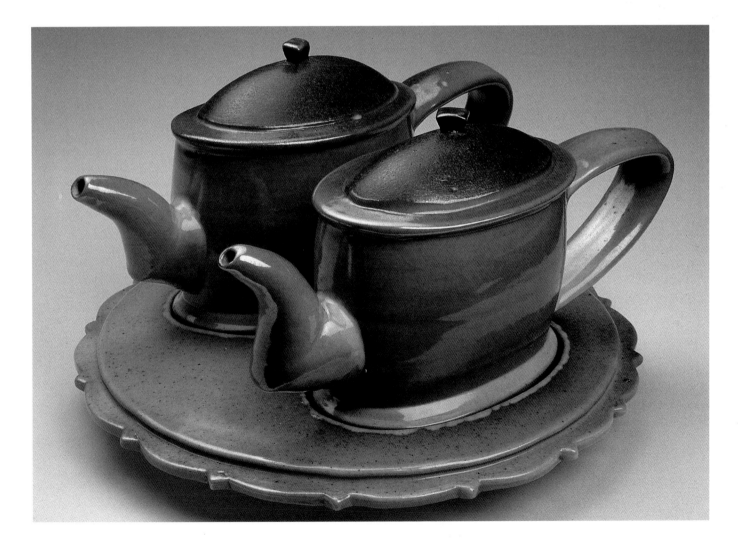

Two bottles by Anne James. (23cm h. and 18cm h.)
Thrown and beaten porcelain. Lustre and sawdust firing. 2000.

such as gold, silver and platinum. These are applied by painting, printing and latex resist techniques. The pieces are fired again in a top-loading electric kiln to 850°C, removed with tongs whilst they are still red-hot, then smoked or reduced with sawdust. Many of the pieces are fired and smoked several times with extra layers of lustre being added each time, building up a multi-layered quality.

Setters

In cases where the biscuit firing is much higher than the glaze (as with bone china), it is essential that the clay ware receives the maximum support during the firing process, particularly as most of the movement occurs when the kiln reaches its highest temperature. Due to the high distortion factor encountered with bone china, and if the shape is to be controlled, any open form requires a 'setter' of some description.

If the form is circular at the top, it can be placed upside-down on a refractory clay ring, or setter, with an alumina wash to prevent sticking in the firing. If the form is irregular at the top edge, an individual setter needs to be made. In simple terms, this is an item that resembles a lid and is cast separately (the preferred making method for bone china). Its function is to contain the top edge or rim of a form during firing and is discarded afterwards. If the piece has been successfully fired with no distortion, the ware can be glazed and fired at the lower temperature, if necessary.

With bone china teapots, coffee pots and lidded containers, the lids will require firing with the body to avoid distortion. These act as setters in themselves and will need an alumina wash between the lid and the body.

To maintain completely flat pieces such as tiles or plaques, the ware can be sandwiched in-between substantial amounts of alumina, which cover and weigh the piece down during the firing.

With porcelain, there will not be any distortion until the high glaze firing. If the ware is to be glazed and setting is required, the glaze can be wiped off the rim. The piece can then be placed, either on an alumina-washed refractory clay ring or, if circular-rimmed like a cup, placed rim to rim with the handles lined up (known as 'boxing'). In the latter case, alumina with some gum arabic can be painted onto the rims, as this will hold them secure. After firing, the rims will appear rough and gritty, but they can be polished with carborundum paper.

Saggars are often employed for use with high-firing clays to lessen distortion and protect the ware during gas or wood firings. These are drum-shaped containers made of refractory clay with 50% grog added. They are normally filled with a 'placing' material in which the ware is bedded – calcined alumina if using bone china, or silica sand if using porcelain.

In the West, it is normally associated with low-firing clays, which, upon removal from the kiln, are reduced (or carbonized) by being plunged into sawdust, then water – the ware as a result being exposed to a dramatic thermal shock. Eastern raku tends to be oxidized and air-cooled.

One maker who works with raku-fired porcelain is **Anne James** (UK). By 'opening up' the body by adding grits, and treating the clay as a low-fired material, she is able to achieve interesting effects through combining lustre and sawdust firing.

The work is either thrown and modified by beating, or slab-built, using her own grogged or gritted porcelain body (*see* Chapter 1). It is then covered with fine layers of coloured slips and burnished. This is the process of polishing the clay when firm (but before firing) with a smooth pebble or spoon. The pieces are biscuit-fired to 1000°C, after which they are decorated with resin lustres – mixes of resins and precious metals

METHOD FOR MAKING SETTERS FOR IRREGULAR FORMS.

Fill the mould from which the setter is to be made then cast as normal

Drain the mould and remove the spare and reservoir ring

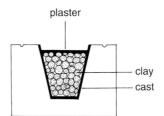

Fill the cast up with small pieces of plastic clay to approx 1cm under the rim. Smooth off the top of the clay with a small amount of plaster

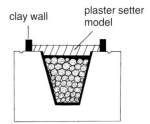

Soap up top of model including the plaster inside the cast. Place a clay wall around the top to form the model of the setter. Pour plaster in

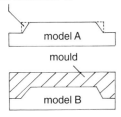

A. Once plaster has set remove model and carve back to an angle of 45°. Take care not to disturb the rim impression.
B. Soap up model and pour mould

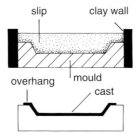

Cast and drain at the same time as the piece which requires setter. Release clay wall leaving overhang

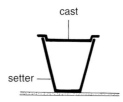

When the cast of the setter is removed from the mould place it into the piece and dry together. Fire them together with an alumina wash between the rim and the setter

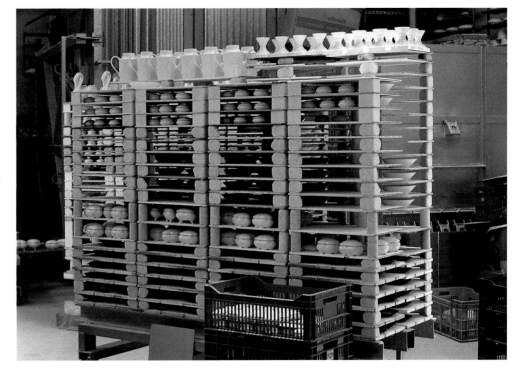

Firing stack of hard-paste porcelain at the JPM factory, St Yrieix, France.

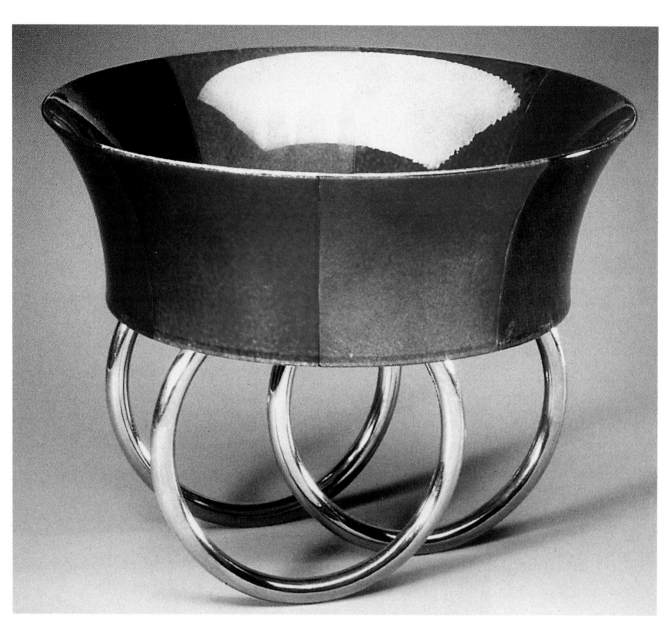

*'Excelsior' porcelain prototype designed by Mathilde Brétillot
for La Manufacture de Sèvres, Paris 1996–7.*

7

Designers/Makers Working Within the Ceramic Industry

Introduction by Sue Pryke

With the decline in formal dining and the increase in global living, manufacturers are finding that there is a shift in the traditional sales of dinnerware and more demand for a wider variety of forms to match the ever-growing preference for multi-cultural cuisine.

The prevalence of the bowl for rice and pasta and the possibilities created by isostatic dust pressing offer opportunities to explore a variety of forms that no longer rely on the traditional forming techniques evolved from the potter's wheel. The industry in the UK is under threat from overseas competitors, who can provide authentic rice bowls and sushi dishes and undercut UK production tremendously. Most of the larger producers in the UK now outsource some of their products from overseas too in order to sell competitively.

These factors have enabled manufacturers to explore and experiment with form and adopt a more contemporary approach to form and pattern, which over recent decades has remained within the realm of studio potters and designers of small ranges for production. An example of the latter was the tableware range launched by Next in the1980s, designed by Janice Tchalenko and Carol McNicoll, intended for mass production but appealing to a small audience, especially those familiar with the studio work of the designers.

Traditional manufacturers are moving into a more contemporary arena. Wedgwood is a prime example, showcasing its interests and new-found manufacturing flexibility by exhibiting at 100% Design, one of the leading design shows in the UK, and promoting new designers and makers with one-off pieces as well as volume ranges designed by distin-guished fashion designers. Wedgwood has always had a relationship with artists and designers, for example commissioning work such as Eduardo Paolozzi's Op Art plates in the 1960s and Glenys Barton's figurative work. Today, the company is working with designers from the fashion industry: Vivienne Westwood, Paul Costello and Jasper Conran, plus a variety of young product or ceramics designers such as Kathleen Hills and Michael Sodeau.

The importance of IKEA as a key player in the realm of tableware and homewares, with its strong company brand and promotion of good, accessible design, has encouraged larger manufacturers to take brave steps into the world of contemporary design. The market for contemporary tableware is increasing. To meet this demand, Denby is producing a cool white collection that still has the durability of its other products, Royal Worcester is employing food guru Jamie Oliver to design a table and cookware range, supermarkets such as Asda are selling a broad range of tableware with a variety of shapes and finishes, and Sainsbury's and Marks & Spencer are investing in their homeware ranges, with M&S opening a homeware store in Gateshead.

Designers are no longer having to produce concepts for bland traditional ranges day in, day out – they are actually drawing on the research they gathered as students and designing items they like!

It is now a very contemporary market and there is a very reassuring symbiotic relationship evolving between designers and industry. The manufacturers are actually listening to the designer, whereas in the past the designer was

considered a luxury and the attitude was that ranges could be developed without skilled aesthetic input. What the designer can offer industry is the innovative approach to tableware design that has always been particular to the craft industry and art schools. Wedgwood again is an exemplar in this arena, introducing engine turning and Jasper ware, and inventing other techniques in order to produce ware efficiently.

There is also innovation in the use of computer-aided design (CAD), rapid prototyping and automated production. Although factories in Eastern Europe and the Far East are able to supply ware to many UK factories and retailers at a lower cost, they cannot compete with the strong brand identity associated with UK manufacturers and the 'Made in England' backstamp. Equally, designers will find a source of income in other continents, with their inherent knowledge of English and Western style and lucrative Western markets. Knowledge of markets, factories and innovative craft practices coupled with experience of CAD will ensure a good grounding for any ceramics designer in today's competitive climate.

Sue Pryke is a freelance designer for IKEA and senior lecturer in Ceramics and Glass at De Montfort University, Leicester.

Breaking with Tradition

The cross-referencing between manufacturer and the individual designer or maker has played an important role in the recent history of the ceramic industry by introducing a breath of fresh air into a world that was in danger of not moving with the times. Most notably perhaps has been Rosenthal in Germany, which set the trend in the 1960s. Under the initiation and guidance of Philip Rosenthal, son of the founder, the factory broke with the traditional, familiar and long-repeated forms in porcelain and glass in the 1950s with the intention of raising the design standards of everyday objects.

The principle and ethos of subscribing to original contemporary design attracted internationally renowned artists and designers from a variety of disciplines to the Rosenthal Studio-Line approach. After its launch in 1961, more than thirty artists worked for the limited Art-Editions collection. People such as Eduardo Paolozzi, Henry Moore, Victor Vasarely and Salvador Dali have contributed to the Rosenthal Relief Series, Art-Objects, Year plates and Christmas plates. This acknowledges that porcelain sits comfortably within the art world, as well as reconfirming the historical trend, set by the fine arts, to use this highly prized material.

In 1969 Walter Gropius, the founder of the Bauhaus, designed the 'TAC 1' tableware range for the Rosenthal Studio-Line and it has remained in its collection ever since. Although considered a design classic, it is still very compatible with contemporary design demands. Gropius also designed a new factory for the company in Selb, Germany, in the late 1960s, and by 1979, the year of their centenary celebrations, the factory employed approximately 8,500 people. It continues, to this day, to produce work of exemplary design and quality, and in 1997 Waterford Wedgwood acquired the controlling interest in the group.

Currently, both in the UK and abroad, a blend of contemporary approaches and new developments in manufacturing methods has created a symbiotic relationship between industry and maker. This has resulted in exciting innovative directions, ranging from designing for industry and providing prototypes whilst production is realized by established factories, as in the case of Bodo Sperlein (Germany) for Nymphenburg and Hannah Dipper (UK) for Rosenthal, to surface decoration on limited edition collections with the designer/

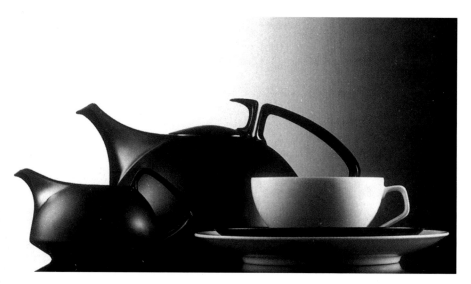

Walter Gropius TAC 1 series. 1969. Produced by Rosenthal.

maker's name appearing on the product, as in the example of Russell Coates (UK) with Spode.

Another approach is to use the industry as a vehicle to realize a specific project, as in the case of the tile installation by Clare Twomey (UK) with a Korean manufacturer for the World Ceramic Exhibition 2001 (WOCEK).

Design awards, residencies and commissions from large companies wishing to generate new ideas play a significant role in giving students an opportunity to work with industry via links with college projects. This has been the case, for example, with Kathleen Hills (UK) and Wedgwood and Antje Dietrich (Germany) with Kahla in eastern Germany. Likewise, established makers such as Kathryn Hearn (UK) and Vicky Shaw (UK) have also realized projects with Wedgwood.

In addition to companies in France, such as Bernardaud in Limoges which has employed designers such as Olivier Gagnère and Martin Szekely, there has been a revival of established companies approaching designer collectives to produce work. This has happened in France, with Artoria in Limoges linking up with designers whose careers have included architectural, furniture and product design, such as Ricardo Bustos and Patrick Norguet.

It has become apparent, however, that this linkage with industry can include a certain level of unwanted compromise on the part of the maker. This has led ceramicists like Pieter Stockmans (Belgium) and Stefanie Hering (Germany) to set up their own production company, which offers them complete freedom and no concerns over quality issues beyond their control.

Concerning the commercialization of a product, there are various possibilities regarding 'ownership' of the design. The ceramicist can:

■ remain owner whilst industry produces and markets the product
■ remain owner and market it, subcontracting the production to industry
■ sell the design outright, thereby relinquishing any control over the product
■ Remuneration can be either on a flat fee or royalty basis (*Artist's Newsletter* has produced a contract concerning royalties and flat fees that can be verified by a royalty solicitor).

This chapter focuses on makers and manufacturers from a variety of countries whose experiences illustrate the differing working relationships available in this field.

Underglaze and enamelled porcelain dish by Russell Coates. (39cm) Produced by Spode.

Russell Coates (UK), Spode

Having worked for several years perfecting the underglaze blue technique made famous by the Japanese with their Kutani ware (*see* Chapter 5), Russell Coates was well-equipped when he was invited by Spode in Stoke-on-Trent to undertake a residency during the Millennium Year of the Artist 2000.

This five-week residency, which he spread over the year, offered him the chance to design a limited-edition giftware range that was subsequently launched in spring 2002. Spode initially adapted four of Coates' thrown items, a vase, dish, bowl and jug, industrially casting them. His underglaze decoration was interpreted as an inglaze transfer onto an 1170°C body.

In conjunction with this, he designed new patterns on existing Spode bone china shapes for its open-edition giftware range. This involved designing onto tiles that were later scanned into a computer. Transfers were made from these images and, in this instance, Spode's design manager would arrange the designs on the pieces with the final approval coming from Coates.

This appears to have been a workable system, proving a successful translation of the ceramicist's work into mass production, with the initial remuneration being a negotiated flat fee leading to a royalty-basis contract once the products started to sell well.

Hannah Dipper (UK), Lynton Porcelain and Rosenthal

After graduating from Bath in 1997, Hannah Dipper spent a year working as a designer/draftsperson at the model-making consultancy, the Hothouse in Stoke-on-Trent, where she learnt about production and manufacturing in the ceramic industry. It was here that she began to appreciate how many skills and traditions would be lost with the decline in the British ceramic industry, and it is these thoughts that helped to shape her work. She considers the making process and qualities of different ceramic materials to be almost as important as the final form, but, she notes: 'I am constantly struggling between these ideals and my desire to design affordable products for mass production.'

Considering herself as 'an industrial designer who specializes in ceramics rather than a craftsperson making a very few exquisite pieces', she is proud of her craft-based education and values the need to understand a material before feeling qualified to design with it, whether it be earthenware or polypropylene.

The 'Lunar Lanterns' were originally a competition entry whilst she was studying at the Royal College of Art. The competition, 'New Routes, New Destinations', was initiated by Rosenthal and challenged the students to consider new forms other than tableware. Her ideas about indoor and outdoor products were in response to a renewed interest in gardening – particularly amongst urban dwellers.

Upon graduation, she first cast the lanterns herself in porcelain. As demand grew, she found a small manufacturer, Lynton Porcelain in Derby, who batch-produced the pieces in bone china, resulting in a facsimile of her own production even down to the polishing of the unglazed exterior surface. However, some months later, Rosenthal's new art director

'Lunar Lanterns' by Hannah Dipper. Produced by Rosenthal. 2001.

expressed an interest in producing the pieces. Although selling successfully independently in London, it was an opportunity not to be overlooked by a freelance designer and so 'Lunar Lanterns' are now manufactured in porcelain and distributed worldwide by Rosenthal.

The models are made by filling balloons with plaster, which is poured down a long tube to create enough pressure. Using a two-piece mould, they are slip cast in porcelain. After a soft bisque firing to 980°C, they are polished with a diamond pad on the outside surface to obtain a smooth, tactile finish. A transparent glaze is applied to the inside and they are fired again to 1240°C. The fittings were originally stainless steel tension wire with brass connectors and a plastic peg, but they are now produced with a simple loop for hanging.

The only modification necessary for industrial manufacture was the thickness of the cast – the lanterns could not be cast too thinly as distortion would occur and therefore setters would be required. This, in turn, would increase the price, so the Rosenthal versions are thicker than the English batch production in bone china.

Kathryn Hearn (UK), Wedgwood

Being an established maker for several years now, Hearn has always maintained a fascination for making processes and a desire to extend that process, as well as challenge the potential of an idea (*see* Chapter 5). Although a lot of her time is spent teaching within ceramics education, she still finds time to experiment and produce her own work. She particularly likes the weight and colour response of porcelain and has been making small batch production and unique pieces for a number of years. However, her interest in using these techniques in a different context led her to approach a bigger industry.

During 1994, she visited Ambiente, the table-top products and interiors trade fair in Frankfurt, where she approached a number of companies with her folio and received very positive responses. However, the first concrete project emerged from her showing at the Contemporary Decorative Arts Exhibition at Sotheby's in 1997, at which the product development manager from Wedgwood saw her work. She was subsequently commissioned to make a body of work using the whole range of Jasper colours (ten to twelve colours), which resulted in another Sotheby's show in 1999.

In 2001 Hearn was commissioned, alongside fellow maker Vicky Shaw, to produce a collection of pieces for Wedgwood at the 100% Design show in London. This served as a dual promotion for maker and industry alike.

'Jasper Tall Stone', black and pale blue rubbed vase by Kathryn Hearn. (25cm h.) Slip cast. 2000.

Bowl composition by Vicky Shaw. Press-moulded bowls and feet, base and spatulas formed from rolled slabs. Fired to 1200°C. 2001.
(Photo: Rod Dorling)

The endorsement that Wedgwood has made to develop relationships with innovative freelance designers and makers, coupled with the support and management offered by the in-house design team, has proved to be very successful. In addition to this, as Hearn says: 'It is great as a maker to be taken seriously within such a commercial, establishment context, and to be paid properly for the work that is undertaken – not often the case for craft-based ceramicists.'

Vicky Shaw (UK), Wedgwood

Having studied industrial ceramic techniques at Stoke-on-Trent in the 1980s, Shaw subsequently developed a method of direct printing onto leather-hard clay (*see* Chapter 5). Since leaving college, her experience within the ceramic industry has ranged from surface pattern designer for the Creative Tableware part of the Wedgwood group, to ceramic print consultant at Kohler Co., in Wisconsin, USA, and more recently with Wedgwood again.

Wedgwood sought to commission two leading designer/makers to give a contemporary interpretation to a Wedgwood icon – Jasper ware. So in 2001 Shaw and Kathryn Hearn produced a collection of pieces for 100% Design.

Shaw was given a colour theme to work to and was encouraged to experiment with the Jasper clay bodies, working along similar themes to the porcelain compositions she had previously produced. She made her collection in her own studio in Stoke-on-Trent and, during the six months the project lasted, had several meetings at the factory or at her studio to discuss work in progress. After a period of experimentation, a range of work for the collection was agreed. The Wedgwood retail outlet in Regent Street, London, commissioned Shaw to make a further collection of thirty-six bowls as a limited edition for the shop.

Shaw feels that the overall experience was a very positive one in terms of the working relationship with the design team, as well as being both a challenge and a rewarding experience as a maker. She is currently developing a project for Rosenthal, working with structure and texture for their Studio-Line, as well as teaching at the University of Wolverhampton.

Kathleen Hills (UK), Wedgwood

Kathleen Hills is one of the new generation of designers who has successfully combined her design and making skills with industrial production. During a work placement with Wedgwood in 2002, whilst studying at the Royal College of Art, she initiated a project that explored her interest in how we form relationships with objects that inhabit our domestic spaces. This led her to look closely at the emotional attachments that may have been formed with these products, concerning herself with the familiarity and confidence of the user through family tradition and cultural or domestic ritual.

She proposed a lighting brief to Wedgwood entitled 'Lighting the Domestic Space', which dealt with the manipulation and exploitation of a familiar product – Christmas tree lights. The result was a site-specific lighting installation that altered the scale and material of this traditional object. By applying a permanence and luxury to the product, it became distanced from its role as an inexpensive item associated with a particular season. Her decision to work with bone china offered associations with luxury, preciousness and tradition, as well as producing an innate translucency in the lights when illuminated.

Whilst lodging in Stoke-on-Trent, Hills enjoyed the domestic routine of the milkman calling in the morning. With supermarkets encouraging the use of plastic cartons, the tradition of the milk bottle is fading, so she felt a

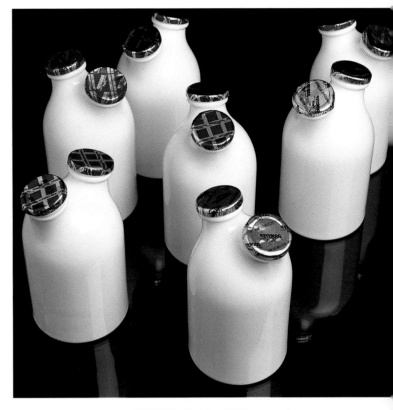

ABOVE: '*Milkii' by Kathleen Hills. Bone china milk jug. (14.5cm h.) 2002.*

BELOW: '*25/12th' by Kathleen Hills. Bone china shades. (17cm diam. × 20cm h.) 2002.*

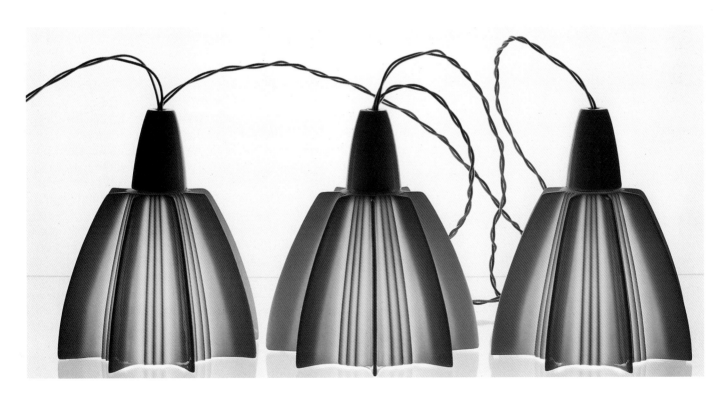

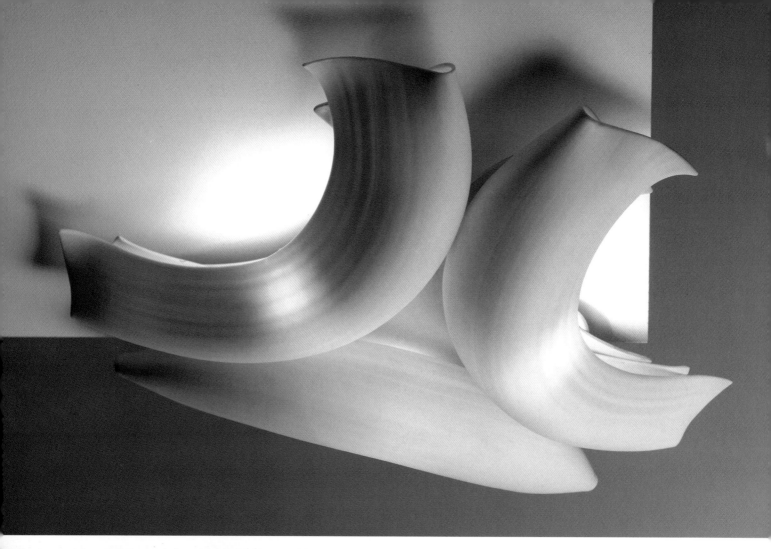

ABOVE: *Ceiling light by Margaret O'Rorke and Wades Ceramics Ltd.*

LEFT: *Making a model from Margaret O'Rorke's mould.*
Wades Ceramics Ltd.

contemporary 'milk jug' was needed. Hills says of her design: '"Milkii" substitutes the glass of the milk bottle with fine bone china, celebrates the form and cultural associations of the bottle, its relationship with the English breakfast and the taboo of the milk bottle on the table!'

She was given access to the design, modelling and production departments at Wedgwood and, working under the guidance of a senior designer, was encouraged to design and produce models using rapid prototyping and milling machines (*see* Chapter 8).

The 'Milkii' product was designed on paper, then translated through DeskArtes, a CAD program, into a rapid prototype model. The final model was created by adding plaster to a resin-milled half-negative of the original form, the two plaster halves then being stuck together. A three-piece mould was subsequently made from that.

Wedgwood produced a limited batch for the final college show; however, they are now being made by a family company in Stoke-on-Trent with the product gaining attention and stockists throughout the UK.

Margaret O'Rorke (UK), Wades

For the past twenty years Margaret O'Rorke has been fascinated by the translucency of high-fired porcelain, making one-off sculptural pieces as a studio potter (*see* Chapter 2). However, these pieces, being experimental and time-consuming to make, are accessible to a very limited market. Her desire to reach a wider audience, whilst still continuing her own work, led her to consider the possibility of working with industry with the aim of producing porcelain lighting for domestic and large-scale installations.

Her approach was to apply to her regional Arts Association (then Southern Arts) in the UK for a Research and Development Grant. In 1999, she discovered a porcelain factory that produced electrical fittings and rubber glove formers called Wades Ceramics Ltd in Stoke-on-Trent, where she was offered a three-month research period. Coming from a thrower's background, O'Rorke had little understanding of industrial processes at that time and so worked alongside the technical and production teams, who assisted her in the realization of this project.

At the outset, there were the inevitable technical problems concerning design issues, suitable casting slips and firing problems, but, once remedied, O'Rorke chose the form she felt to be the most aesthetically pleasing, as well as financially viable, for industrial production by a specialist team. After being advised by Beverly Bigham, an expert lighting technologist, she approached a lighting company, Concord Lighting, to represent and distribute the product.

Angela Verdon (UK), Royal Crown Derby

Angela Verdon is a ceramicist who, over the years, has exploited bone china and porcelain to their best advantage, with her delicately pierced bone china forms of the 1970s and 80s, and her later work in Limoges porcelain in the 1990s up to the present day (*see* Chapter 5).

Her knowledge and understanding of high-firing clays and industrial processes made her an ideal candidate to undertake a project at Royal Crown Derby to commemorate the Year of the Artist 2001. During a residency at the factory, she designed and produced an installation of an illuminated ceramic window in the main entrance foyer.

The window is made up of sixty panels of bone china that have been mounted in a wooden frame. The panels were produced by casting slip into vertical plaster moulds and

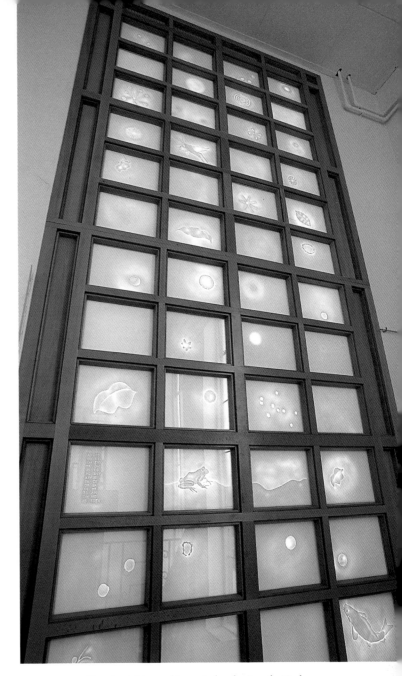

ABOVE: *Illuminated bone china window by Angela Verdon, in main foyer at Royal Crown Derby. 2001.*

BELOW: *Angela Verdon pouring slip into the panel moulds.*

left for four hours until solid. After casting, the slabs were laid onto damp plaster bats for two to five minutes, whereupon the outline of the image was quickly drawn out. When leather-hard, they were carved by hand using a variety of dental and surgical tools.

After drying out for a week, the panels were laid flat directly onto kiln shelves with alumina placed on top to prevent warping (vertical casting reduces warping as the weight of the slip in the spares aligns the clay platelets), then fired straight up to 1260°C with a two-hour soak. In all, 250 panels were made to achieve sixty good ones.

Peter Ting (UK), Lynton Porcelain

Originally known for his 'Ting Ware' ranges in the 1980s, Peter Ting has always maintained an interest in 'the table'; he is currently employed as Living Designer at Asprey & Garrard in London, as well as being Professor of Three Dimensional Design at the University of Central Lancashire.

His collaboration with industry resulted in a two-person show with Takeshi Yasuda in Ireland, which was assisted by the British Council and the Crafts Council of Ireland in 2003. Here, he presented a collection of functional tableware after being challenged to produce original ideas for the tabletop. By moving away from direct function, he took inspiration from the late eighteenth-century aspic and jelly moulds seen in the Wedgwood Museum and decided to make, amongst other things, 'a modern day interpretation of a decorative object masquerading as a functional one'.

Traditionally, these moulds were used to create decorative jellies and aspics for the table. They were made in two parts, with a decorated ceramic inner cone, around which the jelly was formed, and a plain outer cone top covering. The idea was that when the jelly was put down on the table, the outer cone would be removed to reveal the decoration through the translucent jelly. Ting's interpretation of a Belleek-inspired mould was to use a glass outer cone to replace the role of the original aspic, thereby both protecting and revealing the delicate flowers at the same time.

English bone china jelly mould with hand-modelled flowers by Peter Ting. (46cm h.) 2003.

English bone china jelly mould by Peter Ting using onglaze burnished platinum with hand-dotted raised enamel paste. (46cm h.) 2003.

Ting worked very closely with a highly skilled technical team at Lynton Porcelain to produce what appears to be a meticulously hand-crafted object which is in fact industrially produced.

Penny Smith (Australia), Arabia, Finland

Originally trained as a furniture designer in the UK, Smith became interested in ceramics upon her move to Tasmania in the 1970s. Following a period of research and a short residency in Stoke-on-Trent in 1979 with an industrial mould-making supplier, she developed a range of flexible mould-making methods for producing both functional and non-functional slip cast and press-moulded ceramics.

This approach of using aspects of large-scale industrial manufacturing techniques to suit small-scale ceramic studio production has been, and still remains, one of her main preoccupations. It was the mainstay of her own practice as well as her teaching over the last twenty-five years, and this interest has been instrumental in the establishment of the Ceramic Research Unit at the University of Tasmania in Hobart in the early 1990s.

In 1995 she was invited as artist-in-residence for four months at the tableware factory, Arabia, in Finland. Here she had her own studio with other permanent artists and designers, as well as the run of the factory to produce a body of work for an exhibition that was to be held later that year.

During that period, she was able to explore the use of bone china, a medium with which she was not familiar, and one that the factory had recently introduced – their main production at that time being in porcelain and stoneware. The opportunity to use this material, coupled with the importance of light to the Finns, especially during the winter when her visit took place, was a deciding factor in her development of a bone china lighting range.

Regarding this time as a prime learning opportunity, Smith worked very closely with the technical staff of the factory, honing her mould-making and casting skills. The first half of her residency was spent working alongside Matti Sorsa, the head mould maker, creating numerous plaster moulds for the light series. She later adapted these same moulds to create a range of bottle, vase and wall forms based on a limited number of component elements, thereby exploring the potential for flexibility within the making process.

To exploit the inherent translucency of bone china, Smith created patterns on the inside faces of the plaster moulds by trailing liquid latex and allowing it to dry before sealing the moulds and casting. This created thin areas within the cast walls that would enhance translucency after firing. This

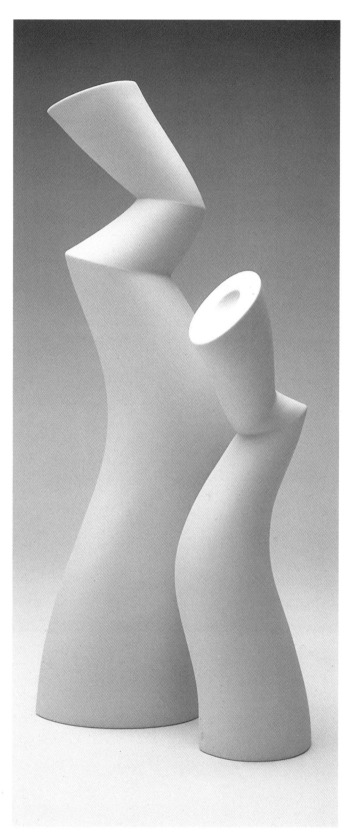

'Dialogues' by Penny Smith. (38cm h.)
Slip cast porcelain, polished exterior
and glazed interior. 2002.

process was also used with slip-trailed coloured bone china slips coupled with incising through a black glaze applied to the raw ware.

Whilst at the factory, she was also invited to produce a limited range of glassware of the same shapes and patterns at the Iittala glass factory, a sister manufacturer to Arabia based outside Helsinki. These products were exhibited in conjunction with her bone china collection resulting in a solo show later that year.

During her time at Arabia, Smith came to feel that the invaluable knowledge and expertise afforded by working closely with Matti Sorsa could ultimately benefit others. So, by means of a research grant, Sorsa was invited to Tasmania to assist her and fellow colleague and ceramicist, Les Blakebrough, establish the Ceramic Research Unit at the University of Tasmania in Hobart in 1995, now one of the foremost ceramic institutions in Australia.

OPPOSITE PAGE:
'Lightworks Series 111' by Penny Smith.
Slip cast bone china with stoneware bases. (38 and 59cm h.)
Produced at the Arabia factory, Helsinki. 1995.

THIS PAGE:
'Southern Ice' by Les Blakebrough.
Large porcelain bowl with high foot. Unglazed with metal salts surface decoration. 1997. (Photo: Uffa Shultz)

Les Blakebrough, Australia

Although possibly better known for his collaborative research and development of the Southern Ice porcelain body (*see* Chapter 1), Les Blakebrough has had extensive experience in the ceramic industry at various points of his career. His current individual work is thrown using a variety of decorating techniques including water erosion and metal salt decoration (*see* Chapter 5).

In the past, there have been several attempts to establish factories in Australia. For example, Royal Doulton set up a sanitary ware manufacture in Sydney and introduced alongside it a tableware section and small studio line. However, it sadly floundered a few years later, due mainly to a successfully established industry in Staffordshire that was already exporting to the colonies and the rest of the world coupled with a flourishing market in Britain. It then became the general belief that the Australian market was not big enough to support the major investment of a large factory. Despite this, there is a success story with one company, Australian Fine China in Western Australia. Due to the persistence of Blakebrough and others, this company beat its competitors, Wedgwood and Worcester, to supply the tableware for the new Parliament House in Canberra.

Coming from a country where there has never been a large-scale ceramic industry, Blakebrough was obliged to visit leading European manufacturers to satisfy his interest in industrial

processes. So, with the support of a Churchill Travelling Fellowship in 1993, he went on a study tour, spending time at Royal Copenhagen Porcelain in Denmark, Arabia in Finland and Royal Worcester in the UK. In each, he worked alongside the staff to realize his own projects whilst learning from their technical expertise. One such lesson was at the Royal Copenhagen factory, where he discovered how to make a seamless mould in a cracking, or 'splitting off' method using thin fillets of metal and tapered wedges. This results in a piece with no obvious seam lines, which is particularly useful for use with high-firing clays (*see* Andreas Steinemann, Chapter 4).

At Arabia, Blakebrough was introduced to CADCAM techniques (*see* Chapter 8) to resolve some of the technical difficulties he was experiencing whilst designing a cup and saucer. And, finally, he was able to refine this cup and saucer using a hard foam modelling technique at Royal Worcester.

As well as producing one-off exhibition pieces, Blakebrough continues to be a leading researcher in Australia into industrial processes for the craft-based industry at the Ceramic Research Unit of the University of Tasmania.

Clare Twomey (UK), Korea

Clare Twomey is primarily concerned with using clay as a vehicle for self-expression, being particularly interested in the translation of the concept to the clear physical statement. This occurs normally in the form of installations, one of which resulted in an 'audience participation' piece involving a novel approach to working with the ceramic industry.

In 2001 she entered the prestigious World Ceramic Exposition 2001 Korea (WOCEK) biennial competition. WOCEK originated as a concept by the influential Kyonggi Province Governor, Lim Chang-Yuel, to create three huge exhibition sites spanning the area surrounding the capital city of Seoul. It took four years of meticulous planning by a highly specialized committee to bring the concept to fruition. The planning included curating exhibitions, organizing the ceramic biennial competition, liasing with international ceramic groups and travelling worldwide to collect objects and information.

In Twomey's entry 'Consciousness/Conscience', she invites her audience to walk across a floor of raised tiles to view a line of photographs that plot the careful manufacture of the tiles. In the process of walking towards these images, the tiles are crushed underfoot and the viewer is left with the knowledge that he or she has participated in their destruction, hence the title! As Twomey explains: 'Each viewer has a personal experience of interacting with this manufactured ceramic environment. There is also a collective experience, a time-based deterioration of the environment.'

Upon hearing that her piece had been selected, and having entered a body of work that she had been making in her own

studio up until then, Twomey needed to form a strategy that would realize this project over 5,500 miles away. The nature of the installation meant that the ceramic pieces, consisting of 3,000 slip cast porcelain hollow boxes fired to 300/400°C, would of course need to be made on-site. Consequently, Twomey investigated two options: working in Korea for a month to produce the pieces herself, or commissioning a manufacturer. After five months of communicating by fax with Korean manufacturers, a suitable one was found through an intermediary who eventually oversaw the entire project. However, due to time restrictions, contracts were drawn up, payments were made and production began – on trust alone.

Twomey went to Korea ten days before the opening ceremony to prepare for the delivery and to install the pieces. It took five days to lay the 15 × 3m floor area with the boxes and she was duly rewarded with a certificate of merit.

Sue Pryke (UK), IKEA

Originating from a ceramics and glass background and graduating from the Royal College of Art, Pryke's background has ably equipped her to undertake various industrial projects. After winning the RSA Student Design Awards as an undergraduate, she went on to become a shape designer at Wedgwood before deciding to study further at the RCA. Following on from her postgraduate degree in 1994, IKEA's project coordinator recognized Pryke's innovative approach to design and commissioned a series of domestic forms for the IKEA 365+ range.

These items are part of a range that is constantly being updated and include dinner plates, cereal bowls, serving dishes and teapots. The manufacture of these pieces is by factories in Portugal, Turkey and China, using a variety of industrial production methods – the plates are dust-pressed, the large platters are pressure cast, the bowls and mugs are jigger and jolleyed, and the teapots are slip cast. The decoration is applied using transparent or coloured glazes with lithographically printed transfers in solid colour. The firing temperature is 1350°C.

Embarking on this project, Pryke brought knowledge from her craft-based education, which provided a rich source of innovative approaches to form without the constraints of designing within industrial limitations. Square plates and a square-footed mug were developed early on to offer an informal approach to the tableware range, drawing on Swedish styling, contemporary food trends and appropriate volume production techniques of dust pressing and pressure casting.

Pryke's time is now spent between a senior lectureship at De Montfort University and freelance consultancy work for companies such as IKEA, Queensbury Hunt, Marks & Spencer and Virgin Atlantic Airways.

LEFT AND BELOW LEFT:
'Consciousness/Conscience'
by Clare Twomey. (42sq. m)
Slip cast porcelain and
photography installation.
2001.

BELOW: Porcelain mugs
with square foot (10cm h.)
and square side plates
(18 × 18cm). Designed for
IKEA by Sue Pryke.

Marek Cecula (Poland/USA)

Polish-born Cecula studied in Israel and has lived and worked in New York since 1977. He is a ceramicist who has strived to maintain a co-existence between his art and his design, describing his design criteria as follows: 'As one direction co-habits next to another, there remains a wide transference in the middle. It is within this intersperse that the most interesting and creative aspects of art and design occur.'

He has developed a limited-edition series and short line productions to escape from the market momentum of 'one-of-a-kind' objects, providing original ceramic design for a larger group of consumers. The objective of his designs is to focus on ceremonial aspects of life and provide functional elements to accompany the ritual of utility. He chooses a subdued language of minimalism, where form and colour serve as constructive components for a specific purpose. The work does not carry visible handmade qualities, although this is basically the case through the assembling of individual elements, fabrication and decoration. He derives inspiration from urban reality, where architecture, environment and social habits fuse with the aesthetics of contemporary perceptions.

In 1997 Cecula established Modus Design in New York. It is a creative studio specializing in innovative ceramic design, where prototypes are created and some small-scale production is carried out. Modus Design offers two lines of ceramic production – specifically adapted pieces for mass production by carefully chosen manufacturers, usually in Poland, and another line that concentrates on limited editions produced in the studio.

More recently, Cecula has been working with a material normally associated with the engineering industry. Corundum (Al_2O_3), a natural crystalline alumina, is an advanced ceramic material, possessing a mineral make-up of rubies and sapphires. It is extremely hard and strong (see Chapter 8).

As well as his design work and research, Cecula is also currently head and co-ordinator of the ceramic department at the Parsons School of Design in New York.

Creamer and sugar/spoon set by Marek Cecula. Slip cast porcelain. Fired to 1350°C. Produced in industry and distributed by Modus Design. 2000. (Photo: Bill Waltzer)

Pieter Stockmans (Belgium)

Dinnerware 'Expression' by Pieter Stockmans for Weimar Porcelain, Germany. 1991.

Pieter Stockmans has been described as someone who has a passion for industrial design alongside his installation work (*see* Chapter 4). After training as a ceramicist and sculptor in Belgium, Stockmans wanted to complete his education in the ceramic industry. In 1963 he started working for Mosa Porcelain in Maastricht in the Netherlands, where he discovered that his quest to design innovative products fell short of his expectations. Although aware that youth and, perhaps, inexperience were contributing factors, he established that: 'The creation of an industrial product is determined by the market, the price, the production technique, its function, the company's existing collection etc.'

With this knowledge in mind, he continued working with Mosa for twenty-six years, developing a number of products for various market sectors, in particular the hotel industry. Most notably is 'Sonja', a stackable cup designed in 1967 that became the main prototype for hotel cups in the Netherlands. Since then, Mosa has produced in the region of 50 million of these and seventeen copies of the design can be found on the market.

During this period, Stockmans became very interested in designing products suitable for the elderly or physically handicapped. The 'Ergoform' cup was one such product. Originating from the same basic form, in the production process it could be provided with differing elements, such as one or two handles, or stripped of them, depending upon individual requirements.

After amassing a wealth of experience, a decision was taken to start his own company, and in 1991 he launched the 'Expression' range of dinnerware. Unfortunately, production

of this was fraught with technical and financial problems and it was discontinued. He subsequently had it produced by Weimar Porcelain in Germany, marketing it under his own name. It is slip cast and dust-pressed hard-paste porcelain fired to 1400°C in a reduction atmosphere.

The philosophy underlying this service is that, by offering a variety of functions, usability is increased substantially and therefore 'part of the designer's responsibility is thus transferred to the consumer'. The mortar was the starting point for the form; although this used to be a common object in all kitchens, it has now fallen out of use to a considerable extent. The service is multi-functional, being completed by lids that double up as small boards to be used on the table. A matching serving spoon accompanies each dish.

In 1987 he established Studio Pieter Stockmans in order to obtain a more independent position with respect to the industry. Here he is able to experiment and continues to produce small series using traditional methods that are unsuitable for mass production.

Stefanie Hering (Germany)

Stefanie Hering is another maker who has worked closely with large ceramic manufacturers as a freelance designer until finally deciding to establish her own production company,

Espresso, tea and coffee bowls by Stefanie Hering. (6 to 9cm h.).

Márta Nagy (Hungary), Herend

After studying under the legendary Imre Shrammel in the porcelain faculty at the Hungarian Academy of Applied Arts in Budapest in the late 1970s, Nagy has established herself as one of the most significant ceramicists working in Hungary today. Her work embraces two very different genres, each with its own unique characteristic. Her work as a ceramic artist, in which she is producing individual sculptural pieces (*see* Chapter 3) sits comfortably alongside her industrial work.

The two most dominant and internationally recognized factories in Hungary are the Herend Porcelain factory and the Zsolnay Porcelain factory. Each has very different markets, with Herend originally catering to royal and aristocratic households and Zsolnay more for the middle classes. Nagy has worked as a designer for both. For Herend in 1996, she produced a range of items based on fruit, in which she strove to maintain the intrinsic purity of the porcelain by using very little supplementary decoration. Later, in 1998, she started work for the Zsolnay Porcelain factory, working on a series of pieces that exploited the factory's famous eosin glaze.

She is currently a professor at Pècs University, where she gained a doctorate in ceramic sculpture, and continues to exhibit her work widely.

'hering BERLIN', in 1999. Together with her former workshop partner, Wiebke Lehmann, and Hering's husband, the architect Gotz Esslinger, a new brand was created which currently enjoys international acclaim. Based on Esslinger's plans, a custom-built building has been erected to accommodate the studio, workshop and private apartment under one roof in the Konigsweg in Zehlendorf.

From 1993, Hering worked with companies such as: Rosenthal and Hutschenreuther in Selb, Germany; Porcelaines Bernardaud in Limoges, France; and Spal Porcelanas in Alcobaça, Portugal. From the outset, she would build up a close collaboration with the art direction, technical and marketing departments and continue this until the end of the project.

Hering's own production company, which currently employs five people, involves throwing, slip casting and roller machine methods, with strict quality control being uppermost to maintain high standards. She uses KPCL TM 10, a porcelain throwing body from Limoges and a casting slip from an original recipe from Hutschenreuther, also available from KPCL. Although using industrial techniques, there is still a large proportion of hand-decoration in the manufacturing processes. Although the pieces illustrated here are produced using a roller machine, the decoration is applied by hand using Shellac and the water erosion method. The pieces are fired to 1400°C, with a biscuit exterior and glazed interior (*see* Chapter 5).

Hubert Kittel (Germany)

Kittel studied industrial design at the Burg Giebichenstein (University of Art and Design) in Halle, eastern Germany, in the mid to late 1970s. Remaining in education, apart from a short break in 1980–83 when he worked as a designer in a porcelain company, since 1994 he has been Head of Department of the ceramics and glass department at the Burg Giebichenstein. Kittel has maintained a strong and passionate interest in porcelain, which is reflected not only in his own work (*see* Chapter 4), but also in the work of the students who graduate from the university.

OPPOSITE PAGE:
TOP: 'Grape Bonbonnière' by Márta Nagy.
Slip cast porcelain with pierced decoration and gold leaf.
Produced at the Herend Factory. 1997.

BOTTOM: Tableware set for children by Hubert Kittel.
Slip cast hard-paste porcelain with sprayed inglaze colours.
Fired to 1400°C. 1996–2000. (Photo: Klaus E. Goltz)

His tableware range for children was originally designed as a 'learning set' for his daughter – 'my own cup, my own pots – my first tools'. He developed different sizes, handles, solutions for locking the lid and keeping the cups warm, as well as using a combination of porcelain and wooden elements to increase the durability of the product. The entire range, which includes bowls and plates, can be adapted to the needs of a growing child between the ages of four to twelve years. The colour range changes and many of the items are stackable. One piece is oven-proof and they are all dishwasher-proof, except for the wooden elements. He says of the design: 'The image should be soft, compact, funny and with the appeal of touch and use me!' Between 1990–95 the range was industrially manufactured by a porcelain company, but now is part of Kittel's own production under the title of a 'craft design product'.

'Zeppelin' by Antje Dietrich.
Slip cast hard-paste porcelain.
Reduction-fired to 1450°C.
Produced by Kahla Porzellan.
2001. (Photo: Frank Rüdiger)

Antje Dietrich (Germany), KAHLA

Graduating from the Burg Giebichenstein University in 1992 and later working as an assistant in the department, Dietrich has used her knowledge of industrially produced porcelain to produce work for the KAHLA Porzellan Factory in Thuringia, eastern Germany.

Established in 1844 by Christian Jacob Eckhardt, KAHLA originally produced porcelain cups, pipes and doll's heads. Now, through innovative, design-oriented product development, modern technology and successful marketing strategies, KAHLA has become the largest porcelain manufacturer in Thuringia. It employs two in-house designers, but also uses freelance designers such as Cornelia Muller, Barbara Schmidt and Simone van Bakel. The importance placed on design within the factory has been rewarded by twenty-seven design awards in the last eight years.

Collaboration between KAHLA and the Burg Giebichenstein students has produced some innovative designs, including those of Dietrich.

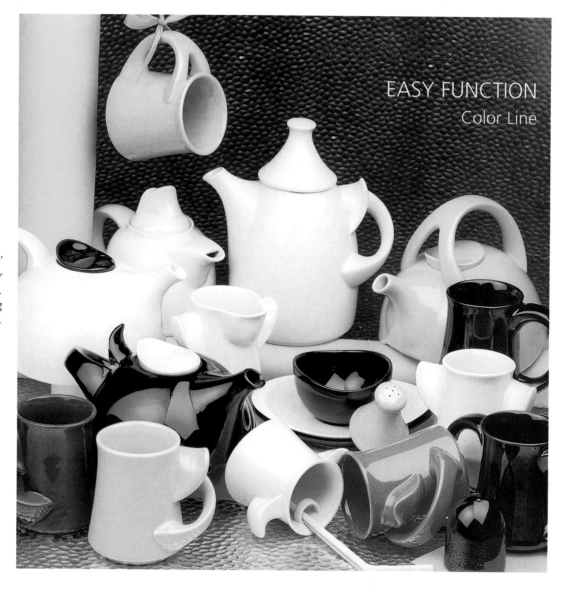

EASY FUNCTION
Color Line

*'Easy Function Colour Line'
by Angela Schwengfelder
and Michaela List.
Produced by Annaburg
Porzellan. 1992.*

Dietrich's piece 'Zeppelin' is the result of an international workshop, known as 'KAHLA Kreativ', which has been held at the factory since 1992.

Angela Schwengfelder/ Michaela List (Germany), Annaburg Porzellan

Graduating from Burg Giebichenstein in 1991, Schwengfelder and List collaborated to produce the 'Easy Function' line, now produced by the Annaburg Porzellan company. The idea behind the line originated from their thesis work with

physically handicapped people. The two designers went on to win the prestigious Westerwaldpreis (Industrial Ceramic section) in 1992 with this design. List now works in the social field, whilst Schwengfelder teaches in the ceramic and glass faculty of Burg Giebichenstein.

The 'Easy Function' range is intended primarily for people with a limited ability to grip; it is also suitable for physically handicapped children who can use it to help them to learn to eat and drink. The angled handles with thumb rests make it possible to hold the item firmly, even when the hand cannot be completely closed. The base of the teapot is curved in such a way that most of the liquid can be poured out with the minimum of tilting. Cups and mugs with spouts make it possible to drink independently with a paralysed mouth; they do not fall over even if put down without full control. Being sensitively designed, the range aims to avoid any hints of being 'crockery for the handicapped'.

Michael Flynn (Ireland), Meissen

Originating in Ireland, then emigrating to Germany as a child and now having a workshop in both Wales and Germany, Flynn seems capable of adapting easily to whichever country or situation he finds himself in. This, in many ways, is true of his work too. He initially trained as a painter then latterly as a sculptor, under the guidance of Alan Barrett-Danes in Cardiff, where he developed the energetic figurative style that has become his trademark (*see* Chapter 3). His work is based on the narrative, gathering themes from a variety of sources whilst changing his clay to suit. He is as equally comfortable working in raku as he is in porcelain.

In 2000 he made a collection of pieces at Meissen Porcelain in Germany. He was invited to participate with a group of other artists to make one-off pieces for the 'Pfeifer Edition 2000'. This was to commemorate the one-hundredth anniversary of the birth of Pfeifer, who had been the director of the Meissen porcelain factory during the 1930s. However, when the Nazis came to power, he was thrown out because of his liberal views.

Meissen wanted Flynn to make the pieces in the factory; however, he preferred to make them in his own studio in Germany. This was quite an undertaking, as his studio was eight hours' drive away. Nevertheless, they delivered the clay and, once made, collected the bisque-fired pieces for the glaze firing at the factory. Flynn then spent three weeks in the factory applying the onglaze enamels to the twenty-five pieces he had made.

After discussions with Meissen's technical staff, a body was made up especially for him. So, by adding toilet paper to their usual porcelain recipe, modelling was made much easier. The hollow pinched-out sections such as torso, limbs and so on were often assembled by sticking dry pieces together with the wet clay. The dryness depended on the type of porcelain used. They were glazed and fired to 1450°C in a gas kiln, with onglaze enamels being added later for the decoration.

The pieces were exhibited at the Grassi Museum in Leipzig, along with work from twenty other German and Austrian artists, most of whom were painters and sculptors. The Meissen Museum bought two of the collection, whilst some were sold and the remainder were split between the factory and Flynn.

Quoting from Jane Waller's book *The Human Form in Clay*, Flynn says of his work:

> Basically I am interested in how people have responded to their world at different times in history, in the beliefs and traditions that have developed, how they have originally been presented and how I might express them in contemporary terms.

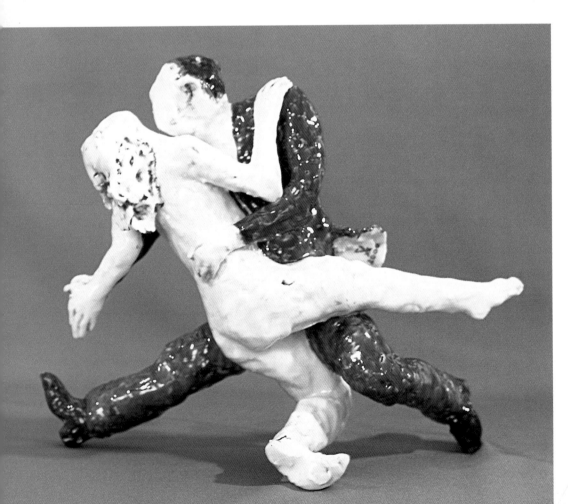

THIS PAGE:
'Dance Partners' by Michael Flynn. (32cm h.) Hard-paste porcelain. Made at Meissen. 2000.

OPPOSITE PAGE:
LEFT: 'Salto' by Bodo Sperlein. Slip cast chandelier in hard-paste porcelain. Produced by Nymphenburg. 1999. (Photo: Graeme Duddridge)

RIGHT: 'Scenario' by Bodo Sperlein. Hand-built textured light in hard-paste porcelain. Produced by Nymphenburg. 1999. (Photo: Graeme Duddridge)

His collaboration with Meissen highlights the fascination he holds for understanding the tradition to which a material, such as European porcelain, belongs and how those traditions relate to the finished object.

Bodo Sperlein (Germany/UK), Nymphenburg

German-born designer Sperlein studied ceramics at the London Institute (Camberwell College of Art) in the mid-1990s. After establishing his studio in London, his career has involved working independently on numerous projects and commissions (*see* Chapter 8), as well as designing his own collection for the German porcelain manufacturer Nymphenburg in Munich in 1999.

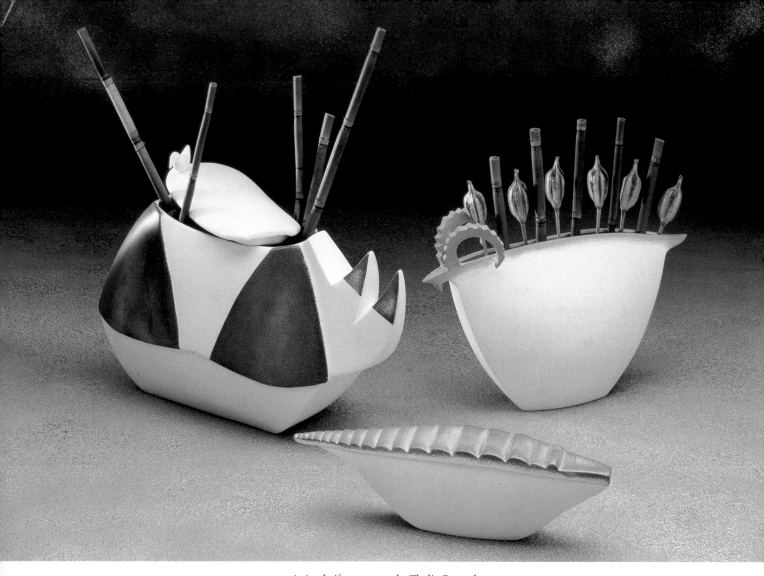

Animal giftware range by Thalia Reventlow.
Hard-paste porcelain produced by Bernardaud. (Photo: Dominique Cohas)

Thalia Reventlow (Danish/French), Bernardaud

Danish-born Reventlow has lived and worked in southern France for several years. Originally a hand-builder and thrower, she was pleased to accept the challenge to have a range of pieces produced industrially. Having had some previous experience working for Tharaud porcelain in Limoges, where she designed a tableware range, she was familiar with some of the pitfalls that could be encountered. She was offered the possibility of royalty remuneration, but as it was not clear whether the design would be produced, she wisely opted for a three-monthly salary – the time she had worked on it.

Reventlow was later commissioned by Bernardaud, one of the largest porcelain manufacturers in Limoges, to design a giftware range. Her brief was to design a range of vases and lidded containers adapted from her usual studio style.

She supplied plaster prototypes to the factory, after which they followed the normal production route. Bernardaud was not prepared to pay royalties in this instance, and so Reventlow was paid a monthly salary for the duration of creating the prototypes and ten examples of each piece for her own use. This came at a time in her career when gaining experience, skills and knowledge outweighed the financial rewards.

Olivier Gagnère (France), Bernardaud

Gagnère is one of a number of designers originating from a non-ceramic background who have worked for Bernardaud. He is considered to be a leader of contemporary French tradition in the decorative arts, having worked in the fields of furniture, lighting and glass as well as ceramics, and his

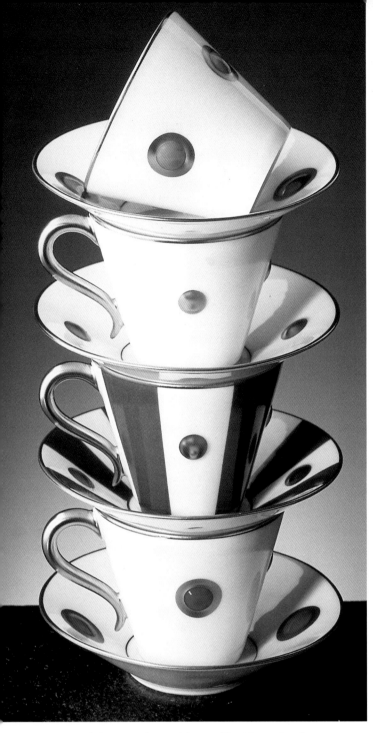

'Ithaque and Lipari' designed by Olivier Gagnère.
Produced in hard-paste porcelain by Bernardaud.

'Couronne' vase designed by Martin Szekely.
Produced in hard-paste porcelain by Bernardaud. 1999.

Martin Szekely (Hungary/France), Bernardaud

work has been described as 'being located between the margin of tradition and innovation'.

He has recently designed an 'ambience' for a literary-style café at the Musée du Louvre, installed in one of the former salons of the Duc de Mornay, as well as the Salon de Thé Bernardaud located in Rue Royale, Paris, in 1995.

Amongst his ceramic design for Bernardaud is the collection 'Ithaque and Lipari', in which he works within the medium of the grand classic tradition applying a contemporary approach.

In 1999, Bernardaud commissioned Hungarian-born Szekely, who now lives and works in Paris, to design a piece for a limited-edition series. Szekely is renowned in the design world for the purity of his ideas. Whether in the private or public sector, he favours simple, strong, yet elegant lines, but with a reference to contemporary styles without being trend-driven. His designs are always linked to a craft process regardless of the mode of production. The object is not created to decorate, but rather to subtly inhabit a space. For him, the 'Couronne' vase shown here was 'an object created for the celebration of the bouquet: the simplest of domestic rituals'.

Hervé van der Straeten (France), Bernardaud

Trained at the L'Ecole des Beaux-Arts in Paris, Van der Straeten quickly established his name as a costume jewellery designer and since 1985 has accessorized many of the Paris fashion shows.

As well as jewellery, he has created a collection of home accessories such as mirrors, candlesticks and lighting. Then, at a recent Biennale de L'Email (Enamel Biennial) in Limoges, he was approached by Pierre Bernardaud who suggested a collaboration with the Bernardaud porcelain company that resulted in a tableware collection based on Greek Mythology.

ABOVE: 'Bacchanale' dessert plate designed by Hervé van der Straeten. Produced by Bernardaud.

BELOW: 'Underscore' porcelain plate and mug with aluminium tray designed by Ricardo Bustos. Produced by Artoria. 2002.

Ricardo Bustos (Argentina/France), Artoria and Les Porcelaines Avignon

Born and trained as a painter in Argentina, Bustos moved to France in the 1990s, where he developed a career as a designer using a variety of materials. He opened his own gallery in

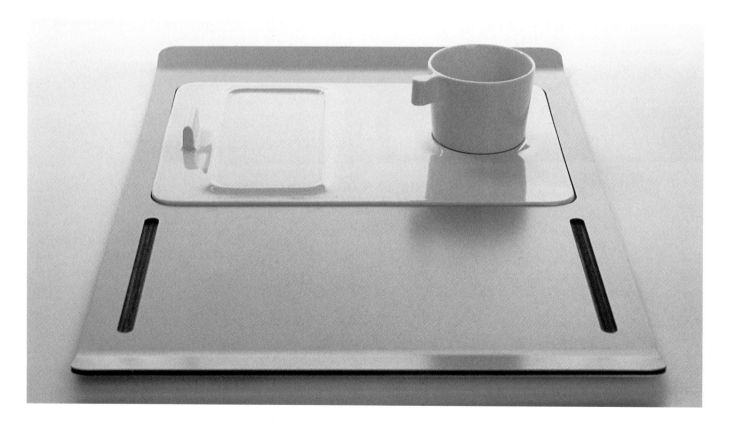

Paris, at which he shows his permanent collection of steel furniture, as well as temporary exhibitions by other designers.

In 2002, Les Porcelaines Avignon collaborated with a design collective, which included Bustos, to create Alliages. The name refers to the double meaning of the word – alliance or alloy, the intention being to establish contacts between manufacturers and creative designers. By encouraging other French companies to share their technical expertise with the Alliages designers, quality prototypes or short production runs can be produced, which, in turn, can be presented to future manufacturers.

This is a welcome initiative and one that deters designers from needing to seek manufacturers in Poland or India, for example. There is a word of caution, however. Quoting from an article written by Laurence Salmon in the March/April 2002 issue of *Atelier d'Arts*, Bustos stresses: '...this initiative will remain meaningless unless other manufacturers take this up and see the long-term interest of creative design'.

In September 2002 Bustos designed the 'Underscore' tray for Artoria, a small porcelain company in Limoges. It was subsequently launched at the Maison & Objet fair in Paris.

Patrick Norguet, (France) Artoria

Furniture designer Patrick Norguet is another designer who has worked with Artoria in Limoges. His inventive design has helped to consolidate Artoria's contemporary image, with work featured at Colette in Paris, Corso Como in Milan and the MOMA boutique in New York. Norguet welcomes the fact that, when working with Artoria, he is able to 'enter into the history of the material'. Unfortunately, he finds this is not the case with the majority of French manufacturers, and so he has subsequently looked to Italy as he feels that manufacturers there are 'undeniably more open'.

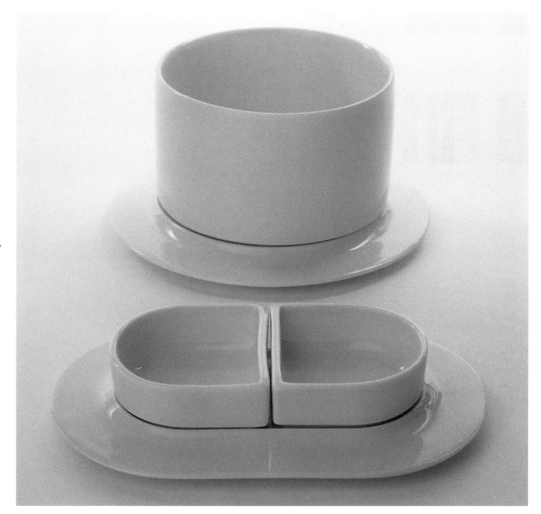

'Ring 2' designed by Patrick Norguet. Porcelain. Produced by Artoria. 2002.

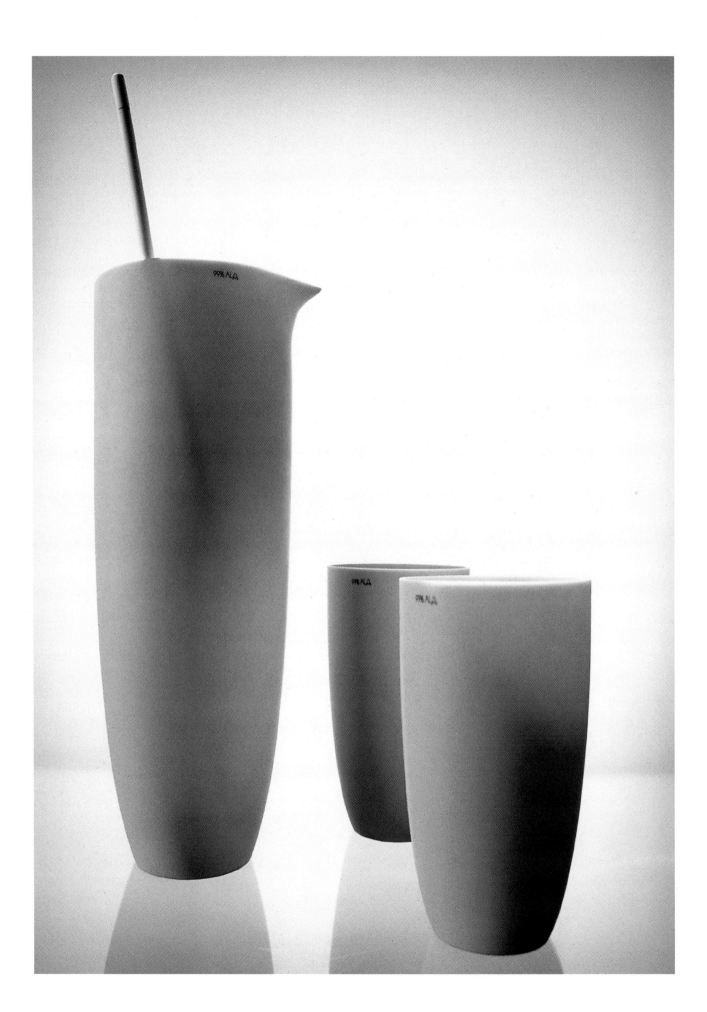

8

Advanced Technology

This chapter aims to serve as a snapshot of the possibilities open to porcelain and bone china in their role as 'advanced' ceramic materials. Since the early Chinese discoveries of over 1500 years ago, through the European porcelain industries and right up to the present, these high-firing clays find themselves firmly in the studio ceramicists' domain. However, they increasingly feature, in one form or another, in today's technical ceramic world and, surprisingly perhaps, in our everyday products.

An exhibition entitled 'Super Ceramics Exhibition' was held at the Netherlands Design Institute in Amsterdam during the Ceramic Millennium in 1999. However, advanced ceramics are not made from the natural raw materials. Chemically pure metal oxides form the basis of this entire range of newly designed materials which resemble synthetic substances, rather than fired clay. Featured items from the technical end of the ceramic spectrum included surgical scissors with hard ceramic coatings; kitchen knives with ceramic blades, produced by Kyocera (Japan); and even bulletproof vests with ceramic plates protecting the back and chest, used by police in extreme conditions.

Various technical ceramics have already proven themselves with their unique, controllable qualities of hardness, inertness, energy conduction, heat and corrosion resistance. Amongst those exhibited were a walking-stick handle, which adjusts to the temperature of the hand by heat conduction; heat-resistant tiles employed on the nose cones of spaceships; and a ceramic membrane, used for separating and purifying fluids such as olive oil and fruit juice.

Medical implants also featured. For example, the tops of hip prosthetics can be made from advanced ceramic materials, as well as from metal. They bear a remarkable chemical similarity to natural bone. As well as being very tough, their bio-compatibility and successful absorption by the surrounding tissue make this type of ceramic ideal for prosthetic use.

The current work of Dutch maker **Simone van Bakel** demonstrates an entirely innovative use of porcelain, treating it as a bio-ceramic implant. Being fascinated by the way people use their bodies and having already worked for a while on the theme of 'Skin', this recent work is a natural progression for her. Therefore, following an invitation from the European Ceramic Work Centre in s'Hertogenbosch (Holland) to produce something with the theme of 'Dutch Souvenirs', she invited Matthias Keller to collaborate with her in the Floral Sculpture Clinic project.

Their starting point stemmed from the wealth of flowers the Dutch are renowned for and the new bio-ceramic material (which up until now has only been used for medical purposes, as a replacement for gristle/cartilage). The project involved making a collection of jewellery that translated into bracelets, necklaces and ornamental implants. Van Bakel describes it as 'jewellery which grows together with the human body – a permanent ornament!' Likened to the ethnic initiation rituals of body piercing and tattooing, implants are becoming a common aspect of Dutch street culture.

The prototypes are, in fact, made from porcelain and fired to 1260°C (whereas the bio-ceramic material is fired to 1600°C). Following consultation, the implant is slipped under the skin, through a series of minute incisions, and is placed on the bone in such a way that it stays secure. After implanting, the incisions are stitched, resulting in no visible scars. For further information visit: www. Floralsculptureclinic.nl.

Another use of advanced ceramic material is demonstrated in the recent work of **Marek Cecula** (*see* the Chapter opening illustration and Chapter 7). Experimenting with the very hard, naturally occurring mineral known as corundum, he has produced a range of pieces which are hard and translucent.

The name 'corundum' is derived from the Sanskrit word *Kuruvinda*, meaning 'ruby'. Possessing the same mineral make-up as rubies (red corundum) and sapphires (blue corundum), it is almost pure alumina (99.9%) and is second in strength and hardness only to diamond. It is also very abrasive and is more commonly found in emery paper

OPPOSITE PAGE:
'Nectar' set by Marek Cecula. (22cm h. and 11cm h.)
Slip cast industrial corund 99.9% alumina.
Fired to 1750°C.
(photo: Bill Waltzer)

RIGHT: 'Narcis' implants prior to insertion.

FAR RIGHT: Simone van Bakel with 'Narcis' implant. 2003.

BELOW: VPP bone china wall light installation for Sothebys by Bodo Sperlein. 2000. (Photo: Graeme Duddridge)

coatings, which are made up of a hard grey-black mineral consisting of corundum and either hematite or magnetite.

Corundum is usually used in the machine-parts industry and is fired in custom-built kilns to extremely high temperatures reaching 1750°C. This makes it particularly durable whilst retaining its delicate, translucent character. Adapting this material to ceramic processes, Cecula has produced a body of elegant slip cast work (although corundum mass can also be extruded or pressed). It is cleaned and polished at the bisque stage, as well as after firing; however, at this point it can only be cut with a diamond saw.

VPP (Viscous Plastic Processing) is a process with which **Bodo Sperlein** and others have experimented in conjunction with bone china. In basic terms, it is a process that can alter the nature of the material to which it is applied. In this case, the usual bone china body is blended with binders using a high-energy, high-shearing mixing (mechanical kneading) regime. The combination of viscous, gelatinous binders and high-shearing mixing disperses and coats the clay particles thoroughly. This renders the bone china very pliable when wet (similar to PVC), and extremely tough and rigid when dry – virtually the opposite to its usual characteristics.

Approximately 5% of binder is added to the body to allow the material to be used in sheet form, either by draping, rolling or manipulating it in a way that would not normally be associated with bone china. It has even been used for injection moulding. Although it has been likened to paperclay, this material is more versatile because of its elastic behaviour when wet, and its great strength when dry. It is fired through the usual routes, during which it behaves identically to conventional bone china.

The process has been developed for industrial applications, and small quantities are not normally available. However,

for further information contact: Dr Gavin Buckles at CERAM Research, Queens Road, Penkhull, Stoke-on-Trent ST4 7LQ, UK.

A maker who uses a combination of plastics and bone china is **C.J. O'Neill** (Ireland/ UK). On a recent project, she collaborated with plastics artist **Stella Corrall** to design and make some bowls which capitalize on the translucent quality of bone china. On first impressions, the decoration looks like silk-screened enamels showing through from the inside. However, on closer inspection, it is clear that a thin layer of plastic has been applied to the interior.

After slip casting with Valentine's bone china slip, the pieces follow the normal procedure for unglazed ware of soft-bisque sanding, then firing to 1240°C. Polishing with wet and dry paper ensures a satin-matt finish, after which the plastic strips are inserted. Dyed plastic PVC inserts are held in place by tension. One end is hooked under the lip on each side of the bowl then pressed into place.

'Solas Coinneal Stripe' by C.J. O'Neill. (15 × 15 × 8cm)
Slip cast bone china with plastic inserts by Stella Corrall. 2002.
(Photo: Steve Yates)

CADCAM (Computer-Aided Design and Computer-Aided Manufacture)

Apart from the exciting possibilities offered by altering the clays themselves, there have also been important developments within the ceramic design and model-making fields using computer technology. Increasingly, CADCAM has become a popular tool, not only within the ceramic industry, but also with individual makers (*see* Tavs Jørgensen, Brian Adams and Justin Marshall). The introduction of this technology in the early 1980s has had a significant effect on the ceramic industry, both in practical and economic terms. Wedgwood, for example, has been using CADCAM technology for fifteen years, with 95% of its design work being carried out using this method. Traditionally, model-making skills relied on a modeller's expertise, precision and knowledge of working with plaster, plus his or her ability to visualize both positive and negative shapes. Today, using this new technology, a jug, for example, which would normally

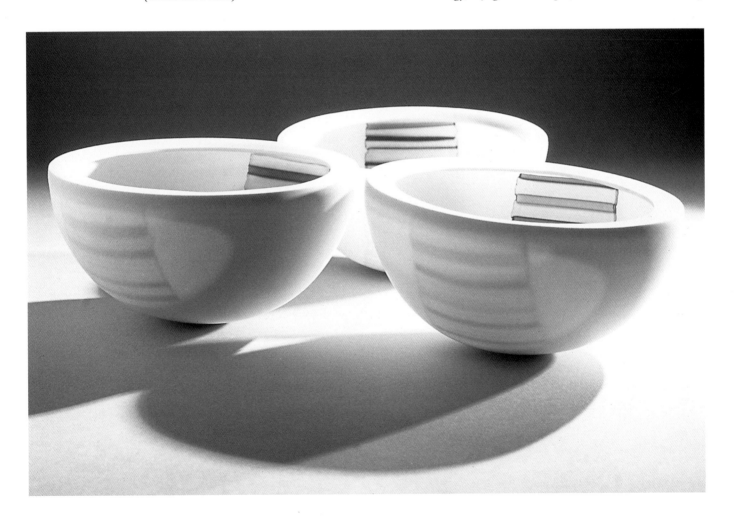

Example of a CAD image from the 'Ripple Vase' range by Brian Adams. 2001.

take two to three weeks to model in plaster, can now be completed in twenty-four hours.

In order to understand the basic principles of this technology, a brief explanation of CADCAM is required; however, the following individual makers describe in more detail their particular approaches: CAD (computer-aided design) involves outline drawings being re-created on a computer using an 'object-oriented' drawing system. Plans and elevations of these drawings are converted into three-dimensional 'wire models' on the screen. They can be viewed from any angle and modified in any way, as well as rendered to show shape, colour and shadows.

CAM (computer-aided manufacture) facilitates the making of a three-dimensional model using various rapid prototyping techniques. This relies on two-dimensional data

held on the computer being linked directly with a milling machine, which, in turn, produces the prototype or model.

A maker who has carried out extensive research with this type of work in the UK is Danish-born **Tavs Jørgensen**. Describing his fascination for computers he says: 'Initially I viewed new technology with some scepticism, perhaps not surprisingly, given the craft environment in which I started my career. As my work changed towards designing for the ceramic industry, I started to use computers and began to realize the potential of this emerging tool.'

Here he clearly describes the Rapid Prototyping (RP) process:

Rapid prototyping is a generic term to describe a number of technologies that enables production of real physical objects

Diagram of cup translated into 'sliced' CAD image. (Courtesy of Tavs Jørgensen)

directly from three-dimensional computer aided design data. The principle of rapid prototyping relies on building an object from a series of stacked cross-sections. A computer model (three-dimensional drawing) is divided into very thin layers by the software, thereby converting a 3D manufacturing task into a series of 2D ones. The object is then constructed, layer by layer, by a computer-controlled RP machine. The bonded stack of layers forms the final solid object.

The main advantage with the RP technology is that it gives almost total geometrical freedom to create objects that were previously almost impossible to build, or required numerous separate development stages.

There are five main commercial processes to choose from:

- ■ stereolithography (SLA)
- ■ selective laser sintering (SLS)
- ■ fused deposition modelling (FDM)
- ■ Z Corp
- ■ laminated object manufacture (LOM).

The first three provide models in plastics or resins, Z Corp uses a powder (usually plaster) fused with a binder and LOM creates models by layers of glued paper. In the ceramic industry, the technology has already become firmly established for creating realistic presentation prototypes that would normally require enormous amounts of modelling and mould making. The preferred method is FDM, as it produces high-quality prototypes of robust ABS plastic (normally used in the manufacture of car bumpers) that can be tested and handled, like the final item.

Z Corp machines are a cheaper alternative, but the material strength and surface quality are not as good as with FDM. The textured surface, which is characteristic for RP in general, also means that the process is rarely used to make

the final models from which the production moulds are made. For this task, CNC (computer numerically controlled) milling machines remain the better option, as these can use the same computer data as an RP object.

(LOM) Laminated Object Manufacture

Tavs Jørgensen goes on to describe this process:

Objects are built up by layers of pre-glued paper that is joined, layer by layer, with a heated roller. Each layer is cut by a laser beam representing the cross-section of the object at that particular level. The build platform moves downwards and the cycle starts again. The laser intensity is set to cut through only one single layer of paper, thereby not damaging the previous layers. The rest of the glued paper acts as support for the model while building, but it is essentially scrap being automatically cross-hatched, by the laser, for easy removal. Although the build material is usually paper, a variety of other sheet material, such as MDF (multi-density fibre-board), can be used.

LOM is particularly suited for creating large models and is most commonly used in the automotive industry. The process is rarely used in the ceramic sector, but for the 'Contour Project' LOM was the only RP method that could deliver the pronounced stepped nature.

Jørgensen concludes by saying:

The RP technology holds a great potential not only for creating accurate prototypes, but also for direct manufacture. However, in this case the RP was used only in the initial stages of the model/prototype. To arrive at a finished ceramic shape,

Diagram of a LOM machine.
(Courtesy of Tavs Jørgensen)

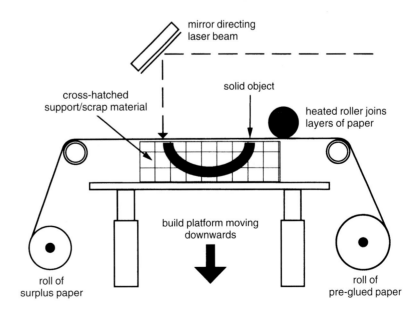

CONTOUR PROJECT.
(COURTESY OF TAVS JØRGENSEN)

LEFT: *MDF sections cut by LOM RP machine for Contour cups.*

BELOW LEFT: *'Contour' cup model (stacked MDF section).*

BELOW: *Laser cutting sections using LOM machine.*

BOTTOM: *'Contour' bowl by Tavs Jørgensen. (21 × 8.7cm h.) Slip cast bone china. Fired to 1200°C. Model produced using LOM process. 2002.*

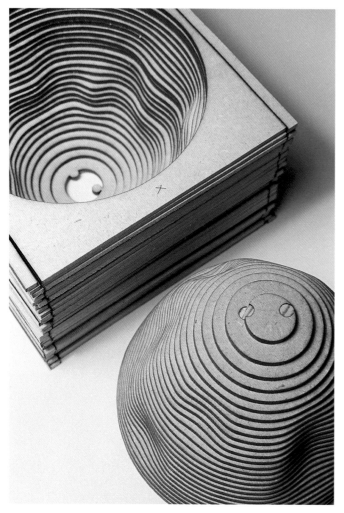

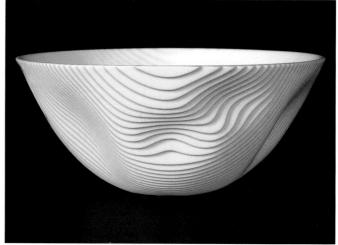

very traditional making skills still had to be applied. The MDF models had to be developed through a series of plaster and silicon rubber moulds before working moulds could be made. The rapid prototyping process did add a unique aesthetic, which would not have been possible to replicate using traditional modelling skills.

Further development is continuing on the 'Contour range' with new shapes in the pipeline. However, despite many attempts with different materials and settings, the LOM method of construction has proved too inefficient for this type of object. The contour lines are now made using software emulation with the layers still being cut using computer-controlled lasers.

Brian Adams (UK) has also used one of the CADCAM processes in his recent work.

Deriving source material from the repetition and subtle complexities found in nature, such as the construction of a shell, the ripple on a pond and so on, he produced a range of 'Ripple Vases' in both porcelain and earthenware. He used porcelain in this instance, not for the translucent qualities, but for its permanence. Like Jørgensen, he exploits:

> The technology to create objects that, while simple and familiar, are impossible to create by conventional means. Similar to a 3D photo, the form emulates a normally brief and ephemeral moment of a ripple on water and, like a photograph, freezes that moment in time. The aesthetic of the objects do not proclaim or celebrate their digital origins and yet this object is truly a product of technology.

His work draws on computer visualization skills and layer manufacturing technologies, using them to generate forms of great complexity in the digital space and then translate those forms as tangible objects. He says: 'I am interested in the gap between the virtual space of the computer and the tangibility of physical objects.'

A digital model is produced on the computer using 3D Studio MAX, and exported as an STL file (the standard format for all layering manufacturing). In this case, the model was manufactured in ABS plastic using the FDM method. The two parts of the model were assembled and the model worked on to improve the surface quality. As the surface of most rapid prototyping models are not of a high enough quality for direct moulding, a silicon rubber mould is taken from the RP model, then a series of plaster 'waste' moulds made from that to achieve the finished model. Once made, this is 'cased' and working moulds are made.

Sharing some of Jørgensen's views, Adams concludes by saying:

> But CADCAM for me does not completely replace the need to make. Many of the layer manufactured models are simply not of a high enough standard – the surface quality, in particular, can be poor. Also, as some of my work develops around the idea of 'repetition', one smaller form being the sub-set of the whole, these objects need many models and moulds plus many hours in the workshop. The hand of the craftsman, therefore, still plays a role in their appearance.

The CADCAM work of **Justin Marshall** (UK) was produced as part of a research project funded by the Arts and Humanities Research Board (AHRB) and carried out at Bath Spa University College in 2001. He investigated the potential of using the DeskArtes 'Design Expert' software program to produce digital forms and surfaces in conjunction with appropriate RP techniques from the perspective of a *craftsman*, not a designer. Describing himself as such, he says:

> One of the defining features of a craftsperson is the importance of 'designing through making', having 'ends in view' rather than the fixed final outcomes which many designers work towards. Therefore this software was not investigated as a passive tool for modelling pre-existing designs, but as an active medium with which to experiment. The CAD modelling process was considered as an integral part of the creative process of developing new forms and surfaces, not a means to an end.

After the successful manufacture of the LOM models (as previously described), cold-cure silicon moulds were produced from these models. Plaster models were then produced from the silicon moulds. However, the stepped surface texture developed in the virtual environment caused major problems, trapping air during the casting process and resulting in loss of surface detail in the model. To partially overcome this problem, silicon models were then produced from the silicon moulds. These, in turn, were used to make plaster slip casting moulds. Marshall makes some interesting observations concerning this:

> The problems encountered at the moulding stage illustrate how important it is to have a good knowledge of the processes involved in producing the actual ceramic work when using CAD, and to remember that it is only one stage in the making process. The virtual environment can be seductive and it is easy to forget the inherent restrictions of ceramic production processes and get carried away designing the 'virtually' unmakeable.

For further information refer to articles written by Justin Marshall in *Ceramics Technical* (No.14, 2002) and *Ceramic Review* (No.194, 2002).

As with all new technologies in their infancy, CADCAM was initially prohibitively expensive. Although the costs of these methods are now falling, up until recently it was only the largest ceramic companies which could operate these facilities. There are now, however, specialist firms offering services to smaller ceramic manufacturers and individuals,

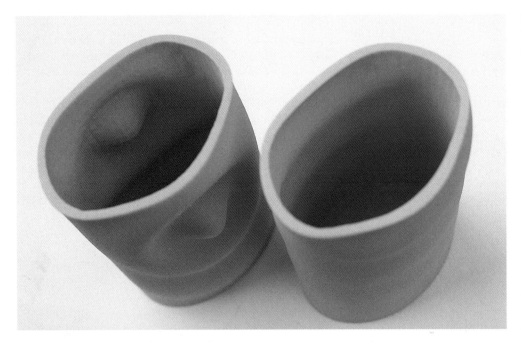

Rapid prototype model of 'Ripple Vase' made using the FDM process. (Courtesy of Brian Adams)

BELOW: 'Ripple Vase' by Brian Adams. (30cm h.) Slip cast porcelain. 2001.

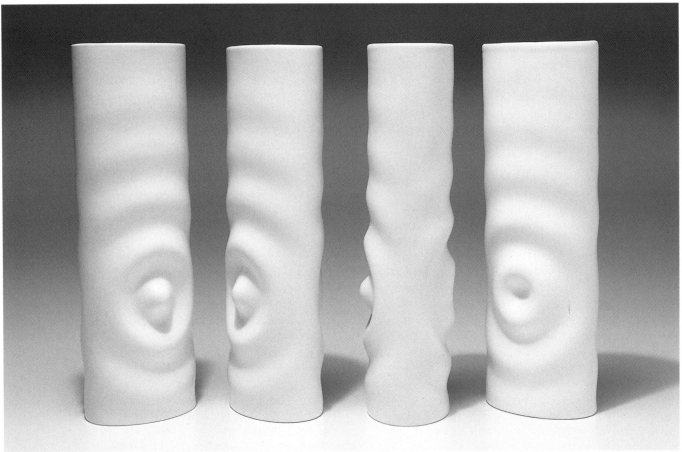

making it possible to realize a variety of projects. One such company is The Hothouse in Stoke-on-Trent. It provides the very latest CAD design facilities for shape and pattern development, with Virtual Reality tools being implemented into the design processes, plus a variety of RP machines (*see* Suppliers).

SILICON MODELLING AND MOULDING FROM A *LOM* MODEL WITH RESULTING PLASTER SLIP CAST MOULD.

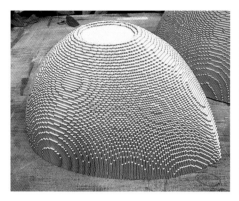

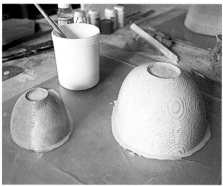

LOM model.

Applying silicon rubber to LOM model.

Silicon mould being removed from LOM model.

Silicon model produced from silicon mould (with slip cast mould in plaster).

Plaster slip cast mould.

Three pouring bowls by Justin Marshall. (14–28cm h.) Slip cast in semi-porcelain. 2001. (Photo: courtesy of Justin Marshall)

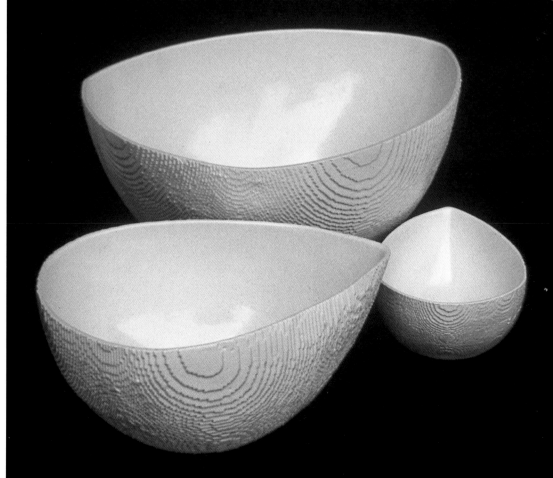

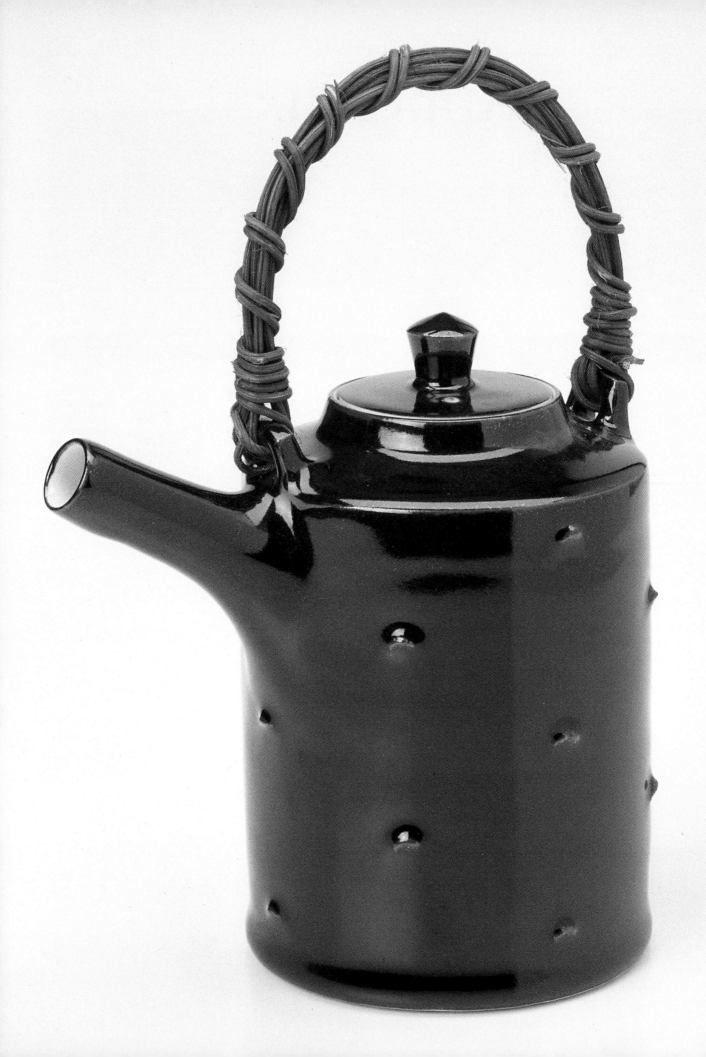

Appendix

The Appendix contains information about the individual slips, colours and glazes used by some of the makers featured in this book.

Bristle Clear Glaze for Porcelain (Sandra Black) 1220–1300°C

- 29.3 nepheline syenite
- 9.7 whiting
- 6.4 barium carbonate
- 7.9 zinc oxide
- 3.9 talc
- 10.1 china clay
- 5.0 ball clay
- 27.7 silica
- + 5 tin oxide (for white glaze)

Barium Base Glaze (Pippin Drysdale) Orton cone 6 – 1220°C

- 20 barium carbonate
- 60 potash feldspar
- 10 whiting
- 10 magnesite (heavy)
- + 4 bentonite (USA)
- 25 ferro frit 4113

Crackle Ash Glaze (Joanna Howells) 1280°C

- 16.8 flint
- 32 feldspar
- 16 china clay
- 32 wood ash (different ashes give different effects)
- 3.2 whiting

Mo Jupp's Clear Glaze (Joanna Howells) 1280°C

- 16 flint
- 11.9 china clay
- 5.3 dolomite
- 17.6 wollastonite
- 63.2 cornish stone
- 2.0 bentonite

Calcium chloride is used to suspend the glaze. Ball-milled for two hours.

Deep Celadon (Chris Keenan) 1280°C

- 21 quartz
- 27 china clay
- 19 potash feldspar
- 33 wollastonite
- 0.5 red iron oxide

OPPOSITE PAGE: *Teapot by Chris Keenan. (24cm h.) Thrown Limoges porcelain with Tenmoku glaze and woven cane handle. 2001. (Photo: Michael Harvey)*

Geoffrey Whiting's Tenmoku (Chris Keenan) 1280°C

- ■ 85 cornish stone
- ■ 15 whiting
- ■ 10 china clay
- ■ 20 quartz
- ■ 10 red iron oxide

All-Purpose Porcelain Glaze (John A. Murphy)

- ■ 25 china clay
- ■ 25 ball clay
- ■ 15 ferro frit 3195
- ■ 20 flint
- ■ 5 talc
- ■ 5 Superpax (tradename for zirconium silicate)

Porcelain Slip for Larger Pieces (Mieke Everaet)

- ■ 1kg dry porcelain
- ■ 200g molochite
- ■ 2g peptone
- ■ 2g CMC (an organic cellulose gum acting as a binder and suspension agent)

Black Porcelain Slip Used for Inlaying (Sandra Black) 1280°C

- ■ 100 porcelain clay
- ■ 10 black iron oxide
- ■ 5 manganese dioxide
- ■ 2 chrome oxide
- ■ 3 cobalt oxide

Porcelain Casting Slip (Alison Gautrey) 1280°C

- ■ 10kg Potclays HF 1149 porcelain
- ■ 900ml water
- ■ 20ml sodium dispex

Bone China Slip for Dipping and Biscuit Application (Caroline Harvie)

- ■ 4pt bone china casting slip
- ■ 2–3pt water
- ■ 100g body stain

+ a few drops of calcium chloride
+ a few drops of dispex and/or more water if needed

Jack Doherty's Body Stains for Use in Soda Firing

Orange/Russet

- ■ 33 china clay
- ■ 33 AT ball clay
- ■ 33 porcelain

Yellow

- ■ 90 porcelain
- ■ 10 titanium

Speckle

- ■ 98 porcelain
- ■ 2 ilmenite

Black

- ■ 50 chrome
- ■ 20 cobalt
- ■ 50 alumina hydrate
- ■ 60 iron oxide
- ■ 30 manganese dioxide

Soft Green

- ■ 40 china clay
- ■ 35 flint
- ■ 25 feldspar
- ■ 8 iron oxide
- ■ 16 chrome
- ■ 2 cobalt
- ■ 2 copper carbonate

Dark Brown

- ■ 25 chrome
- ■ 25 iron oxide
- ■ 10 manganese
- ■ 40 alumina

1–7% of these colours are added to the dry clay body, which is then reconstituted.

Underglaze Blue for Painting (Russell Coates)

- ■ 50 calcined china clay
- ■ 20 cobalt oxide
- ■ 20 manganese oxide
- ■ 6 iron oxide
- ■ 5 nickel oxide
- ■ 5 copper oxide

Reduces the 'bleeding' that would normally occur with pure cobalt oxide.

Rice spun porcelain bowls by Alison Gautrey. (26cm w.)
(Photo: Graham Murrell)

Glossary

Alabaster A hydrated calcium sulphate. The pure crystalline form of gypsum.

Alumina An oxide of aluminium. Supplied as calcined alumina or alumina hydrate. An important ingredient in clays, providing plasticity and glazes, acting as an opacifier or matting agent.

Ash glaze Glaze containing a proportion of ash from burnt organic material.

Ball clay Very fine-grained sedimentary clay used to render a porcelain or bone china clay plastic.

Bentonite A fine-grained clay used to render porcelain and bone china clay plastic. Can be a substitute for ball clay.

Bisque or biscuit firing The initial firing of a clay, turning it into ceramic.

Blunging Method of mixing clay and water mechanically to make casting slip.

Body stains Ceramic colours made from metallic oxides that have been blended and prepared to add to slips and clay bodies.

Bone ash Calcium phosphate derived from calcined cattle bones. Used in glazes for a milky quality and major ingredient in bone china.

Bone china Highly translucent white body with large proportion of bone ash. English hybrid of soft-paste and hard-paste porcelain.

Calcine To heat a substance in order to drive off the water content.

Casting Forming ceramics by pouring slip into a porous mould.

China clay A pure form of primary clay high in alumina. Also known as *kaolin*.

Corundum (99.9% alumina) Extremely hard, abrasive mineral with a strength and hardness second to diamonds.

Deflocculation Means retaining a high-density but fluid slip by means of adding an electrolyte or deflocculant. These aid the dispersion of particles in the slip, leading to increased fluidity but requiring less water.

Dispex Sodium dispex is a manufactured product containing Sodium Silicate and Soda Ash, which acts as a defloculant

Dottle A type of long sponge on a stick, usually synthetic, used for cleaning the interiors of tall forms and rims.

Earthenware Porous pottery usually fired to temperatures under 1100°C.

Electrolyte 'A compound which, when dissolved in water, partially dissociates into ions (electrically-charged atoms and molecules)'. Courtesy of A.D. Dodd's *Dictionary of Ceramics*, London, Newnes-Butterworth, 1967.

Engobe Decorating slip applied to ware at the unfired or bisque stage.

Feldspar Mineral used as a fluxing agent in clay bodies and a frit in glazes.

Fettling Cleaning up the seam lines on greenware with a knife or sponge prior to firing.

Flatware General term used in mould making to describe plates, dishes, saucers and so on.

Flux An oxide that lowers the melting point of a glaze and helps vitrification of a clay body.

Frit Ground glass or glaze added to a clay body or a glaze.

Greenware Unfired or raw clay ware.

Gypsum Partially dehydrated mineral from which plaster is derived.

Hollow ware General term used in mould making to describe teapots, cups, jugs and so on.

Isostatic dust pressing Manufacturing process whereby powdered clay dust is spray-dried and compacted through a machine to form a shape (e.g. plates, platters, etc.).

Jasper ware Name given by Wedgwood to a fine grain, vitreous, coloured stoneware. Unglazed.

Jigger and jolleying A technique used in industry to form shapes by means of a profiled tool at a fixed distance from the rotating surface of a plaster mould using clay.

Kidney Tool A kidney-shaped tool in either hard or soft rubber or pliable sheet-steel.

Lathe A machine used for turning plaster models horizontally.

Livering Condition of a casting slip when it appears thick and jelly-like.

Pâte sur pâte Literally meaning 'paste on paste'. Technique used to build up decoration by painting layers of slip on top of each other.

Pinholing Small air hole present just beneath the surface of a casting slip.

Plaster A soft porous stone resulting from the combination of partially dehydrated gypsum and water.

Porosity The amount of 'pore' space in a dried plaster or ceramic material, which may consist of both open and sealed channels.

Quartz A natural crystalline silica used in body and glaze recipes.

Quartz inversion A change of volume in silica crystals at 573°C when they increase in size, and on cooling when they revert back to their previous size.

Reduction Starving the atmosphere in a kiln of oxygen by altering the burners or adjusting the damper (bung), or both.

Riffler A forged-steel tool with serrated edges used for fine detail modelling in clay or plaster.

Saggar Container made from coarse refractory clay in which pots are placed to protect them from flames during gas or wood firing. They are also used for supporting certain objects whilst being filled with alumina or silica sand.

Semi-porcelain Clay which falls between earthenware and porcelain.

Setter An extra item used to control warping of the rims of high-firing clays. Either cast and fired at the same time as the piece, or a pre-fired refractory ring used as support during the firing.

Slake When a material such as clay or plaster is mixed with water and broken down or dissolved into a solution.

Slip Suspension of clay in water

Soda ash/sodium carbonate A common deflocculant used in the manufacture of some casting slips.

Sodium silicate Water glass – a common deflocculant.

Specific gravity A number achieved by dividing the weight of a material by the weight of an equal volume of water. Used in determining weights of casting slips and glazes.

Surform Rasp used for carving plaster.

Thixotropy The ability of certain clay suspensions to thicken up on standing. A characteristic of over-flocculated slips.

Turning The process of paring down clay or plaster to achieve a form whilst the object rotates.

Undercut Area on a model or positive that prevents removal or withdrawal from the mould.

Viscosity The resistance to flow offered by a liquid. The opposite of fluidity.

Vitrification The progressive fusion of a material or body during the firing process.

Wedging Preparation of a plastic clay by kneading to expel air before use.

Whirler Machine with a plaster turntable that rotates, used mainly to make flatware and simple drop-out moulds. Turning is carried out vertically.

Wreathing Small uneven ridges or waves on the drained inside surface of a cast piece.

Bibliography and Further Reading

Andrews, Tim, *Raku* (A & C Black, 2002)

Åse, Arne, *Water Colours on Porcelain* (Norwegian University Press, 1989)

Battie, David, *Sotheby's Concise Encyclopedia of Porcelain* (Conran Octopus, 1990)

Blackman, Audrey, *Rolled Pottery Figures* (Pitman/A & C Black, 1978)

Blandino, Betty, *The Figure in Fired Clay* (A & C Black, 2001)

Chaney and Skee, *Plaster Mold and Model Making* (Prentice Hall Press, 1973)

Colclough, John, *Mould Making* (A & C Black, 1999)

Doherty, Jack, *Porcelain* (A & C Black, 2002)

Dormer, Peter, *The Culture of Craft* (Chapter by Neal French) (Manchester University Press, 1997)

Fournier, Robert, *Illustrated Dictionary of Practical Pottery* (A & C Black, 4th Edition, 2000)

Frith, Donald, *Mould Making for Ceramics* (A & C Black)

Gibson, John, *Pottery Decoration Contemporary Approaches* (A & C Black, 1987)

Gleeson, Janet, *The Arcanum* (Bantam Press, 1996)

Hamer, F. & J., *The Potter's Dictionary of Materials and Techniques* (A&C Black/Watson-Guptill, 4th Edition, 1997)

Harrison-Hall, Jessica, *Ming Ceramics in the British Museum* (The British Museum Press, 2001)

Lane, Peter, *Contemporary Porcelain* (A & C Black, 1995, 2003)

Lightwood, Anne, *Working with Paperclay* (The Crowood Press, 2000)

Meslin-Perrier, Chantal, *The National Museum Adrien Dubouché, Limoges* (Museums and Monuments of France, 1992)

Minogue, Coll and Sanderson, Robert, *Wood-Fired Ceramics* (A & C Black, 2000)

Rhodes, D., *Stoneware and Porcelain* (Pitman, 1960)

Sandeman, Alison, *Working with Porcelain* (Pitman, 1979)

Scott, Paul, *Ceramics and Print* (A & C Black, 1994)

Troy, Jack, *Wood-Fired Stoneware and Porcelain* (Chilton Press, 1995)

Tudball, Ruthanne, *Soda Glazing* (A & C Black, 1995)

Waller, Jane, *The Human Form in Clay* (The Crowood Press, 2001)

Wardell, Sasha, *Slipcasting* (A & C Black, 1997)

Whyman, Caroline, *Porcelain* (Batsford, 1994)

Wood, Nigel, *Oriental Glazes* (Pitman/A & C Black, 1978)

Suppliers

UK

Bath Potters' Supplies
Unit 18
Fourth Ave
Westfield Trading Estate
Radstock
Bath
Somerset BA3 4XE
Tel: 01761 411 077
Fax: 01761 414 115
Email:
enquiries@bathpotters.demon.co.uk

Briar Wheels & Supplies Ltd
Whitsbury Road
Fordingbridge
Hants SP6 1NQ
Tel: 01425 652991
Website: www.briarwheels.co.uk

British Gypsum
Jericho Works
Bowbridge Road
Newark
Notts NG24 3BZ
Tel: 01636 703351

CERAM Research
Queen's road
Penkhull
Stoke-on-Trent
Staffordshire ST4 7LQ
Tel: 01782 845431
Fax: 01782 412331
Email: info@ceramres.co.uk

Clayman
Morells Barn
Park Lane
Lagness
Chichester PO2 6LR
Tel: 01243 2645845

4D Modelshop
The Arches
120 Leman Street
London E1 8EU
Tel: 020 7264 1288
Email:
info@modelshop.demon.co.uk
Website: www.modelshop.co.uk
Creative materials centre.

The Hothouse Centre for Design
St James House
Webberley Lane
Longton
Stoke-on-Trent
Staffordshire ST3 1RJ
Tel: 01782 59700
Email: hothouse@dialpipex.com

Imerys Minerals Ltd (formerly English China Clays)
Par Moor Centre
Par Moor Road
Par
Cornwall PL24 2SQ
Tel: 01726 818000
Fax: 01726 811200
Email: perfmins@imerys.com
Website: www.imerys-perfmins.com

Metrosales
Unit 3, 46 Mill Place
Kingston-upon-Thames
Surrey KT1 2RL
Tel: 020 8546 1078
Suppliers of polyester, nylon fibre and paper products.

Potclays Ltd
Brickkiln Lane
Etruria
Stoke-on-Trent
Staffordshire ST4 7BP
Tel: 01782 219816
Email: potclays@btinternet.com

Potterycrafts Ltd
Campbell Road
Stoke-on-Trent
Staffordshire ST4 4ET
Tel: 01782 745000
Fax: 01782 746000
Email: Sales@potterycrafts.co.uk
Website: www.potterycrafts.co.uk

Scarva Pottery Supplies
Unit 20
Scarva Road Industrial Estate
Banbridge
Co. Down BT32 3QD
Tel: 018206 69699
Fax: 018206 69700
Email:
david@scarvapottery.demon.uk
Website: www.scarvapottery.com

South Western Industrial Plasters
63 Netherstreet
Bromham
Chippenham
Wiltshire SN15 2DP
Tel: 01380 850616
Suppliers of plaster and flexible moulding materials.

Alec Tiranti
27 Warren Street
London W1P 5DG
Tel: 020 7636 8565
Modelling tools and small equipment.

Valentine's Clay Products
The Sliphouse
Birches Head Road
Hanley
Stoke-on-Trent
Staffordshire ST1 6LH
Tel: 01782 271200

W. J. Doble Pottery Clays
Newdowns Sand and Clay Pits
St Agnes
Cornwall TR5 0ST
Tel: 01872 552979

Australia

Ceramic Supply Co.
17–19 Paves Street
Guildford NSW 2161
Tel: 612 9892 1566
Email: csco@bigpond.com

Clayworks Australia
6 Johnstone Court
Dandenong
Victoria 3175
Tel: 613 9791 6749

Pottery Supplies
South Castlemain St
Paddington
Queensland 4064
Tel: 617 3368 2877

Walker Ceramics
Boronia Road
Wantirna
Victoria 3125
Tel: 613 9725 7255

USA and Canada

AFTOSA
1032 Ohio Avenue
Richmond
CA 94804
Tel: 800 2310397
Website: www.aftosa.com

American Art Clay Co.
W. 16th Street,
Indianapolis
IN 46222
Tel: 317 244 6871
Website: www.amaco.com

Laguna Clay Co.
1440 Lomitas Avenue
City of Industry
CA 91746
Tel: 800 452 4862
Website: www.lagunaclay.com

Minnesota Clay Co.
8001 Grand Avenue South
Bloomington
MN 55420
Tel: 612 884 9101

Tuckers Pottery Supplies Inc.
15 West Pearce St
Richmond Hill
Ontario
Canada L4B1 H6
Tel: 800 304 6185
Email: Tuckers@passport.ca
Website: www.tuckerspottery.com

Index